THE POLITICS
OF PAINTING

*Fascism and Japanese Art
during the Second World War*

ASATO IKEDA

UNIVERSITY OF HAWAI'I PRESS
HONOLULU

23 22 21 20 19 18 6 5 4 3 2 1

Library of Congress Cataloging-in-Publication Data

Names: Ikeda, Asato, author.

Title: The politics of painting : fascism and Japanese art during the Second World War / Asato Ikeda.

Description: Honolulu : University of Hawai'i Press, [2018] | Includes bibliographical references and index.

Identifiers: LCCN 2017057798 | ISBN 9780824872120 (cloth alk. paper)

Subjects: LCSH: Painting, Japanese—20th century. | Painting—Political aspects—Japan—History—20th century. | Fascism and art—Japan—History—20th century. | World War, 1939-1945—Japan—Art and the war.

Classification: LCC ND1055.4 .I42 2018 | DDC 759.52/0904—dc23

LC record available at https://lccn.loc.gov/2017057798

Publication of this book has been assisted by grants from the following organizations:

Furthermore:
a program of the J.M. Kaplan Fund

FURTHERMORE: A PROGRAM OF THE J. M. KAPLAN FUND
ASSOCIATION FOR ASIAN STUDIES
FORDHAM UNIVERSITY

Designed by Mardee Melton

CONTENTS

List of Illustrations
vii

Acknowledgments
ix

Introduction
1

CHAPTER ONE
Japanese Paintings, Fascism, and War
8

CHAPTER TWO
Yokoyama Taikan's Paintings of Mount Fuji
25

CHAPTER THREE
Yasuda Yukihiko's *Camp at Kisegawa* and Modern Aesthetics
48

CHAPTER FOUR
Uemura Shōen's *Bijin-ga*
67

CHAPTER FIVE
Fujita Tsuguharu and *Events in Akita* (1937)
85

Conclusion
100

Notes
103

Selected Bibliography
121

Index
129

Color plates follow page 86

LIST OF ILLUSTRATIONS

FIGURES

FIGURE 1. Kanō Motonobu, *Fuji Mandala* (Kenpon chakushoku Fuji mandara zu), 16th century. Ink and color on silk, 186.6 x 118.2 cm. Fujisan Hongū Sengen Taisha.

FIGURE 2. Kusakabe Kimbei, *Fujiyama from Hakone Lake,* ca. 1890s. Photograph, 21.5 x 27.9 cm. Royal Ontario Museum.

FIGURE 3. *Shashin shūhō,* October 4, 1944.

FIGURE 4. Sesshū Tōyō, *Mt. Fuji and Seikenji Temple* (Fuji miho seikenji zu). 43.2 x 101.8 cm. Ink on paper. Eisei Bunko Museum, Tokyo.

FIGURE 5. Hitler looking at a painting by Sesson (1504–1589) at the Japan Ancient Art Exhibition, Berlin, in 1939. Nomura Art Museum.

FIGURE 6. *Night Attack on the Sanjo Palace, from the Illustrated Scrolls of the Events of the Heiji Era* (Heiji monogatari emaki), second half of the 13th century. Ink and color on paper. 41.3 x 700.3 cm. Museum of Fine Arts, Boston.

FIGURE 7. *Battle of Ichinotani and Yashima,* first half of the 17th century. Ink, color, and gold on paper. Photo Courtesy: John Bigelow Taylor. John C. Weber Collection.

FIGURES 8. Tange Kenzō, Greater East Asia Co-Prosperity Sphere Memorial Hall (Daitōa kensetsu chūrei shin'iki keikaku), 1942. *Kenchiku zasshi* 56.693 (December 1942).

FIGURE 9. Kajiwara Hisako, *Sisters* (Shimai), ca. 1916. Kyoto Municipal Museum of Art.

FIGURE 10. Kainoshō Tadaoto, *Nude* (Rafu), ca. 1921. The National Museum of Modern Art, Kyoto.

FIGURE 11. Fujita Tsuguharu, *Picturesque Nippon* (Gendai Nippon), 1937. Reproduced in *Atorie,* May 1937, p. 65.

COLOR PLATES (following page 86)

PLATE 1. Yokoyama Taikan, *Japan, Where the Sun Rises* (Nihon hi izuru tokoro), 1940.

PLATE 2. Yokoyama Taikan, *The Wheel of Life* (Seisei ruten), 1923.

PLATE 3. Katsushika Hokusai, "Fine Wind, Clear Weather" (Gaifū kaisei), also known as "Red Fuji," from the series *Thirty-Six Views of Mount Fuji,* 1830–1831.

PLATE 4. Yokoyama Taikan, *Landscapes of the Four Seasons Copy, Original Attributed to Sesshū* (Shiki sansuizu mosha den sesshūhitsu), 1897.

PLATE 5. Kanō Tan'yū (1602–1674), *Mt. Fuji* (Fujisan zu), 1667.

PLATE 6. Fifty sen bill, in circulation between 1938 and 1948, incorporating a photograph by Okada Kōyō.

PLATE 7. Yokoyama Taikan, poster for the 1939 Japan Ancient Art Exhibition in Berlin.

PLATE 8. Yasuda Yukihiko, *Camp at Kisegawa* (Kisegawa no jin), 1940–1941.

PLATE 9. Yasuda Yukihiko, *Parting at Yoshino* (Yoshino ketsubetsu), 1899.

PLATE 10. *Portrait of Yoritomo* (Kenboku chakushoku den Minamoto no Yoritomo zō), 1179 (?).

PLATE 11. *Illustrated Account of the Mongol Invasion* (Mōko shūrai ekotoba), 13th century.

PLATE 12. Tsuchida Bakusen, *Island Women* (Shima no onna), 1912.

PLATE 13. Saeki Shunkō (1909–1942), *Tearoom*, 1936.

PLATE 14. Uemura Shōen, *Dance Performed in a Noh Play* (Jo no mai), 1936.

PLATE 15. Uemura Shōen, *Sudden Blast* (Kaze), 1939.

PLATE 16. Uemura Shōen, *A Long Autumn Night* (Nagayo), 1907.

PLATE 17. Suzuki Harunobu, *Poem by Jakuren Hōshi, from an untitled series of Three Evening Poems (Sanseki)*, 1766–1767.

PLATE 18. Suzuki Harunobu, *Autumn Wind,* from the *Six Elegant Poets series* (Fūryū rokkasen), ca. 1768.

PLATE 19. Uemura Shōen, *Late Autumn* (Banshū), 1943.

PLATE 20. Uemura Shōen, *Lady Kusunoki* (Nankō fujin), 1944.

PLATE 21. Kitō Nabesaburō, *Shiny Encounter* (Kagayaku taimen), *Shufu no tomo,* May 1941.

PLATE 22. Women Artist Patriotic Group (*Joryū bijutsuka hōkōtai*), *All Women Work for the Imperial Nation in the Great East Asia War* (Daitōasen kōkoku fujo mina hataraku no zu), 1944.

PLATE 23. Fujita Tsuguharu, *Events in Akita* (Akita no gyōji), 1937.

PLATE 24. Fujita Tsuguharu, *The Battle of Nomonhan* (Haruha kahan no sentō), 1940.

PLATE 25. Fujita Tsuguharu, *Sleeping Beauty* (Nemureru onna), 1931.

PLATE 26. Suzuki Harunobu, *Woman Admiring Plum Blossoms at Night,* 18th century.

PLATE 27. Katsuhira Tokushi, *The Composition of Bonden Offering* (Bonden hōnō no zu, 1931).

PLATE 28. Hamaya Hiroshi, *New Year's Visit with Jizo, Niigata Prefecture,* 1940.

PLATE 29. Fukuda Toyoshirō, *Those Who Sell Vegetables* (Sansai uru hitotachi), 1932.

PLATE 30. Mitani Toshiko, *Morning* (Asa), 1933.

PLATE 31. Fujita Tsuguharu, *Sumo Wrestler in Beijing* (Hokuhei no rikishi), 1935.

ACKNOWLEDGMENTS

I am truly fortunate to have been connected with and supported by a group of wonderful mentors, colleagues, friends, and family, and I am grateful for the research institutions that provided me with the resources to write this book.

I would like to express my sincere gratitude, first and foremost, to Joshua S. Mostow and John O'Brian at the University of British Columbia. I would like to acknowledge here that revisiting the idea of "Japanese fascism" was indeed Joshua's idea, and his expansive knowledge of premodern/modern Japanese and non-Japanese art and literature as well as critical theory guided me through my graduate studies and beyond. I benefited from John's expertise in modern art and its politics. I was extremely lucky and privileged to have *both* of these two great thinkers and scholars as supervisors. I see Sharalyn Orbaugh as my third advisor, and I am indebted to her thought-provoking and helpful comments and feedback.

My academic interest in the intersection between art and politics goes back to my study at Temple University Japan, where I took intellectually stimulating courses by Jeff Kingston, Leonard Horton, and Geeta Mehta. With encouragement from Kathlyn Liscomb and Machiko Oya at the University of Victoria, where I completed my BA in the history of art, I decided to pursue a graduate degree and studied under Ming Tiampo and Reesa Greenberg at Carleton University, Ottawa. Ming's mentorship, guidance, and friendship have been foundational to my life for the past decade, and I simply cannot thank her enough.

In 2013, as Anne Van Biema Fellow, my project was funded by the Freer | Sackler Galleries, Smithsonian Institution, where I received support from Ann Yonemura, James Ulak, Reiko Yoshimura, Takako Sarai, and Motoko Shimizu. Between 2014 and 2016, I was the Bishop White Committee Postdoctoral Fellow at the Royal Ontario Museum in Toronto. This position allowed me to devote myself to writing. I would like to thank the Bishop White Committee members as well as my ROM family: Chen Shen, Deepali Dewan, Wen-chien Cheng, Sascha Priewe, Jack Howard, Max Dionisio, Gwen Adams, Kara Ma, Celio Barreto, Su Yen Chong, Josiah Ariyama, Akiko Takesue, Yasuko Enosawa, and Mariko Takashima.

Fordham University, where I am currently assistant professor in the Department of Art History and Music, has generously provided me with research grants. I would like to thank my wonderful Fordham colleagues, Jo Anna Isaak, Barbara Mundy, Nina Rowe, Maria Ruvoldt, Kathryn Heleniak, Richard Teverson, Andrée

Hayum, Elizabeth Parker, Angela Michalski, Katherina Fostano, Larry Stempel, Daniel Ott, Matthew Gelbert, Eric Bianchi, Nathan Lincoln-Decusatis, and Sevin Yaraman for creating a lively and joyous department and a work environment that encourages research. Critical insights I received from an art history work-in-progress meeting at Fordham in 2013 led me to substantially refine my ideas for this book.

I would not have been able to continue my scholarly project, which tended to be seen as controversial and provocative at best (and which sometimes seemed dubious even to me), without moral support and encouragement from others. This does not indicate by any means that this book can receive full endorsement from the following individuals, but kind words from and stimulating dialogues with Mark Selden, Laura Hein, Aya Louisa McDonald, Kawata Akihisa, Bert Winther-Tamaki, Gennifer Weisenfeld, Kendall Brown, Paul Berry, Julia Adeney Thomas, Alicia Volk, Akiko Takenaka, Maki Kaneko, Takashi Fujitani, Lisa Yoneyama, and Michael Donnelly have meant a great deal to me. I would also like to acknowledge the moral and emotional support from my colleagues, friends, mentors, role models, cheerleaders, and somehow spiritual healers/personal therapists (in some cases all at the same time): Ming Tiampo, Francesca Simkin, Justin Jesty, Namiko Kunimoto, Rie Shirakawa, Robban and Arianne Toleno, Nathen Clerici, Malia Cordel, Dafna Zur, Kari Shepherdson-Scott, Kanna Hayashi, Moa Sugimoto, Keishi and Miho Otani, Manabu and Ai Ikeda, Eriko Kay, Noriko Nagao, Sari Aokage, and Eiji Makino. Without support from Satoshi Kondo, who took good care of our daughter, Aili, I would not have been able to complete this book. I am also very grateful to my parents, Tetsuya and Kyoko Ikeda, for their full and unconditional support of my life in general.

I dedicate this book to my grandparents. My paternal grandfather, Kenji Ikeda, was an elite engineering student at Waseda University and was therefore not drafted to the war. He showed me where an air raid shelter (*bōkūgō*) was located in the yard of our house when I was very little. My paternal grandmother, Wakako Ikeda, was born and grew up in Ōdomari, Karafuto (today's Sakhalin, Russia), and repatriated to the mainland when the war ended. Even when I asked, she never talked about what it was like to live there. My maternal grandmother, Eiko Isoda, was a daughter of a wealthy family in Chichibu, Saitama, and her life, according to her, was not much affected by the war. She continued to drink Brazilian coffee, she said. My maternal grandfather, Katsuichi Isoda, grew up in Sendai, Kagoshima, near a kamikaze attack airbase. He remained a nationalist after the war and took me to Chiran Peace Museum for Kamikaze Pilots when I was a young adult. There is no question that these interactions with my grandparents first formed my curiosity about the wartime period, and writing this book, to some degree, was a very personal project.

The production of this book was made possible by grants from Furthermore, the Association for Asian Studies, and Fordham University. Francesca Simkin's thorough copyediting magically transformed my writing, and this book benefited from additional editorial help from Jennifer McIntyre and Nick Hall. I would like to thank Stephanie Chun and Grace Wen at the University of Hawai'i Press for their hard work.

INTRODUCTION

In 1970, the American government gave the "most problematic" collection of Japanese art back to Japan, though only on indefinite loan. The collection in question includes 153 paintings, most of them militaristic, violent battle scenes executed in oil on canvas, that were painted in the Western style (*yōga*) during the Second World War. (In the Asia-Pacific theater, the Second World War started with Japan's invasion of Manchuria in 1931 and ended with its unconditional surrender in 1945.)[1] Many of these works, such as Fujita Tsuguharu's *The Battle of Nomonhan* (1940), which is discussed briefly in Chapter Five, were paintings commissioned by the state and were known as War Campaign Record Paintings (*Sensō sakusen kirokuga*) (see Plate 24). The paintings were confiscated by the American occupational government in 1951 and rediscovered in 1967 by Japanese photographer Nakagawa Ichirō at the Wright-Patterson Air Force Base in Ohio. Nakagawa's color photographs of the paintings were then exhibited at the Seibu Department Store in Tokyo, and spurred Japanese artists and art critics to call for their return, which took place in 1970.[2]

Despite the repatriation, the National Museum of Modern Art in Tokyo, where the collection is held, has never displayed the collection in its entirety. Fearing, probably rightly, that neighboring nations such as China and Korea would be angered by such a display, the museum cancelled a planned war painting exhibition in 1977 and has since decided to display only a few of the works, on a rotating basis, at any one time.[3] An important critic of Japanese contemporary art, Sawaragi Noi, highlighted the sensitive nature of the situation surrounding the display of these paintings in his 2002 book, calling the collection a "Pandora's Box" that would reveal the hidden violence inherent in Japanese modern history.[4]

To think of the confiscated collection as encapsulating the essence of Japanese war art, however, is problematic, as it does not comprehensively represent Japan's wartime artistic output.[5] Many thousands of artworks produced during the war did *not* depict contemporary battles and soldiers, and significantly, the collection barely includes any prominent Japanese-style paintings executed with ink or color on silk or paper (*Nihon-ga*). The attention given to the confiscated collection has created a curious divide, in the public discourse, between the explicitly propagandistic Western-style War Campaign Record Paintings, on the one hand, which are problematic and politically charged, and the "rest," which depict landscapes, women, and children and are "non-militaristic," "apolitical," and "unproblematic" and "happened to have been produced during the war," on the other.

The question, therefore, is how does one analyze non-battle paintings? This book proposes a model of analysis that focuses on works that allude to Japan's traditions, icons, and culture—such as Mount Fuji, historical warriors, beautiful women, and rural customs—and engages with the concept of Japanese fascism. Japanese fascism, just like German and Italian fascism in Europe, was characterized by the belief that there was once a culturally authentic community that became lost in the process of modernization and that must be restored. Japanese fascism sought to recreate a traditional, national community inhabited by Japanese people and united by their authentically Japanese spirit, uncontaminated by modernity. Fascism, in the context of the Second World War, used cultural authenticity as a justification for violence against other countries, such as the United States and Britain, which espoused democracy, individualism, and liberalism. This book revisits the issue of Japanese fascism to elucidate the connection between non-battle paintings produced during the war and their political meanings.

By illuminating the politics of the seemingly "apolitical" paintings, this book challenges the postwar labeling of *only* battle paintings as a "Pandora's box." At the same time, by examining wartime Japanese paintings through the lens of fascism, this book suggests the global dimension of wartime Japanese nationalist art and opens up the possibility of discussion and dialogue in scholarship that looks at the art produced outside Japan—especially in Nazi Germany and Fascist Italy—around the same time. Ultimately, the book will offer a model of nuanced interpretation that attends to changing relationships between visual iconography/artistic style and their meanings by carefully situating artworks within their specific historical context. The careful historicization is essential to understanding the art of fascism, in which politics has been rendered merely "aesthetic," as Walter Benjamin has observed.[6]

Specifically, I look at paintings produced in the 1930s and early 1940s by four prominent painters. Three of these—Yokoyama Taikan (1868–1958), Yasuda Yukihiko (1884–1978), and Uemura Shōen (1875–1949)—painted in the Japanese style, and the fourth, Fujita Tsuguharu (1886–1968), painted in the Western style. Despite their different styles and subject matter, these four artists all maintained a close tie with the state and painted what they considered most representative and authentic of Japan. Their paintings, as I will show, are artistic manifestations of Japanese fascism.

Yokoyama Taikan produced countless paintings of Mount Fuji, the tallest mountain in Japan, as an embodiment of the country's "national body" and spirituality, as contrasted with the "individualistic" and "materialistic" modern West. Yasuda Yukihiko found Japan in the historical figures of the medieval Minamoto warriors and painted them in a style inspired by *yamato-e* (Japanese pictures, defined as opposed to Chinese paintings). Uemura Shōen sought to paint "Japanese women," drawing on the genre of Edo-period *bijin-ga* (beautiful people pictures) and also alluding to "Japanese" *noh* aesthetics and wartime gender expectations. Fujita Tsuguharu located Japan in the countryside, where authentic traditions were thought to have survived the onslaught of modern Japan.

While War Campaign Record Paintings were produced almost exclusively by Western-style painters, many of the works that embodied the vision of "return to Japan" were, understandably, Japanese-style paintings, which were considered to represent a more traditional form of Japanese art than Western-style oil painting, which had only begun emerging at the beginning of the Meiji period (1868–1912).

Art produced during the Second World War has been largely neglected in the history of art in general. For example, *Janson's History of Art: The Western Tradition*, one of the most popular introductory art history survey textbooks in North America, covers twentieth-century art in three chapters—"Toward Abstraction: The Modernist Revolution, 1904–1914," "Art between the Wars," and "Postwar to Postmodern, 1945–1980"—with remarkable gaps between 1914 and 1919, and again between the early 1930s and 1945.[7] Even though various countries (Britain, Australia, Canada, and the United States, among others) produced official war art, such works tend to be stored in military institutions or war museums. Likewise, paintings that portray battles and fronts tend to be discussed separately from the rest of each country's respective national art.[8] However, since the 2000s, the field has seen growing scholarship in the form of both academic books and exhibition catalogues, with the latest being Monica Bohm-Duchen's *Art and the Second World War* (2013), which investigates art produced internationally during the Second World War and even includes a chapter on Japan.[9]

The Second World War has been a particularly sensitive topic in Asia. In Japan, views on the war are widely divergent. The Left seeks to interrogate the country's violence toward Asia, while the Right, which has dominated postwar government, tends to reiterate the positive effects of colonialism (such as modernization), to deny that Asian people suffered under Japan's control, and to justify the war on the grounds both that it was inevitable in the face of Western colonialism and that its purpose was to free Asians from Western exploitation. The issue is most contentious in the field of education. Historian Ienaga Saburō (1913–2002) famously fought censorship by the Ministry of Education, which sought to eliminate "inconvenient" facts from school history textbooks, such as mass rapes and murders, systematized sex slavery, biological experimentation on Chinese civilians and prisoners of war (POWs), and forced labor.[10] The Japanese government has issued official apologies for some of these, but they are constantly undermined by national leaders' frequent, ill-conceived comments, which make it difficult to believe in the sincerity of the

apologies. Prime Minister Abe Shinzō, for example, has persisted in the view that there was no Nanjing Massacre and that Asian women enslaved by the military were prostitutes, even though an apology had already been made to the "comfort women" (*ianfu*) (i.e., not "prostitutes") by the Hashimoto government in 1995.[11] The conservative government's views naturally anger formerly colonized nations, especially Korea and China, and Japan's diplomatic relations with those nations are still affected by a war that ended more than seventy years ago.

The lack of critical investigation of wartime complicity is to a large extent a result of the American occupational government's changing policies during the Cold War, which left the question of Japan's war responsibility (*sensō sekinin*) largely unsolved. The occupation government did not hold the emperor accountable in the Tokyo War Crimes Tribunal even though the so-called holy war was fought in his name, and it restored former military officials to the government in order to fortify Japan against the Cold War communist threat. What emerged within this context was what historian Igarashi Yoshikuni calls the "foundational narrative," which says that the United States restored Japan's peace with the atomic bombs and that the emperor symbolizes that peace.[12] This narrative obscured both the ethical question of America's use of nuclear weapons and Japan's responsibility for suffering in Asia by (re)presenting Japan as a victim rather than a perpetrator.[13]

Another reason why the art produced during the Second World War has generally been understudied in the discipline of Japanese art history is that, as art historian Mimi Yiengpruksawan argues in her survey of the field in 2001, conservatism still prevails, preventing "questioning, argumentative, skeptical" scholarly inquiry. As she explains, historical narratives and canons related to Japanese art developed in accordance with the Japanese modern state's promotion and tight control of art as a "national treasure."[14] Especially in the Euro-American context, where an Orientalist view of Japanese art still exists, Japanese art tends to be discussed separately from politics. The fact that the paintings I examine in this book allude to Japan's traditional art from the past might explain why they have eluded critical scholarship. Yokoyama Taikan's paintings of Mount Fuji build on a long history of Japanese pictorial art that depicts the revered mountain, Yasuda Yukihiko draws on *yamato-e* paintings that developed in ancient Japan, and Uemura Shōen emulates Edo-period *bijin-ga*: the paintings do not look particularly different from some works of pre-modern Japanese art.[15] Understandably, therefore, specialists and lovers of Japanese art might be reluctant to relate traditional-looking art to explicit political debate and a contentious and emotive war.

Since the death of Emperor Hirohito in 1989 and the fiftieth anniversary of the end of the war in 1995, however, scholars have begun investigating Japanese war art in a more critical light.[16] In Japan, art historians Kawata Akihisa and Tan'o Yasunori co-authored the book *War in Images: From the Sino-Japanese to the Cold War* (1996), which launched the field by examining works ranging from Meiji-era woodcut war prints to War Campaign Record Paintings.[17] The 2000s then saw the beginning of a boom in publications on Japanese war art—not just for art history specialists and students but also for a general audience—that carried on into the 2010s; the book *Art in Wartime Japan 1937–1945* (2007) brought together major

specialists in the field, notably Kawata Akihisa, Ōtani Shōgo, Hariu Ichirō, and Sawaragi Noi, and reproduced several hundred paintings created during the war, including some that had been lost, as well as others that had been confiscated by the United States.[18]

The public and scholarly interest in Japanese art produced during the war has also resulted in a number of exhibitions on the subject. In 2005, the Niigata Prefectural Museum held a landmark exhibition called *Shōwa no bijutsu: 1945 nen made mokuteki geijutsu no kiseki* [The Art of the Shōwa Period: The Trajectory of Propaganda Art to 1945], displaying both leftist and rightist artworks from the 1920s to 1945. The 2006 retrospective of Fujita Tsuguharu, the leading war painter who was once ostracized by the Japanese public, was organized by the National Museum of Modern Art in Tokyo and subsequently prompted a "Fujita boom."[19] In 2013, the Museum of Modern Art in Hayama, held an exhibition titled *Sensō/bijutsu 1940– 1950: Modanizumu no rensa to henyō/War/Art 1940–1950: Sequences and Transformations of Modernism,* which, despite its name, did not theorize the relationship between war and modernism but nevertheless pointed to that issue by displaying paintings produced by prominent modernists during the war, both Western and Japanese style.

In the English-speaking world, art historian Bert Winther-Tamaki published a ground-breaking article in 1997, "Embodiment/Disembodiment: Japanese Paintings during the Fifteen-Year War," which analyzed wartime works by artists including Matsumoto Shunsuke, Yokoyama Taikan, and Fujita Tsuguharu in relation to the issue of the human body.[20] The PhD dissertations of Mayu Tsuruya (2005) and Maki Kaneko (2006), completed in the United States and England, respectively, followed Winther-Tamaki and showed how war art was entrenched in the development of a Japanese modern art that was intricately related to Japan's nation building. In so doing, both Tsuruya and Kaneko refuted the previous assumption that war art was a product of historical aberration.[21] *Art and War in Japan and Its Empire: 1931–1960,* which I co-edited with Ming Tiampo and Aya Louisa McDonald in 2012, is the first English-language anthology on Japanese war art and brings together scholars from Asia, North America, and Europe—including Bert Winther-Tamaki, Mayu Tsuruya, Maki Kaneko, Kawata Akihisa, Laura Hein, Julia Adeney Thomas, and Michael Lucken.[22] Recent publications by Winther-Tamaki and Kaneko—respectively, *Maximum Embodiment: Yōga, the Western Painting of Japan, 1912–1955* (University of Hawai'i Press, 2012) and *Mirroring the Japanese Empire: The Male Figure in Yōga, 1930–1950* (Brill, 2014)—are significant contributions to the field and the first two monographs on wartime paintings.

When Japanese art produced during the Second World War is discussed at all, however, the bulk of the attention has been paid to Western-style paintings that depict battles. While much has been written about Japanese-style paintings and national identity during the Meiji period, there is scant work that discusses the same issue for the 1930s and early 1940s: Thomas Rimer's essay "Encountering Blank Spaces: A Decade of War, 1935–1945," included in the exhibition catalogue edited by Ellen Conant, *Nihonga: Transcending the Past: Japanese-Style Painting, 1868–1968,* is the only writing on the subject in English.[23] On the other hand, it must be noted

that some scholars have presented sophisticated analyses of how artworks that do not necessarily depict battles and soldiers could justify Japan's colonialism and the war. My own study is indebted to the close and nuanced readings of artworks and their historical context demonstrated by such art historians as Miriam Wattles, Ikeda Shinobu, Gennifer Weisenfeld, Kari Shepherdson-Scott, and Kendall Brown.[24]

This book builds on previous scholarship about Japanese wartime art; at the same time, it importantly departs from the earlier scholarship by closely engaging with the idea of Japanese fascism.[25] My discussion of Japanese fascism is indebted to the recent growth of scholarship in the field. Harry Harootunian's 2001 book *Overcome by Modernity: History, Culture, and Community in Interwar Japan* is central to understanding the sense of cultural crisis experienced and discussed by intellectuals in the interwar period, which had global resonance.[26] Alan Tansman's monograph and anthology on Japanese fascism and its aesthetics and culture are pioneering works that incorporate new methodologies with which to understand fascism in the field of cultural production, most importantly in the realm of literary works.[27] While Tansman's anthology include authors who investigate different media, such as crafts, literature, architecture, monument, film, and exhibition, it does not offer a study of pictorial arts. This book expands the recent dialogue among Japanese specialists about fascism, bringing the scholarly inquiry into the previously unexplored field of paintings.

Chapter One lays out a theoretical framework for the book by defining Japanese fascism. Reviewing the historiography on the topic, I argue that Japanese fascism is a useful concept with which to explore how modernity was a central problem to the state during the war and to distinguish the cultural nationalism of the 1930s and early 1940s from the nationalism of Meiji Japan. The examination of wartime Japanese paintings is then situated within the larger narrative of modern Japanese art history to show how artists and the state came to work closely during the war under state's tight censorship.

Chapter Two examines paintings of Mount Fuji by Yokoyama Taikan, particularly *Japan, Where the Sun Rises,* which was displayed at the 1940 Celebration of Japanese Imperial Reign's 2600th Anniversary. This chapter establishes the model with which I approach the art of Japanese fascism. I show how the artist maintained a close relationship with the state and proactively called for extensive state control of art production. His Mount Fuji painting, which was meant to celebrate Japan's imperial family and spirituality, resonated with and reinforced Japanese fascism, which proclaimed Japan's cultural uniqueness.

Chapter Three closely examines a single painting by the Japanese-style painter Yasuda Yukihiko: *Camp at Kisegawa (Kisegawa no jin).* Consisting of two folding screens, the work portrays the emotional reunion of the Minamoto brothers, two samurais of the Kamakura period. Yasuda's painting alludes to Japan's past by evoking the tradition of Japanese warriors and hierarchical human relations, which were understood as particularly Japanese during the war. While the painting was certainly modeled on the *yamato-e* style from the medieval period, it was also informed by modernist aesthetics that had been introduced from the West in preceding periods. This chapter thus engages with the issue of "fascist modernism"—the fascist

appropriations of modern aesthetics, which has been addressed in scholarship on German and Italian fascism.

Chapter Four investigates several paintings by Uemura Shōen, one of the most successful female artists in Japanese art history and one of the most active artists during the war. Examining a number of her works, including *Dance Performed in a Noh Play* (1936), *Late Autumn* (1943), and *Lady Kusunoki* (1944), I argue that her paintings treat Japanese women as a repository of traditional values, and that Shōen thereby participated, like Taikan and Yasuda, in the politics of Japanese fascism. This runs contrary to mainstream Japanese feminist art history, which has treated her as a feminist artist who produced anti-war works.

Chapter Five examines Fujita Tsuguharu's *Events in Akita* (1937). This mural painting, which depicts customs and festivals of the snow-covered rural regions of Akita, embodied the ideal of Japanese fascism by portraying rural Japan, and particularly Tohoku and snow country. In the 1930s and early 1940s, Japan's rural areas, in contrast to Westernized, modern cities like Tokyo, were thought to have preserved indigenous cultural characteristics. The discursive interest in the countryside was manifested in various fields, such as in *mingei* (folk art), *mingokugaku* (folk studies), woodblock prints, photography, and literature. Fujita was a rare Western-style painter who sought to represent Japan using the foreign medium of oil.

1

JAPANESE PAINTINGS, FASCISM, AND WAR

Non-battle paintings produced in Japan during the Second World War were profoundly steeped in the state's wartime ideology, whose ultimate aim was to restore Japan's unique cultural sensitivities. The principles of this ideology were exemplified by an official document titled *Kokutai no hongi* (Cardinal Principles of the National Entity of Japan), and theorized in the public arena by important intellectuals and cultural figures; it was also discussed during the 1941 "Overcoming Modernity" symposium. The yearning for the past that dominated the political and cultural currents of 1930s and early 1940s Japan can perhaps best be understood in reference to recent fascism studies, which view fascism as a backlash against modernity.

This chapter examines the concept of Japanese fascism, which will be used as an interpretive tool throughout this book. Viewing wartime Japan as fascist is a useful construct, as this allows us to maintain the important distinction between the "new" nationalism of the 1930s and 1940s and that of the Meiji period (1868–1912). It also allows us to highlight the degree to which modernity became a fundamental problem to Japan during the Second World War, and to situate wartime Japan in a global context.

Following that is a broad overview of the history of modern Japanese art—a history in which the paintings discussed in this book play an important part—paying particular attention to the changing relationships between art/artists and the state over time. This relationship was close during the Meiji period, but was increasingly challenged by some avant-garde and Leftist artists during the Taishō period (1912–1926). But after the Manchurian Incident happened in 1931, with it tighter state control and increasing military aggression, many artists began once more to develop

collaborative relationships with the state by submitting works to state-sponsored exhibitions and joining patriotic organizations. The flip side of that, of course, is the degree to which the state imposed censorship and controlled artists; this ideological affinity, as we will see, is reflected in the paintings of Taikan, Yasuda, Shōen, and Fujita.

JAPANESE PAINTINGS AND "RETURN TO JAPAN"

The non-battle paintings produced during the Second World War usually deployed artistic styles and subject matter that were considered representative of Japan's national tradition and cultural identity. The most conspicuous and compelling example of this is perhaps Yokoyama Taikan's repeated portrayals of Mount Fuji (see Plate 1), which will be discussed further in Chapter Two. Drawing on a national icon that had been frequently represented in literature and visual arts throughout the country's history, Taikan visualized Japan through the image of the lofty, magnificent mountain. He specifically employed the mountain to metaphysically embody the idea of *kokutai* (national body), the sacred bond between the emperor and his subjects, and associate it with the "Japanese spirit," which was, both in his thinking and in public discourse at large, believed to manifest the uniqueness of the Japanese people and distinguish them from the culture and people of "the West" (specifically, the Americans and British) or, in other words, the enemy. In this context, Mount Fuji, a natural site and cultural symbol, takes on a political function, signifying a fighting spirit and justifying both the violence perpetrated in Asia and the antagonism felt toward the West.

Taikan was by no means an exception in this regard. Japanese-style painter Yasuda Yukihiko's most celebrated wartime work, *Camp at Kisegawa,* completed in 1941, also seeks to distill the idea of Japan into portrayals of the famous warriors and historical figures Minamoto Yoshitsune and Yoritomo (see Plate 8). (This will be discussed in more detail in Chapter Three.) Not only is the painting executed in a style that alludes to indigenous Japanese *yamato-e* paintings, but it also exemplifies Confucian ideals of society in which the junior serves the superior. Uemura Shōen, a successful female Japanese-style painter and the focus of Chapter Four, attempted to articulate Japanese aesthetics with portrayals of beautiful Japanese women (see Plate 14). Her wartime writings confirm that her paintings of women express the unique traditional characteristics of Japanese culture and were her contribution to the nation at war. Although not a Japanese-style painter, Fujita Tsuguharu (discussed in Chapter Five) envisioned Japan in a similar way, but via a monumental painted mural that depicts old traditions and customs surviving in the snowy countryside of Akita (see Plate 23). His painting is part of the wartime cultural discourse of finding Japan in the peripheries of the country, where modernization had not completely wiped out traditional lifestyles.

These paintings mirror the cultural nationalism of the 1930s and early 40s, articulated by the idea of *Nihon kaiki,* or "return to Japan."[1] In tandem with the appearance of more nationalistic visual art, publications that attempted to define

characteristics unique to Japan began to appear after the Manchurian Incident of 1931, with the discussion becoming particularly prominent between around 1935 and 1945.[2] *The Essence of the National Polity* (*Kokutai no hongi*), published in 1937 by the Ministry of Education and taught in schools, is the most important text participating in this discourse. It is an official document that articulates Japan's fundamental existential difference from the West, declaring that it is incumbent on Japanese people to remember their own traditions and culture, specifically those that existed prior to Meiji-period Westernization, and that this is the only way to solve the social and cultural problems they were facing. The document defines *kokutai*, or national polity—that is, Japan's central principle—as unity between the emperor and his subjects. It explains that the emperor, ruler of the divine land, is a descendant of the Sun Goddess Amaterasu and that his subjects must dedicate their lives to him. To sacrifice themselves for the public good is to fulfill their responsibility as Japanese subjects. Written against the backdrop of the Second Sino–Japanese War, it is clear that the discussion of "things Japanese" was used to justify and promote military conflict. The 1940 Celebration of the Japanese Imperial Reign's 2600th Anniversary feted the putative founding of Japan by Emperor Jimmu in 660 BC and the nation's subsequent history. It was essentially an ideological extension of *Kokutai no hongi*, and involved the whole nation through various events and mass spectacles such as festivals, plays, art exhibitions, and athletic events.[3]

The theoretical aspect of the official state ideology outlined in *Kokutai no hongi* was buttressed by major Japanese philosophers of the time. The "return to Japan" discourse and the purpose of Japan's war were most clearly articulated by the infamous symposium "Overcoming Modernity" (*Kindai no chōkoku*), which took place in 1942 at the beginning of the Pacific War. The symposium is now considered to be the most seminal debate among cultural figures that addressed the direction of Japan's future. Participants included leading intellectuals and writers: members of the Kyoto School of Philosophy, the Literary Society, and the Japan Romantic Group. Echoing *Kokutai no hongi*, they argued that Japan's modernization, which started in the Meiji period (1868–1912) and matured in the Taishō period (1912–1926), had introduced problematic ideologies and lifestyles to Japanese society, most notably individualism, liberalism, and consumerism, which were embedded in both the Western Enlightenment tradition and capitalism.[4] Through the development of Western-inspired commercial industry and commodity culture, they argued, the people of Japan now pursued their individual interests and desires at the expense of traditional values.[5]

JAPANESE FASCISM

Precisely how to characterize the ethos of wartime Japan has been hotly debated. Some scholars use the term "ultranationalism" to highlight the intense zealotry publicly embraced by a majority of Japanese at the time.[6] Many others favor "militarism," pointing to the fact that the state was "hijacked" by military officials who ignored the voices of the civilian government, starting with the Manchurian Incident in 1931.[7]

I propose that wartime Japan in fact manifested a very specific form of ultranationalism and militarism: fascism.

There is a long history of scholarship on Japanese fascism, beginning in the 1930s. Two Soviet Japanologists, O. Tanin and E. Yahan, wrote a book entitled *Militarism and Fascism in Japan* in 1933, and Japanese intellectuals, including Hasegawa Nyozekan, Imanaka Tsugimaro, Gushima Kanezaburō, Sassa Hirō, and Tosaka Jun, wrote on and criticized fascist aspects of Japanese politics during the 1930s.[8] Significantly, many of these authors were Marxists who analyzed fascism from an economic perspective and understood it as an inevitable consequence of bourgeois capitalism.

In 1947, political scientist Maruyama Masao delivered a speech on Japanese fascism, calling it "Emperor-System Fascism" (*tennōsei fashizumu*). In the speech, Maruyama highlighted a number of Japan-specific elements, such as the *zaibatsu* (industrial and financial business conglomerates) and the feudal system.[9] Maruyama stated,

> Japanese fascism . . . shared the ideology of its Italian and German counterparts in such matters as the rejection of the worldview of individualistic liberalism, opposition to parliamentary politics which is the political expression of liberalism, insistence on foreign expansion, a tendency to glorify military build-up and war, a strong emphasis on racial myths and the national essence, a rejection of class warfare based on totalitarianism, and the struggle against Marxism.[10]

In 1987 Yoshimi Yoshiaki developed the influential idea of "grassroots fascism" (*kusano ne no fashizumu*), a state fascism that was enthusiastically embraced by politically frustrated, financially suffocated Japanese citizens, especially those in rural areas.[11]

It is important to note that several scholars have argued against using the term "Japanese fascism," dismissing the concept as inappropriate and counterproductive. George Macklin Wilson, Peter Duus and Daniel Okamoto, and Ben-Ami Shillony have all contested "Japanese fascism" on the grounds that Japan did not have a political revolution, charismatic leader, or fascist-style party, all of which have been seen as prerequisites for a fascist system.[12] In fact, fascism could be a contested characterization even within the European context: it has been argued, for example, that Italian fascism and German Nazism should not be discussed within the same theoretical framework of fascism, as there are many political, economic, and cultural differences between them.[13]

While there are influential works that present compelling and useful records of fascism and fascist culture/art prior to the 1990s, it was only in the 1990s that scholarship began to move away from the previous predominantly Marxist analysis of fascism.[14] Some scholars have begun considering fascism as an ideology, rather than an economic structure and political system, and exploring its applicability to, and manifestation in, culture. British historian Roger Griffin is, without question, the leading figure in the growing field of fascism studies.[15] While his "checklist" approach, which suggests that fascism needs to fulfill certain criteria, seems limiting

and Western-oriented, his proposal to understand fascism as a global phenomenon and generic concept, in the same vein as socialism and democracy, has been ground-breaking and influential.[16] Beyond his fascism checklist, Griffin has broadly understood fascism as a search for cultural authenticity and a manifestation of cultural crisis resulting from modernization. He writes,

> The mythic core that forms the basis of my ideal type of generic fascism is the vision of the (perceived) crisis of the nation as betokening the birth-pangs of a new order. It crystallizes in the image of the national community, once purged and rejuvenated, rising phoenix-like from the ashes of a morally bankrupt state and the decadent culture associated with it.[17]

Focusing on the cultural myth that fascism creates, Griffin also importantly acknowledges one of the central contradictions of fascism: fascism repudiates modernity, especially its principles of liberalism, democracy, and individualism, but it uses modern technology and science.

Whether directly referencing works by Griffin and others or not, cultural historians who have engaged with the issue of fascism and culture in the 1990s and 2000s are informed by the growing consensus on fascism initiated and advanced by the historians. If fascism is the ideology that reclaims a country's cultural authenticity in an attempt to resist a homogenizing modernity, then cultural production is indeed central to maintaining its politics. Scholars of cultural studies—such as Simonetta Falsca-Zamponi, Jeffrey Schnapp, Alice Kaplan, Hal Foster, Jeffrey Herf, Andrew Hewitt, Mark Antliff, Emily Braun, Terri Gordon, Ian Boyd Whyte, Winfried Nerdinger, John Heskett, Lutz Kopnick, and Susan Buck-Morss, to name just a few—have studied the culture of fascism in spectacle, theater, dance, architecture, design, paintings, and literature.[18] They have shown how cultural manifestations of fascism can be complex, contradictory, and different from one region to another and from one medium to another. They have demonstrated that fascist art is a form of modernism, just as fascism is a form of modernity.

It is not surprising, then, that this scholarly trend should be found and reflected in the study of Japanese fascism in recent years. One of the most important is historian Harry Harootunian's 2001 book, *Overcome by Modernity: History, Culture, and Community in Interwar Japan*, which, like Griffin's work, regards fascism as a modern nation's particular response to modernity. He writes,

> Fascism in Japan, and elsewhere, appeared under the guise of what might be called *gemeinschaft* capitalism and the claims of a social order free from the uncertainties and indeterminacies of an alienated civil society, where an eternalized and unchanging cultural or communal order was put into the service of the capitalist mode of production to establish a "capitalism without capitalism."[19]

The two most important recent developments, however, are Japanese literature specialist Alan Tansman's monograph on fascism and wartime literature,

The Aesthetics of Japanese Fascism (2009), and the anthology he edited, *The Culture of Japanese Fascism.*[20] Tansman writes,

> In Japan, as in Europe, fascism emerged as a reactionary modernist response to the threats of social and political division created by the economic and social crises following the First World War. The social, economic, and cultural conditions that gave birth to European fascism were shared by Japan.[21]

Harootunian's and Tansman's discussions of Japanese fascism are consistent, convincing, and useful. The concept of Japanese fascism allows us to clearly distinguish the cultural nationalism of the Meiji period from that of the Second World War—an important distinction that needs to be maintained. The use of technology and industrial development in the Meiji period was limited compared with that of the 1930s and early 1940s; while the Meiji period did indeed witness the rise of cultural nationalism, the state promoted Westernization in principle and focused on catching up with the West rather than repudiating it completely. In the nationalism—or fascism—of the 1930s and early 1940s, however, the central issue was Japan's cultural crisis resulting from what was seen as excessive exposure to Western, modern culture. In the context of the Second World War, cultural authenticity became a rhetorical tool to explain and justify the global war.

Moreover, material conditions and sociopolitical and economic infrastructure were very different in the Meiji period compared to the 1930s and early 1940s. As Sandra Wilson explains, due to the lack of technology in the former era, it was difficult for the modern Meiji government in the mid- and late nineteenth century to advocate the idea and benefits of nationhood to its citizens, who tended to affiliate themselves with their local domain and identify themselves with specific social classes governed by the Edo-period system of *shi-nō-kō-shō* (warrior-farmer-artisan-merchant).[22] A strong sense of national identity was held only by the elite, and common people in rural Japan had a hard time even understanding that the emperor, whom they had never seen, was a divine ruler who controlled the country.[23] This lack of shared national identity in the nineteenth century can be explained by the limited circulation of materials, print publications, and therefore ideas in the Meiji period, when the country's modern technology was still in its formative years. As Wilson writes, "In the early 1870s, the government had no nation-wide system of barracks or primary schools; newspapers were few and those that did exist were certainly not geared to the lower levels of literacy."[24]

In stark contrast, by the 1930s Japan was no longer in the process of "modernizing" but in fact had become completely "modern."[25] The Taishō period witnessed a second industrial revolution that was characterized by the development of mass media, including newspapers, magazines, radio, photography, and film, as well as the advancement of transportation systems such as trains, ships, and planes.[26] These developments fundamentally changed the way Japanese people lived. The mass circulation of newspapers and the introduction of radio disseminated knowledge about contemporary events to thousands of people at the same time, considerably

bolstering the idea of a political community, whether local, national, or global. Development of trains and ships allowed a large number of people to visit or actually move to places, including cities in Japan's empire, rather than just reading about them in print media. The downside, of course, was that these same modern mass media, as well as institutions and social structures, were imperative for the state to impose total control over its citizens during the Second World War: the state mobilized newspapers, magazines, and radio to widely publicize their policies and disseminate their ideology, imposing tight control and censorship on them. Modern mass media played a critical role in the state being able to extend its control to every single citizen.

Admittedly, nationalism in the Meiji period laid the foundation for the "return to Japan" movement in the 1930s and early 1940s. As early as the 1870s, in fact, there was a growing unease about the social changes advanced by the government, and certainly by 1904, which marked the beginning of the Russo–Japanese War, intellectuals and politicians alike, represented by Tokutomi Sōhō (1863–1957), were angered and disappointed by the racism of the West, which did not see Japan as an equal political partner.[27] The late Meiji period saw a growing number of theories and books on Japanese national culture, which were often also targeted at Western audiences. Politician and educator Nitobe Inazō's (1862–1933) *Bushido: The Soul of Japan* (1900) and Okakura Tenshin's (1862–1913) *The Ideals of the East* (1903) and *The Book of Tea* (1906), which were all written first in English, are good examples. Okakura's theorization of Japanese aesthetics in relation to Asia was instrumental in establishing "*datsuō nyūa*" (Exiting the West, Returning to Asia), the countermovement to the earlier Meiji trend and the ideology of Pan-Asianism, which declared that "Asia is one."[28]

Despite the backlash against and criticism of the modernization project, however, Meiji officials generally believed that Japan needed to "catch up" with the West and that Japan's "particularities" should exist within the logic of civilization and "universal" principles grounded in the Western Enlightenment tradition.[29] As Dennis Washburn points out,

> Human agency, subjectivity, and reason make progress appear to be the natural state of the world. This is the assumption that supported the claims of the early Meiji modernizers, who saw in scientific knowledge and rationalism the underpinnings of a universal human culture that was moving toward the perfection of institutions and societies.[30]

The goal of Meiji Japan was to incorporate Western political and social principles so that Japan would be treated as an equal on the global stage by modern Western nations.

Most importantly, the 1930s' and early 1940s' brand of nationalism was specifically concerned with modernity that had been achieved in the previous decades of the early twentieth century. As was articulated in *Kokutai no hongi* and at the "Overcoming Modernity" roundtable, what wartime Japanese state officials and intellectuals problematized were the effects of modernity. They believed that Western Humanist and Enlightenment schools of thought introduced to Japan since the Meiji period had engendered the ideas that individuals have the right to freedom and

that reason and intellect can be used to challenge traditional and religious practices. Also, they argued, a modern way of life had given birth to the compartmentalization of society, the specialization of skills, the development of the nuclear family, and the use of empirical science to demystify the world. For the wartime state officials and intellectuals, these were negative consequences of modernity that resulted in the alienation of individuals, the fragmentation of community, and the loss of communal connections. They proposed, instead, to re-create a hierarchical but unified, organic, and harmonious community that they believed had once existed in the past. Often using religiously laden language alluding to spirituality, obligation, and sacrifice, they sought to create an alternative lifestyle and worldview that prioritized feeling and sensual pleasure rather than rationality, intellect, or ideas. The "reinstallation" of the authentic Japanese community was understood as the reason for the war and justification for the violence: the war was understood as an opportunity to remove the "sickness" of Westernization.[31]

Cultural authenticity might have been evoked in Meiji nationalism, but it was never a justification for violence. The two wars Japan had fought earlier—the Sino–Japanese War and the Russo–Japanese War—were conflicts over specific territories in the context of Japan's and the West's imperialist ambitions. But the Second World War, which might have started out as a territorial conflict over Manchuria, ultimately came to be understood as a conflict between different *cultures*. The fascination and obsession with, and theories about, Japan's cultural uniqueness in public discourse increased dramatically around 1937, which popularized the idea that Japan was fighting the war to protect itself from the homogenizing modernization, Westernization, and globalization that was destroying its indigenous culture. Making the distinction between Meiji nationalism and nationalism during the Second World War is thus important to our understanding of why Japan fought the war and how it justified violence.

Using fascism as an interpretive framework also allows us to appropriately situate Japan and the Japanese art of the 1930s and early 1940s in a global context. While the period is characterized by battles among nation-states (and colonies), there were concerns and interests that were shared across continents. Japan had close political, cultural, and economic connections with the West throughout the late nineteenth and early twentieth centuries, and its relationship with the Axis Nations (fascist Italy and Nazi Germany) had a pronounced impact on the direction of Japanese artistic practices. It is to indicate this global connectedness in the early twentieth century that I use the term "Second World War" throughout this book to refer to the period between 1931 and 1945, rather than, for example, "Asia-Pacific War," a term that geographically and theoretically isolates Japan from what was going on in the rest of the world during those years.

ART AND STATE IN MODERN JAPAN

As I have suggested, it is productive to take fascism—a particular form of cultural nationalism and militarism unique to 1930s and 1940s Japan—seriously in reading the paintings of Yokoyama Taikan, Yasuda Yukihiko, Uemura Shōen, and

Fujita Tsuguharu. At the same time, it is necessary to situate their works within a broader narrative of Japanese modern art history in order to illuminate the changing relationships between art/artists and the state. The wartime paintings should also be considered, more specifically, in reference to the state censorship and control that grew along with the country's military aggression and violence on the Asian continent, which mobilized a large number of leading artists and art critics for the war effort. As I will show, art was integral to Japan's modern nation-building in the Meiji period, which came to be questioned and challenged in the 1910s and 1920s by Leftist avant-garde artists. However, beginning in 1931 with the Manchurian Incident, this artistic landscape changed radically, and after the crackdown on Leftist artists around 1933, there was hardly any artistic resistance to state ideology and policies; most artists worked for the state, especially after the Second Sino–Japanese War (1937–1945) and into the Pacific War (1941–1945). Taikan, Yasuda, Shōen, and Fujita were among the most prominent and active painters during these war years.

Western artistic techniques and aesthetics had initially been introduced to Japan in the Edo period (1601–1868), but it was only during the Meiji period that the Western artistic system was introduced to Japan in a comprehensive manner.[32] During that time, art became more closely tied to the country's modern nation building, which entailed radical Westernization. The government established the first national art museum, the Tokyo National Museum (then *Monbushō hakubutsukan*, or Museum of the Ministry of Education), in 1872, which was followed by the founding of the first national art school, the Tokyo National School of Fine Arts (*Tōkyō bijutsu gakkō*) in 1887. In 1907, the government established a state-sponsored annual exhibition, the Ministry of Education Art Exhibition (*Monbushō bijutsu tenrankai*), modeled on French salons, in 1907.[33]

The national art school taught two kinds of painting: Japanese style and Western style. Okakura Tenshin, with support from American professor and art critic Ernest Fenollosa (1853–1908), established modern Japanese-style painting (*Nihon-ga*), a synthesis of "traditional" Japanese art (including Kanō school, Tosa school, and Maruyama-Shijō school) and European academic art, which was to become Japan's "national" art.[34] Meanwhile, Kuroda Seiki (1866–1924), who had studied under an impressionist artist in France and became the first director of the Western Painting department at the Tokyo National School of Fine Arts in 1896, taught the "Western" medium of oil painting. He emphasized the importance of the history-painting genre in such a way as to reconcile the foreign medium, style, and genre with subject matter from Japanese history.[35] The binarism between the Western style and the Japanese style was pervasive, but Meiji artists—both Japanese and Western style—generally worked within the framework of state institutions and sought to create art that would represent Japan's national identity.

The close tie between art and state began to be challenged in the 1910s and 1920s during the Taishō period (1912–1926); within that framework, a daily life filled with the products of modern technology and science led to expressions of a "free spirit," especially in cities. The younger part of the populace came to embrace democratic ideals introduced from the West, prompting large-scale political and

social movements that called for universal male suffrage and workers' rights. Women's entry into the workforce allowed them to be economically independent and stand outside the Meiji-period patriarchal paradigm of "good wife, wise mother" (*ryōsai kenbo*). So-called *mobo* (modern boys) and *moga* (modern girls) wore fashionable Western clothes and hairstyles, were knowledgeable about Western intellectual discourses, and were the main consumers in capitalist urban areas: they became cultural icons of the period. Although we see evidence of intellectuals' and cultural figures' continuing concerns with Japan's cultural authenticity, they neither dominated society nor determined the state's official ideology.

Within this context, the younger generation of artists rebelled against the hierarchical, traditional style of the academic school and its exhibition system, established in the Meiji period.[36] This anti-establishment, anti-mainstream spirit was best articulated by Takamura Kōtarō (1883–1956), a sculptor, poet, and critic who went so far as to touch on the critical issue of artists' national identity. In a piece that appeared in the magazine *Subaru* in 1910, he wrote,

> I was born as a Japanese; and as a fish cannot leave the water to make his life, I will always be a Japanese, whether I acknowledge that fact to myself or not . . . [And yet] when my own sense of self is submerged in the object of my attention, there is no reason for such thoughts to occur to me. At such times, I never think of Japan. I proceed without hesitation, in terms of what I think and feel. Seen later, perhaps the work I have created may have something "Japanese" about it, for all I know. Or then again, perhaps not. To me, as an artist, it makes no difference at all.[37]

Distinguishing himself from the older generation of Meiji artists, for whom art was intricately related to nation building, Takamura made it clear that his Japanese nationality did not consciously affect his artistic production.

Reflecting this increasing resistance to national institutions, a number of young Western-style painters, including Arishima Ikuma (1882–1974), Ishii Hakutei (1882–1958), and Umehara Ryūzaburō (1888–1986), proposed an alternative exhibition venue, forming the Nikakai (Second Section Society) in 1914. Many of these painters traveled to Europe and became literate in the latest trends of European modernism. Another important group whose members overlapped with the Nikakai's was the Shirakaba-ha, or Shirakaba school, which launched the literary magazine *Shirakaba* (White Birch).[38] *Shirakaba,* published from 1910 to 1923, reproduced photographs of works by European modernist artists such as Rodin, Cézanne, van Gogh, Gauguin, and Matisse, and published translations of their writings. The Shirakaba artists placed artists' subjectivity, individuality, and personality above everything else, and understood art as the subjective expression of individuals.

The influence of European modernism and experimental artistic practice loomed large around this time among Japanese-style painters as well. Representing this trend was Tsuchida Bakusen (1887–1936), who established, along with other progressive Japanese-style painters, the Society of the Creation of Japanese Painting

(*Kokuga sōsaku kyōkai*), a private exhibition alternative to government-sponsored annual exhibitions, in 1918.[39] Like the Shirakaba artists, Bakusen, who made a trip to Europe in 1921, was deeply interested in European modernism, especially in the work of Paul Gauguin.

Much more radical than the Japanese modernists of the 1910s were the avant-garde artists who emerged in the 1920s, and who, following Dadaist artistic practice, consciously, and sometimes violently, tried to push the boundaries of social custom, decorum, and artistic tradition. One of the most important of these art groups was MAVO, founded in 1923 by Murayama Tomoyoshi (1901–1977).[40] Murayama advocated not only dramatic change in artistic forms, but also changes in Japanese society at large through the incorporation of artistic practices into everyday life. Murayama's artistic career started with Cubist- and Constructivist-inspired paintings, but developed into three-dimensional installation art and performances incorporating avant-garde dance that shocked the viewer with explicit sexualization of bodies and deliberate gender bending. Murayama eventually became interested in theater that would agitate audiences for a political purpose; his cutting-edge avant-garde activity grew into a more explicitly propagandistic Leftist art practice in the late 1920s.

The Leftist activity in Japan originated in the Meiji period and was revived and reached its peak in the 1920s, inspired by the success of the Bolshevik revolution of 1917 in Russia.[41] The Japan Communist Party (*Nihon kyōsantō*) was founded in 1922, and was recognized as Japan's official branch of the Communist International (Comintern). As its membership increased over the course of the 1920s through growing readership of its magazine *Red Flag* (*Akahata*), the party advocated over-throwing the capitalist government, the nationalization and redistribution of land to peasants, opposition to imperialist war, and the independence of Japan's colonies such as Korea and Taiwan. Numerous literary figures participated in the proletarian movement, united by the Japan Proletarian Literary Arts League (*Nihon puroretaria bungei renmei*). They published important literary magazines such as *Tanemakuhito* (founded in 1921), *Bungei sensen* (founded in 1924), and *Senki* (founded in 1928), which published numerous important proletarian writings by communist party members, including Nakano Shigeharu (1902–1979) and Kobayashi Takiji (1903–1933), author of the canonical Japanese Leftist novel *The Cannery Boat* (*Kanikōsen*), published in 1929.[42]

Visual artists such as Okamoto Tōki (1903–1986) and Yanase Masamu (1900–1945) produced visual propaganda for the proletarian movement, such as posters advertising proletarian newspapers, art exhibitions, and films.[43] They also produced posters that advocated better working conditions/environments, as well as increased wages and social welfare and protection for farmers, factory workers, and construction workers. Murayama Tomoyoshi, the leader of MAVO, also participated in these activities, turning his attention to theater as a more effective means to raise social and political consciousness among the uneducated and illiterate masses. His 1930 play *Bōryokudanki* (The Gang Diary), for example, glorifies the Chinese railway workers who stood against their exploitative managers and is widely recognized as an important literary work.[44]

ART, WAR, AND STATE CONTROL

The artistic freedom of the Taishō period evaporated during the war. The scope and content of artistic activity and production came to be significantly limited, curtailed by the country's military aggression overseas and tightened national security and state control at home. However, it is important to note that there were artists who willingly collaborated with the government from as early as the 1930s, when state control was still relatively loose. In order to grasp the complex dynamics and changing balance between artists' agency and state control, it is imperative to carefully chronicle Japan's military activity and domestic policies in the 1930s and early 1940s.

In 1931, the Japanese army made an advance into Manchuria without official approval from the civilian government, thereby marking the point where military officials took control of Japan's political direction. Since Taiwan and Korea were already Japanese colonies by that time, the advance into Manchuria extended Japan's expansion into the Asian continent. In 1937, with the so-called Marco Polo Bridge Incident, Japan began an undeclared war with China that radically affected the lives of citizens at home. While the advancement into Manchuria had been a decision taken by the military without consultation, by this time the Japanese government was fully collaborating with the army. Prime Minister Konoe Fumimaro called for the establishment of a "New Order in East Asia" in 1938, proposing that Japan create a new world culture, united with Manchuria and China. In reality, however, as historian Mary Hanneman points out, "Japan simply sought to establish its own hegemony over Asia."[45]

In 1940, Konoe officially declared the creation of this "New Order"; he reorganized economic, political, and cultural structures under the state, and founded the Imperial Rule Assistance Association (IRAA), a single unified political entity that officially ended party politics. In the same year, Japan signed the Tripartite Pact with Germany and Italy, supplanting the Anti-Comintern Pact that Japan had signed with Nazi Germany in 1936. In 1941, General Tōjō Hideki replaced Konoe and almost immediately declared war with the United States: in December of that year, Japan attacked Pearl Harbor and declared war against the British and Dutch forces that occupied Guam, Wake Island, Hong Kong, the Philippines, Singapore, Burma, Fiji, Samoa, Indonesia, and New Caledonia, among others. Finally, renewing Konoe's 1938 New Order, the Japanese government declared the establishment of a Great East Asia Co-Prosperity Sphere (*Daitōa kyōeiken*), in which China, Manchukuo (the puppet state set up in Manchuria), Taiwan, Southeast Asia, and the South Pacific would fall under Japan's leadership with a self-sufficient economic structure free from Western exploitation.

Soon after the Manchurian Incident, the state became intolerant of alternative political views and tried to exercise total control over every single citizen. This totalitarianism makes the 1930s and 1940s clearly distinct from preceding periods in Japan's history. Gradual militarization of the country in the early 1930s was buttressed by two separate activities: elimination of opposition forces and the incorporation of everyone else into organizations and communities that espoused state politics using various events such as rituals and festivals. By June 1933, 392 members of the Japan

Communist Party had been arrested. The literary figures and visual artists mentioned earlier were also imprisoned. Kobayashi Takiji was arrested in February 1933 and tortured to death, which became the subject of Tsuda Seifū's (1880–1978) painting *Victim*. Tsuda was then arrested because of the painting. Okamoto and Yanase were arrested in 1932, and Murayama was imprisoned twice, once in 1930 and again in 1932.

By 1935, the state had virtually eliminated all opposition forces, that is to say socialist and proletarian advocates, by prohibiting their activities and arresting them under the Peace Preservation Law, which was implemented in 1925 and allowed the *kempeitai,* the military police, to use physical force.[46] The careful erasure of anti-war forces during this period is important, as it later allowed the state to mobilize all citizens without prominent resistance. The political significance of and therefore danger for the Leftists lay in the fact that they were virtually the only political group that questioned the fundamental principles of the modern Japanese state: the imperial system and colonialism.[47]

Most of those arrested did not remain in prison. Significantly, they underwent *tenkō,* often translated as "conversion" or "recantation." *Tenkō,* Tiberius Sipos explains, is "a publicly declared ideological and epistemological conversion which takes the form of an individual narrative and which is brought about by brutal and sustained coercion from the state, the state apparatuses, or any other authority with the power of life and death over the subject of conversion."[48] In short, the Leftists abandoned the practice of their previous beliefs and began espousing state politics.

The *tenkō* movement began on June 8, 1933, when the two leading figures of the Communist Party, Sano Manabu (1892–1953) and Nabeyama Sadachika (1901–1979), issued the "*tenkō* declaration," accusing the Communist International of being unable to address and solve problems specific to Japan.[49] Significantly, 133 of its 392 members underwent *tenkō* within a month of the "*tenkō* declaration," and approximately 95 percent of arrested communist activists had done so by 1942, leaving, surprisingly, only 37 members who had *not* altered their political stance.[50] What emerged thereafter was the so-called "*tenkō* literature": literature by people who had performed *tenkō,* narrating their stories about it in order to broadcast their ideological conversion publicly. Murayama Tomoyoshi's *Byakuya* (White Night), for example, was published in May 1934 in *Chūō Kōron.* In it, the main character, a male intellectual and Leftist activist, reflects on his inability to both lead the Leftist movement and keep his wife from a more attractive, intelligent man. The book is Murayama's expression of total impotence and one of the earliest examples of *tenkō* literature.[51]

While suppressing the Left, the state also invested in promoting pro-war sentiment to anyone who would listen. Most important in this context was the army's National Defense Campaign (*Kokubō sisō fukyū undō*) in the early 1930s, which insisted on Japan's need to have a strong army and secure its rights and interests in Manchuria. As historian Louise Young has observed, this awareness of national defense was successfully disseminated to "the people" regardless of their age, class, or gender through various local organizations throughout the country that regularly hosted exhibitions, festivals, lectures, and parades that promoted the idea of national defense.[52] In 1932, the Kokubō fujinkai (National Defense Women's Organization)

was established, which mobilized women into support of the war: the organization dedicated its activities to organizing celebratory parties to send soldiers off, supporting soldiers' family members, welcoming injured/dead soldiers back home, and sending "comfort bags" (*imon bukuro*) to soldiers on the front.

The government launched the National Spiritual Mobilization Movement (*Kokumin seishin sōdōin undō*) in 1937, in which nationalist organizations rallied the nation, promoting war.[53] The state's investment in the war was also buttressed by the 1938 National Mobilization Law, which justified state control of industries and civil organizations. The military ultimately nationalized the local communities and independent organizations that they had used during the National Defense Campaign, ultimately destroying civil society. The war was conceived as a "thought war" (*shisō sen*), and the military imposed control over both mass media and education. After 1937, all information about the national economy and foreign policies was considered a state secret and went through a screening process before publication.[54] State surveillance on citizens' lives was systematized through the creation of *tonarigumi* (neighborhood associations) in 1940, each of which consisted of several households and functioned as a local monitoring system.

From the early 1930s, the state began commissioning visual propaganda, and many artists started working for official organizations. The Cabinet Information Bureau, in collaboration with the modernist photographer group Nippon Kōbō, founded a photographic propaganda magazine called *NIPPON* in 1934 that was targeted at Western audiences.[55] The magazine was intended to ameliorate the relationship between Japan and Western nations, which had been jeopardized by Japan's advancement into Manchuria, by offering a touristic gaze into an exotic Japan that maintained a "peaceful" relationship with its colonies, including Manchuria. In 1935 the Ministry of Education carried out a restructuring of its annual exhibition in an attempt to bring younger artists, who had hitherto displayed their works in private exhibitions, into the state structure. Called the Matsuda Reorganization, the restructuring was successful in that the state exhibition now included major artist organizations of both Japanese-style and Western-style painters: the Japan Art Institute (*Nihon bijutsuin*) and the Nikakai (Section Two Society).

State control became much more pervasive and unavoidable in the early 1940s. Various state-sanctioned "patriotic" organizations, such as the Patriotic Association of Japanese-style Painters (*Nihon gaka hōkokukai*, 1941) and the Patriotic Association of Japanese Artists (*Nihon bijutsu hōkokukai*, 1943), brought together almost all active artists under national control. In the early 1940s it was generally difficult to obtain art supplies, especially after the American embargo, and naturally official war artists were given privileged access to them.[56] Censorship was so tight and prevalent at this point—every publication and every artwork came under state scrutiny—that it may make little sense to distinguish between "official" and "unofficial" culture, especially later in the war. Kenneth J. Ruoff writes,

> Drawing a strict division between the "official" and "civil" spheres in the Japan of 1940 is perilous, especially when one takes into account the existence of numerous hybrid semiofficial, semi-civil organizations as well as

the considerable influence that the government could exert over private enterprises (e.g., over newspaper companies).[57]

After the mass arrest of Leftists in the early 1930s, artistic "resistance" became extremely rare, almost non-existent. A well-known exception is Western-style painter Matsumoto Shunsuke (1912–1948)'s essay "Ikite iru gaka" (Living Artist), published in *Mizue* in January 1941. In the essay, Matsumoto discreetly criticizes state control of artistic freedom, but he was never arrested for it.[58] In 1939, Takiguchi Shūzo (1903–1979) and Fukuzawa Ichirō (1898–1992), both influenced by European surrealism, established the *Bijutsu Bunka Kyōkai,* which advocated artistic independence and autonomy in the face of state control.[59] As a result, both men were arrested in 1941 and spent eight months in prison.[60] Later, Takiguchi published a text that expressed his regret for his earlier activities.[61] In 1943, to address the shortage of soldiers, the state introduced a system where all healthy high school and university students, except those majoring in science, were drafted; this was called *gakuto shutsujin* (student mobilization). Many art students at the elite Tokyo School of Fine Arts (*Tōkyō bijutsu gakkō*) were conscripted and died on the front.[62]

Beginning in 1938, many Western-style painters were sent to the front to produce War Campaign Record Paintings (*Sensō sakusen kirokuga*), paintings of specific battles and military events. According to art historian Kawata Akihisa, over three hundred Western-style painters produced Campaign Record Paintings.[63] Within a year, ten artists, including Nakamura Ken'ichi, had traveled to Shanghai, two (Kawabata Ryūshi and Tsuruya Gorō) had gone to North China, and several, including Fujita Tsuguharu, had accompanied the Navy.[64] War Campaign Record Paintings were frequently produced by artists who had previously studied in Europe and been known as "modernist" painters—including Fujita Tsuguharu, Miyamoto Saburō, Mukai Junkichi, Inokuma Gen'ichirō, and Ihara Usaburō. Their works were exhibited at War Art Exhibitions (*Sensō bijutsu-ten*), Holy War Art Exhibitions (*Seisen bijutsu-ten*), and Army Art Exhibitions (*Rikugun jūgun gaka-ten*), which were held at department stores and art museums and funded by the military and newspaper companies.[65]

Defined as having "the significant historical purpose of recording and preserving the military's war campaign forever," these War Campaign Record Paintings portrayed Japanese soldiers fighting on the ground, at sea, and in the air, traveling through the Asian continent, interacting with local people (most often women and children) in areas under Japan's control, and attending important political events, such as Burma's "independence" ceremony from its Western colonizer and Japanese military officials' meetings with Western enemies who were about to surrender.[66] Fujita Tsuguharu's monumental painting *The Battle of Nomonhan* (*Haruha kahan no sentō,* 1940), for example, portrays Japanese soldiers advancing in North Asia (see Plate 24). A cluster of soldiers is placed on the right of the painting, where they carefully investigate a tank in which Russians are supposedly trapped. The scene, capturing a nice sunny day and Japanese soldiers making unmistakably dominant gestures, gives an optimistic impression of the country's progress in the war. Yet the painting is misleading: in reality, Japan lost 50,000 troops to the Russians in this battle.[67]

By depicting contemporary soldiers, battles, and political events, many Western-style painters contributed to Japan's militarism—here defined as "the belief or desire of a government or people that a country should maintain a strong capability and be prepared to use it aggressively to defend or promote national interests."[68] Their work functioned to depict soldiers in a glorious light, emphasizing their diligence and victory. Many of the artworks also represented indigenous, local people in areas occupied by Japan with Japanese soldiers performing "kind" acts to their Asian neighbors. In so doing, a large number of War Campaign Record Paintings were also closely entangled with Japan's imperialist expansion into the Asian continent and Southeast Asia, which justified its economic and political control over neighboring areas by declaring that Japan was "rescuing" them from Western imperialism/colonialism.

By contrast, the contributions of many Japanese-style painters during the war were much different. Rather than traveling to the front and depicting soldiers, they voluntarily organized, for example, "dedication exhibitions" (*kennō-ga ten*) at department stores such as Matsuzakaya and Matsuya, the proceeds of which were donated to the military. Nihon Bijutsuin (the Japan Art Institute), a non-governmental Japanese-style painting organization to which Yokoyama Taikan (the artist examined in the next chapter) belonged, dedicated the proceeds from sales of their paintings to the army as early as 1932.[69] In 1937, the Japan Art Institute donated a further 7,000 yen to the military. In 1940, Taikan organized a "dedication exhibition" at Takashimaya Department Store, selling twenty paintings from the series titled *Ten Paintings about Mountain, Ten Paintings about Sea* (*Yamani chinamu jūdai, Umi ni chinamu jūdai*); he raised 500,000 yen and donated it to the military, thereby funding four aircraft called "Taikan battleplanes" (*Taikan gō*).[70] Japanese-style painters also played a prominent role in Japan's diplomacy. In 1934, Taikan offered one of his paintings to the puppet emperor of Manchuria, Puyi, as a gesture to display Japan's "friendly" relationship with Northern China.[71] When a group of Hitler Youth visited Japan in 1938, Taikan welcomed them, gave them a lecture about Japanese art, and presented them with a piece of his art.[72] He was also heavily involved in the Japan Ancient Art Exhibition (*Nihon kobijutsu tenrankai*), which took place in Berlin in the spring of 1939 under Hitler's auspices, producing an advertisement poster for it.[73] (This will be discussed in depth in the next chapter.) Similarly, Uemura Shōen, a female Japanese-style painter (the subject of the fourth chapter), visited China in 1941 to present a gift to Wang Jingwei, the leader of Japan's puppet government in Nanjing.[74]

Most importantly, however, many Japanese-style painters involved in activities considered "traditional" displayed their works at exhibitions that celebrated the history of Japan, and painted visual icons that the Japanese public as well as art critics understood as representing the country's unique culture. For example, Taikan and Shōen donated paintings to religious institutions in an act designed to contrast with the commercialized practice of private collection and ownership of fine art by wealthy individuals, a phenomenon resulting from the introduction of Western art practices. Taikan and Yasuda (the artist who is the focus of Chapter Three) upheld the myth of sacred Japan by submitting their works to the Celebration of the 2600th Anniversary of the Imperial Reign Exhibition (*Kigen nisen roppyakunen hōshuku*

bijutsu-ten), which celebrated the religious myth of continuity of the imperial family's reign (see Plate 1). Many Japanese-style painters also engaged with subjects and styles that were taken from and inspired by Japanese history and tradition, such as Mount Fuji, medieval warriors, and beautiful women.

While one could draw the loose conclusion that Western-style painters produced works that embody the militarist aspect of fascism and that Japanese-style paintings mirrored fascism's culturalist aspect, this binarism is not entirely accurate. There are some Japanese-style painters, such as Fukuda Toyoshirō (1904–1970) and Dōmoto Inshō (1891–1975), who did paint contemporary battle scenes and soldiers, and, likewise, some Western-style painters who were interested in representing Japan's cultural tradition through the foreign medium of oil. Fujita Tsuguharu, the subject of the final chapter, known primarily as a prolific producer of War Campaign Record Paintings, is the best example of this contradiction. His gigantic mural painting *Events in Akita* (1937) is an artifact of the social, political, and artistic practices of the 1930s and early 1940s that saw people and customs in Tohoku as most authentically "Japanese."

◆　◆　◆

In this chapter, we have seen how non-battle paintings from the war fit the official ideology of "return to Japan," which, in light of its paradoxical rejection and embrace of modernity, can be understood as fascist. Briefly summarizing the historiography of Japanese fascism and incorporating the research of Harry Harootunian and Alan Tansman, I have suggested the importance of introducing the concept of Japanese fascism to the examination of wartime Japanese art to expand the scholarly inquiry into a global one and to carefully distinguish 1930s and 1940s cultural nationalism from Meiji nationalism. In the context of modern Japanese art history, the collaboration between art and the state during the Second World War marks a comeback of the symbiotic relationship between them in the Meiji period. In fact, the Japanese-style painters Taikan, Yasuda, and Shōen were part of the Meiji discourse of creating national art, becoming once again active and resurfacing in public and art discourse in the 1930s and 1940s. The following chapters will focus on certain landmark works by these four artists and investigate more closely how exactly their paintings manifested Japanese fascism.

2

YOKOYAMA TAIKAN'S
PAINTINGS OF MOUNT FUJI

Precisely how would one go about analyzing Japanese fascism in a cultural artifact? The method with which one approaches this question can be contentious. My inquiry into Japanese fascism and art is indebted to Alan Tasman's 2009 Book *The Aesthetics of Japanese Fascism,* which explores literary works by seminal authors such as Kobayashi Hideo (1902–1983), Yasuda Yojūrō (1910–1981), Kawabata Yasunari (1899–1972), and Yanagi Sōetsu (1889–1961). Tansman writes, "In Japan, as in Europe, fascism emerged as a reactionary modernist response to the threats of social and political division created by the economic and social crises following the First World War. The social, economic, and cultural conditions that gave birth to European fascism were shared by Japan."[1] I fully agree with this understanding of fascism and share Tansman's impulse to situate wartime Japanese culture within a global context and attention to the way in which modernity became the central issue for intellectuals and government authorities in Japan and other fascist nations. However, the way in which I conceptualize the relationship between Japanese fascism and cultural artifact is different from his.

In his analysis, Tansman focuses on what he calls "fascist moments," which "offered images of self-obliteration evoked through the beauty of violence, often in the name of an idealized Japan."[2] The "fascist moments" are those "in which the individual is depicted as merging with, or is called on to merge imaginatively with, a greater whole."[3] Using nuanced and sophisticated literary analysis, Tansman shows how the texts he looks at create a beautiful moment of stillness and eternity where a subject gets lost and is then captivated by the dangerous politics of fascism.

By devoting his analysis almost exclusively to the stylistic and formal characteristics of literary works, however, his theory falls short of explaining the relationship between the aesthetics of Japanese fascism and its political context. This problem becomes most pronounced in the book's last chapter, where Tansman identifies a recurrence of fascist aesthetics in postwar singer Misora Hibari's performances. The reader is left with the obvious question: How do fascist aesthetics work in a non-fascist context? The problem is that Tansman makes fascism purely a matter of style and aesthetic.

I understand wartime Japan as having been steeped in state fascism. In other words, I consider fascism as a set of ideas that were supported by the state and widely disseminated through cultural and artistic institutions with tight government censorship and control. The main question of my project then becomes how exactly the paintings from the late 1930s and early 1940s embody the ideas associated with Japanese fascism. My task is to elucidate the relationship between state ideology and paintings by carefully analyzing the resonance between the political context and how the works were created, exhibited, and received. To this end, I will provide in-depth analysis of several paintings' stylistic characteristics and subject matter and discuss their references to Japan's history and cultural uniqueness. I closely examine where the paintings were displayed, what the artists said about the paintings and politics in general, and how the media discussed them, in order to assess the impact of certain arts, the artists' intentions, and the resonance between Japanese fascism and the paintings.

In this chapter, I aim to establish the methodological model with which one could examine the art of Japanese fascism. I do so by looking closely at paintings of Mount Fuji by Yokoyama Taikan, one of the most active Japanese-style painters during the war (see Plate 1). Although there have been numerous paintings of Mount Fuji in the history of Japanese art, Taikan's Mount Fuji paintings were situated in the specific context of Japanese fascism and intended and received as celebrations of Japan's imperial family and manifestation of the "Japanese spirit." As I will show, Mount Fuji was evoked to justify violence in the name of Japan's traditions and uniqueness, and so functioned as a military symbol. Stylistically, Taikan's obsession with "things Japanese" made him move away from the Chinese model of landscape painting and develop a new style with which to portray the mountain. His involvement in Japan's fascist discourse is also attested to by his role in the fascist international alliance: he welcomed a group of Nazi Youth in Tokyo in the 1930s, and his Mount Fuji was featured in the poster for the 1939 Japanese art exhibition in Germany. With careful historicization, this chapter will show how Taikan's Mount Fuji paintings not only reflected but also reinforced Japanese fascism.

YOKOYAMA TAIKAN

Yokoyama Taikan (1868–1958) is one of the best-known Japanese-style painters of modern Japan, certainly within the country, and there have been countless exhibitions of his work and books published about him.[4] He was born Sakai Hidemaro in

the city of Mito, Ibaraki Prefecture in 1868, the year that the Meiji government was established. Briefly trained by artists of the Kanō school, who dominated the official art scene in the Edo period, Taikan started at the Tokyo National School of Art (*Tōkyō bijutsu gakkō*) in 1889, enrolling in what would ultimately become the school's first graduating class. Taikan had a close relationship with his mentor Okakura Tenshin (1862–1913), otherwise known as Okakura Kakuzō, the school's first dean. As Victoria Weston has argued, the Japanese-style painters and students at the national school around the 1870s—Taikan, Shimomura Kanzan, and Hishida Shunsō—under Okakura's supervision, strived to establish *the* definitive Japanese-style painting, a style that expressed Japan's national identity against the backdrop of Japan's modern nation building.[5]

When Okakura left the Tokyo National School of Art, Taikan followed him, becoming one of the founding members of a private art organization established by Okakura in 1898, the Japan Art Institute (*Nihon bijutsu in*). Okakura's departure was said to be due to a conflict with Kuroda Seiki (1866–1924), who became a professor at the Tokyo National School of Art when the school established a section on Western-style paintings (*yōga*). Kuroda, who had just returned from France, where he had studied the Impressionistic style under French Academic painter Raphael Colin, was an advocate of Western-style art and hailed by professors at the national school.[6] Due to personal rivalries and political struggles at the school, Tenshin ultimately resigned his position.

With guidance from Okakura, Taikan traveled to India (1903), the United States (1904–1905), Europe (England, France, and Italy in 1905), and China (1910). In the early 1900s, Taikan worked in the so-called mōrō-tai style (in which the artist explores an expression of airy atmosphere) and sold his art in the United States and Europe. But this style of work was severely criticized in Japan, and when the Japan Art Institute was moved to Izura, Ibaraki, in 1906, Taikan and other artists at the Japan Art Institute experienced a difficult time there. With Okakura's death, the Japan Art Institute was dismantled, but then revived a year later (and renamed *Saikō inten*). In the 1920s, Taikan produced landmark works such as *The Wheel of Life* (1923), examined later in this chapter, which brought the artist back into the spotlight (see Plate 2).

Throughout the Second World War, Taikan was very active, selling paintings to raise money for the military. The twenty paintings of the series "Ten Paintings about Mountain, Ten Paintings about Sea" (*Yamani chinamu jūdai, umi ni chinamu jūdai*) were sold at Takashimaya Department Store in April 1940 in order to raise 500,000 yen that the artist then donated to the Japanese military, who used the funds to buy four battle planes that they called *Taikan gō* (Taikan battle planes) in his honor.[7] Not many painters had battle planes named after them; Taikan was highly unusual in this regard.

Just as important as those patriotic gestures are Taikan's wartime writings. These not only articulated the fascist dream of restoring Japan's lost traditions and national identity, but also evidenced the degree to which Taikan himself initiated the restructuring of the art community that he deemed necessary to achieve this dream. In his many contributions to major magazines, he essentially proposed implementing

strict state control on the nation's artistic output such that all artists would work for the wartime state. A careful analysis of his public activities is necessary in order to fully understand where he stood politically, before we begin examining his paintings. As I will show, Taikan was not alone in making such a proposal: his opinions were echoed by various artists and art critics at the time. For this reason, examining Taikan's vision allows us to obtain a broader picture of how art-related figures understood their art, their art community, and ultimately their country in the context of the global war.

THE ARTISTIC NEW ORDER

The seminal text in which Taikan lays out his vision is the "Proposal of the New Order in Japanese Art" (*Nihon bijutsu shintaisei no teishō*). It was published in January 1941 in *Asahi shimbun* as well as in a magazine called *Bijutsu to shumi* (Art and Hobbies), and in the art magazine *Bi no kuni* (Nation of Beauty) in February of the same year. The publication of this essay in multiple venues clearly points to his public visibility.[8] In the text, Taikan proposes profound changes to art institutions in conjunction with Prime Minister Konoe Fumimaro's 1940 New Order, which entailed complete restructuring of political and economic institutions: the New Order created a single unified political vector, the Imperial Rule Assistance Association (IRAA), which officially ended party politics; it also set up a national economic system to ensure that industry fulfilled the "public goals of the state."[9]

In this text, with clearly fascist sentiments, Taikan argues that Japanese art has been excessively Westernized and that art ought to reflect the characteristics of its nation, and that for this reason, state intervention is absolutely necessary. While he admits that keeping tradition alive requires active experimentation with new artistic expressions, Taikan proclaims that Japanese art will eventually become "corrupted" and "unsavable" if the state does not intervene and artists continue to blindly pursue changes inspired by Western art. Taikan thus proposes a "new order," which would establish a new state institution that would include all Japanese artists and control the nation's artistic output.

Taikan's statement not only echoes the 1937 *Cardinal Principles of the National Entity of Japan* (*Kokutai no hongi*) and the seminal 1942 roundtable "Overcoming Modernity" by leading philosophers, but also represents the general consensus of the time among art critics and artists that Japanese art should stop imitating the art of the West, particularly France, and return to its own traditions. These points were also addressed in roundtables among artists and art critics, most prominently "Where Will French Art Go?" and "National Defense and Art: What Should Artists Do?," both published in the art magazine *Mizue* in August 1940 and January 1941, respectively.

In the 1941 roundtable, military officials Akiyama Kunio and Suzuki Senkichirō, and one art critic, Araki Sueo, proclaimed that Japanese art had become a "colony of France" (*Furansu no shokuminchi*).[10] It was true that since the beginning of the Meiji period in the late nineteenth century, France had been considered as an

artistic center by Japanese artists: both Japanese-style and Western-style art, to vary-ing degrees, emulated the French Academic style; the state organized national exhi-bitions modeled on French salons; and countless Japanese artists traveled to Paris to study the newest trends in art. In the eyes of Japanese wartime officials and art crit-ics, Japanese art had been bought out by capitalism (*shihon shugi*) and commercial-ism (*shōgyōshugi*), liberalism (*jiyūshugi*), and democracy. Suzuki Kurazō in particular dismissed modern art that employed radical, experimental formal abstractions, say-ing that even patients at a mental hospital could produce ridiculous paintings that consisted merely of "circles and triangles."[11] The critique of French art was also shared by another art critic, Egawa Kazuhiko (1896–1981), and two Western-style painters, Oka Shikanosuke and Miyamoto Saburō (1905–1974). Oka and Miya-moto had studied in France in previous decades. All three artists considered the weakness of French art to be due to the lack of expressions particular to the artists' race. They argued that since successful artists in Paris, such as Picasso and Chagall, were not French, modern French art was actually the product of "foreigners."[12] "French art," in short, had failed to establish the art of the "French race."

All of these art critics and artists argued that Japanese art, produced at a time when the country was entering its most glorious period, should express its own racial identity and appeal to a large audience.[13] Importantly, their discussion was based on their knowledge of European fascist nations, namely Nazi Germany and Fascist Italy, and those states' comprehensive control of artistic production. In the late 1930s and early 1940s, Nazi German art in particular was increasingly introduced to the Japa-nese public through art magazines. For example, art critic Uemura Takachiyo (1911–1998) translated Eugène Wernert's book about Nazi art in the art magazine *Atorie* in October 1937.[14] The book introduces Nazi art as a criticism of the art that came prior to it, namely, the art of the Weimar Republic, which he dismisses as a "Semitic" art that reflected internationalism (*kokusai shugi*), liberalism (*jiyūshugi*), and individual-ism (*kojin shugi*).[15] He sees the art of the Third Reich, on the other hand, as reflecting the artistic sentiments of the Aryan race (*Arian minzoku*), and insists that every art-ist has a responsibility to create art that reinforces the spirit of the masses, realizes its unity, and evokes its power.[16] To achieve this goal, says Wernert, the state needs to encourage, in an official capacity, those artists who meet this aim while discouraging and expelling others. Wartime statements made by Japanese art critics clearly echo such ideas: Suzuki Kurazō, for example, proposed that art institutions be unified, a radical transformation of the existing situation in which hundreds of different art groups held exhibitions only among themselves.[17] Suzuki stated that every individ-ual, whether artist or not, should take on the role of citizen in establishing a national defense state, and that those who could not comply should leave the country.[18]

The Japanese critique of French art was inspired and justified by the global politics of the time, that is, the rise of Nazi Germany and the fall of France in 1940. There was clearly an awareness among artists and art critics alike that the balance of power in world politics was shifting from capitalist, democratic countries—France, Britain, and the United States—to totalitarian, anti-capitalist, anti-socialist (in other words, fascist) countries—Germany and Italy. The fall of France to Germany in 1940 was the decisive event that convinced Japan's visual artists of this shift. Araki Sueo,

for example, opined that the ongoing war, and the fall of France in particular, had greater implications than a mere change of the world map: the war was connected to the larger ideological change that would shortly ensue. Following this statement, the others also stated that now that Germany controlled France, Japanese artists must reassess the influence of French art on their work. They agreed, in the end, that Japanese artists should now emulate the artists of Fascist Italy and Nazi Germany, who drew on pre-modern European masters and therefore successfully produced art representative of their race.[19] Araki in particular praised Hitler and Mussolini, whom he viewed as having achieved this goal; this, for him, was indicative of the responsibility the two leaders had taken for "the fate of their race."[20]

Clearly inspired by the nature of the arguments presented at the two roundtables in 1940 and 1941, Taikan develops three concrete plans for interconnected fields in "The Proposal of the New Order in Japanese Art": exhibitions, private schools, and art education. First, he states that there should be a nationwide exhibition, larger than the existing New Ministry of Education Art Exhibition (*monbushō bijutsu tenrankai,* or *shin-bunten*). There, artists would produce paintings on a particular theme (*kadai*) proposed by the state. The exhibition that he envisages will not be divided between Japanese-style and Western-style art, and will take place every other year, not every year, so that artists will have enough time to study their subject matter. The theme will be announced internationally in order to publicize and promote the achievements of the "Japanese race" (*minzoku*) and display Japan's peaceful, cultural activities to the world. This national exhibition, he argues, will "transcend" (*chōetsu suru*) divisions that currently exist within the art world, and with "powerful instructional direction" (*kyōryoku naru shidōseishin*), allow the state to get rid of the current tendency toward artistic diversity and freedom by centralizing artistic production and ensuring the "healthy" (*kenzennaru*) development of Japanese art. Second, while acknowledging that private art schools (*shijuku*) have existed for a long time, Taikan claims that private organizations are adversely affecting the state-sponsored exhibition, the New Bunten. He proposes that the private organizations all be dissolved.

The third and final proposal is about art education. Lamenting recent weakening of the Tokyo School of Fine Art, which his mentor Okakura Tenshin had founded, Taikan urges the reader to recall the original goal of the school when it was founded: to produce art that expresses the nature of the Japanese race and promote the spirit of the East. Here, he explicitly ascribes the weakening of the national school to the establishment of the Western-style art department, as if to avenge Okakura, who had had to retire from the school because of *yōga* painters. The artist concludes the text with strong political words:

> Konoe's New Order will establish a "high defense nation" [*kōdo kokubō kokka*], in which a million citizens work together as one body [*ichioku kokumin ittai*]. Accordingly, in the art world too, current thoughts about freedom need to be restricted, and every artist, knowing his/her own place, should truly make an effort to uplift the Japanese spirit. Those who would challenge this view should be expelled from this sacred country [*kōkoku*].[21]

Taikan's proposal reflects the state's attempt throughout the first three decades of the twentieth century to create a large, all-inclusive exhibition venue where many major artists would compete against each other. The annual state-organized Bunten exhibition was started in 1907, but came to be conservative in nature, and during the 1910s, young, aspiring, talented artists began exhibiting their works at private exhibitions. Considering this a problem, the Ministry of Education aimed to reconfigure and reorganize the structure of the annual exhibition, which resulted in the birth of the Exhibition of the Imperial Academy of Arts (*Teikoku bijutsu in tenrankai,* or *Teiten*).[22] Although the Teiten came to include some of the young generation of Japanese-style painters, such as Kikuchi Keigetsu (1879–1955), Kaburaki Kiyokata (1878–1972), and the "last master" literati painter, Tomioka Tessai (1837–1924), it did not win support from artists at the Reorganized Japan Art Institute (*Saikō Nihon bijutsu in*), including, ironically, Taikan.

The attempt to create an "all-encompassing" art exhibition continued into the 1930s, taking the form of the 1935 "Matsuda Reorganization," a program of changes carried out by the education minister, Matsuda Genji (1875–1936). Matsuda broadened the scope of exhibition by abolishing automatic participation in the exhibition by veteran artists and successfully inviting artists of private art organizations, such as the Japan Art Institute and Nikakai (Section Two Society), to the Imperial Art Academy.[23] The 2600th Anniversary of the Imperial Reign Exhibition in 1940, where Taikan's *Japan, Where the Sun Rises* was exhibited, was the closest the state could get to the exhibition model that Taikan proposed. Divided into three sections—Japanese-style painting, Western-style painting, and sculpture—the exhibition brought together hundreds of artists who had not necessarily submitted their work to state-sponsored exhibitions in previous periods.

Taikan's proposal for an exhibition administered by the state never materialized, but he tried to achieve his goal by creating state-controlled art organizations himself. In 1943, Taikan became the president of the Japan Art Patriotic Society (*Nihon bijutsu hōkokukai*), which included hundreds of artists. The organization's founding statement, which Taikan would have helped to draft, reads as follows:

> The goal of the current holy war is to uplift the spirit of this nation and spread this to the rest of the world, thereby realizing the ideal of East Asia's Co-Prosperity. In order to achieve this goal, we, citizens in Japan, will express strong support for military battles fought outside Japan, and we will contribute to domestic matters that will strengthen the power of the nation. Cultural war, which coincides with military war, is becoming more and more important. With art, we will take on roles in this cultural war and devote ourselves to the nation by establishing a unified organization and promising to achieve the goal of the nation. Our art will refine the cultural spirit of Japan that maintains its tradition.[24]

In the language of fascism, the organization sets a goal, as a unified structure, to support the nation at war by fighting on the "cultural" front.

Taikan's fascist vision of restoring Japan's cultural heritage and creating purely Japanese art, which we saw in his proposal to restructure art institutions, also characterized his paintings. During the war period, he devoted his art almost exclusively to a single subject: Mount Fuji. Art historian Ōkuma Toshiyuki estimates that Taikan executed an astonishing 524 paintings of Mount Fuji between 1937 and 1944.[25] One of the most representative of his Fuji paintings is a monumental work titled *Japan, Where the Sun Rises* (*Nihon hi izuru tokoro*), which the artist executed in 1940 and is now at the Museum of the Imperial Collections (*Sannomaru shōzōkan*) (see Plate 1). It uses a simple visual language but is an iconic painting of the mountain; Mount Fuji looms large next to the sun colored in vivid red, surrounded by misty and mysterious clouds at the bottom.

But why Fuji? The answer lies in its historical depth and reference. Mount Fuji is a cultural icon that has been repeatedly represented in both visual arts and literary works throughout Japanese history. Taikan's Fuji evokes the layered cultural history surrounding the mountain. Mount Fuji, which measures 3,776 meters and is the tallest mountain in Japan, is an active volcano located on Japan's main island, between Yamanashi and Shizuoka prefectures. Its glorious, awe-inspiring appearance and iconic image as a snow-capped mountain made Mount Fuji a recurring motif in literature and art as well as the object of religious worship. It has appeared in Japanese literature since ancient times, often functioning as a "pillow poem" (*utamakura*), or "noted poetic place," in Japanese *waka* poetry.[26] Later it became an important locational background for narrative literature, including *The Tale of the Bamboo Cutter* (*Taketori monogatari*, tenth century), *The Tale of Genji* (*Genji monogatari*, eleventh century) and *The Tale of Ise* (*Ise monogatari*, middle of the Heian period). The ninth section of *The Tale of Ise*, "The Journey to the East" (*Azumakudari*), in which the main character Ariwara no Narihira travels past Mount Fuji with his friends, was later popularized in the form of illustrated books and also parodied in *ukiyo-e* prints, widely circulated and read by common people during the Edo period (1603–1868).

As Martin Collcutt notes, Mount Fuji had become an object of religious worship by the eighth century.[27] Fuji worship has included many different strands of belief and ritual. Because Japan's indigenous Shinto religion is an animistic religion—believing in the divine in both human and non-human forms—it is unsurprising that this volcanic mountain with its majestic appearance was worshipped in the Shinto context.[28] After esoteric Buddhism was introduced during the Heian period, Fuji became closely associated with Dainichi Nyorai, the cosmic Buddha Virocana. Furthermore, when Pure Land Buddhism became popular around the same period, Fuji was also seen as a place of paradise, with the Buddhist hell believed to be underneath the volcanic mountain.[29] The syncretic belief is what is represented in *Fuji Mandala* (*Fuji mandara zu*), attributed to Kanō Motonobu (1476–1559) and produced in the Muromachi Period (1337–1573) (Figure 1). This is one of the earliest examples of pilgrimage mandala, which were often executed by worshippers or nuns/monks to help spread their faith.[30] This mandala, which is a monumentally

large hanging scroll, follows the style of Shinto mandala painting that shows a bird's-eye view of religious architecture.[31] The long, vertical painting follows the journey of a group of people making a visit to the mountain, starting from the painting's bottom, up through the shrine complex in the middle part, and finally to the mountain residing in the upper part. It is executed in the "indigenous" Japanese style of *yamato-e* paintings: large bands of stylized, horizontal clouds, which often feature in such works, cover the middle part of this painting, simultaneously concealing and revealing human activities and shrines in the area.

In the Edo period, when the government moved from Kyoto to Edo (Tokyo)—which provides a good view of Mount Fuji on sunny days—the worship of Fuji took a clearer shape and was popularized among the common people.

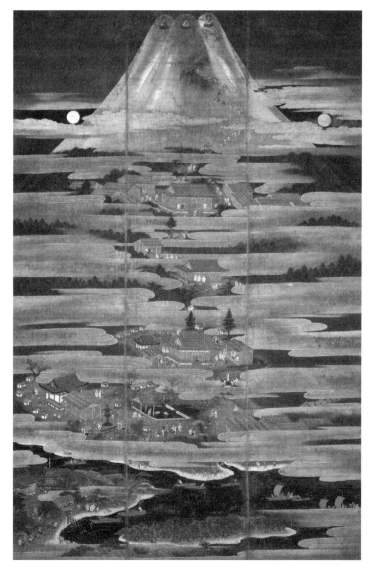

FIGURE 1. Kanō Motonobu, *Fuji Mandala* (Kenpon chakushoku Fuji mandara zu), 16th century. Ink and color on silk, 186.6 x 118.2 cm. Fujisan Hongū Sengen Taisha.

This was in large part due to the emergence of charismatic mountain ascetics such as Kakugyō Tōbutsu (1541–?) and the development of groups or confraternities called Fujikō, organizations worshipping Mount Fuji.[32] The popularization of the Fuji cult and its connection with the common people of the Edo period is best represented by famous *ukiyo-e* woodblock prints, especially landscape prints by Katsushika Hokusai (1760–1849) and Utagawa Hiroshige (1797–1858) from their series *Thirty-Six Views of Mount Fuji* (*Fugaku sanjūrokkei*, 1831), *The Fifty-Three Stations of the Tōkaidō* (*Tōkaidō gojūsantsugi*, 1833–1834), and *One Hundred Famous Views of Edo* (*Meisho Edo hyakkei*, 1856–1859).[33] Among them, Hokusai's "South Wind, Clear Sky" (*Gaifū kaisei*), alternatively known as "Red Fuji" (1830–1831), which portrays Mount Fuji taking on the color red during a summer sunrise, is one of the most famous (see Plate 3). In this print, as with other images from the same series, Hokusai shows an interest in bold pictorial design and the play of geometric shapes. He depicts Fuji in a minimalist manner, stylizing the forms of the mountain, clouds, and trees. The mountain is reduced to a simple triangular shape, clouds that float in the sky are conveyed through repeating wavy lines, and trees at the foot of the mountain are expressed by small dots. The boldness of the design and composition is further reinforced by the daring use of color: only a range of green, blue, and red, beautifully rendered in gradation, are used in this work.

As Kawata Akihisa points out, however, it was only after the beginning of the Meiji period, when Japan's modern nation building started, that Fuji came to be registered as the mountain that stood for "Japan" or "the nation."[34] This modern understanding of Fuji as representative of Japan was of course based on the prominence of the mountain in earlier cultural discourses and religious practices, but it was also indebted to how *foreigners* perceived Fuji as the symbol of Japan. Hokusai's and Hiroshige's landscape prints, many of which depict Fuji and were treasured in Europe, famously influencing modernist artists there, had a great impact on foreigners' image of Japan. What reinforced this discourse were a number of travelers, including German archeologist Heinrich Schliemann (1822–1890) and Danish navy officer Edouard Suenson (1842–1921), who wrote about the mountain in their travel diaries and published them upon their return to Europe.[35]

Mount Fuji appeared repeatedly in so-called Yokohama photographs, photographs sold in Yokohama (an area frequented by foreign residents) that were targeted at foreign tourists in the mid- and late nineteenth century (Figure 2). They were a product of Western Orientalist photography teachers such as Felice Beato (1832–1909), Raimund von Stillfried (1839–1911), and Adolfo Farsari (1841–1898) and their Japanese students, including Kusakabe Kimbei (1841–1934) and Shimooka Renjō (1823–1914), who capitalized on foreign interest in Japan.[36] The self-Orientalizing act of representing what foreigners thought of Japan became more pronounced when the country began participating in international expositions and displaying works that used Fuji as the nation's symbol. For example, Takahashi Yūichi (1826–1894), part of the first generation of oil painters in the Meiji period, reportedly submitted a painting of Fuji to the 1873 international exposition in Vienna, and at least two pieces of lacquerware depicting Fuji by unknown artists were displayed at the 1893 exposition in Chicago.[37]

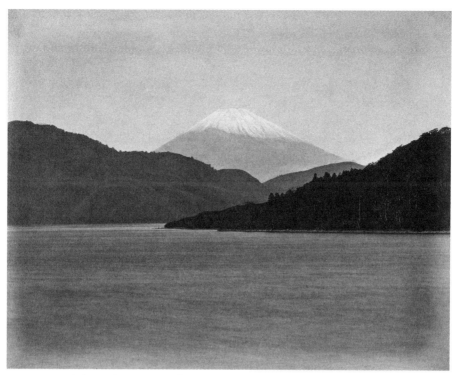

FIGURE 2. Kusakabe Kimbei, *Fujiyama from Hakone Lake*, ca. 1890s. Photograph, 21.5 x 27.9 cm. Royal Ontario Museum.

TAIKAN'S FUJI

While Taikan's portrayals of Fuji are highly indebted to previous Japanese art that takes the mountain as its subject, his own paintings differ from these in several ways. Taikan's paintings participate in, reflect, and actively reinforce the ideology of Japanese fascism, the sentiment that Japan must restore its cultural uniqueness, which had been damaged by Western modernity. Some of the most prominent ideas in the discourse of Japanese fascism are that there had once been an authentic Japanese community reigned over by the emperor; that this community had led a spiritual life; and that this community and its spiritual life should be reclaimed. The assumed existence of a holy connection between the imperial family and its citizens, as well as the assumption of a specific Japanese spirituality, made the Japanese unique and significantly different from non-Japanese people. Taikan's paintings had a strong association with Japanese fascism through its celebration of these particular beliefs.

The 1937 Ministry of Education publication *Kokutai no hongi* (*Cardinal Principles of the National Entity of Japan*) officially proclaimed the government's vision for the country, which clearly outlined the central role that the emperor would play in the national culture and politics. It was the single most important wartime official document; millions of copies were published, disseminated throughout the country, and memorized by schoolchildren. *Kokutai no hongi* renders into official history

mythological Shinto stories found in *The Record of Ancient Matters* (*Kojiki*, 712) and *The Chronicle of Japan* (*Nihon shoki*, 720), which describe the sun goddess Amaterasu Ōmikami as the ancestor of the Japanese emperor. It states,

> The unbroken line of Emperors, receiving the Oracle of the Founder of the Nation, reign eternally over the Japanese Empire. This is our eternal and immutable national entity. Thus, founded on this great principle, all the people, united as one great family nation in heart and obeying the Imperial Will, enhance indeed the beautiful virtues of loyalty and filial piety. This is the glory of our national entity. This national entity is the eternal and unchanging basis of our nation and shines resplendent throughout our history. Moreover, its solidarity is proportionate to the growth of the nation and is, together with heaven and earth, without end.[38]

Although it can be translated as "national entity," the word *kokutai* orthographically consists of two Chinese characters, those for nation and body. As such, the idea of a large, single, unifying national body functioned as a metaphor for the integrity of the nation whereby citizens were organically bound to the emperor.

Taikan clearly agreed with and espoused the ideas outlined in *Kokutai no hongi*, regularly addressing the Shinto myth in his discussion of Mount Fuji paintings. A newspaper article titled "The Spirit of Fuji," which Taikan wrote in 1942, reveals the artist's views on the profound relationship between Fuji and emperor worship.[39] He starts the article by quoting an 1845 poem, *The Song of the Righteous Spirit* (*Seiki no uta*), by Fujita Tōko (1806–1855). Fujita was a Neo-Confucian *mito-gaku* scholar from Mito, Ibaraki, and an advocate of overthrowing the government and restoring the emperor as political leader. The poem reads,

> The sublime "spirit" of the universe
> Gathers pure over this Land of the Gods
> Rising high, it forms the Peak of Fuji,
> Towering aloft, it kisses the skies to a thousand autumns
> Pouring itself forth out of rivers, it flows as waters of the great deep;
> And boundless it courses around our Land
> It blossoms forth as countless clusters of cherry flowers,
> And naught there is compares to their clustered beauty and scent.[40]

By quoting a poem by Fujita, Taikan pays homage to *mito-gaku*, which advocated emperor worship and stemmed from the city of Mito, where Taikan was also born. Indeed, an English publication produced in Japan in 1939 introduces Taikan in association with this ideology:

> Taikan Yokoyama was born in Mito, not far from Tokyo, in the year 1868. Mito was the cradle of the loyalist ideology, which became the motive power behind the Meiji Restoration, and its name is identified with the glorification of the samurai spirit in Japan's recent history. It is needless to

say, then, that Taikan's noble bearing and powerful character are due to the blood of the Mito warriors which runs through his veins.[41]

Taikan was well aware of the emperor-worshipping ideology originating in his local community, and although the lines he quoted in the newspaper article do not directly refer to the imperial family, the rest of the poem does. Thus, he understands Fujita's poem as glorifying both the imperial country (*kōkoku*) and Fuji.

In fact, art historian Bert Winther-Tamaki has suggested that Taikan's Fuji is a representation of the "national body," and by extension a manifestation of emperor worship. He states, "We may perhaps say that the war is disembodied on the physical plane and re-embodied on the metaphysical plane as an ideal Mt Fuji, the traditional sacred symbol of Japan . . . Perhaps this monumental disembodiment can be understood as emblematic of *kokutai*, literally 'national body.'"[42] This direct association between Taikan's Fuji painting and *kokutai* was precisely how Taikan's Fuji was read by some during the war. The eminent scholar of Japan's national history, Akiyama Kenzō, argues that "the Japanese spirit [*kokoro*] that grows on *kokutai* bound to the emperor is the same spirit that allows one to look at Fuji as a sacred mountain" and praises Taikan's painting for capturing this sentiment.[43] Comparing Taikan's Fuji to works by Hokusai, Akiyama argues that Hokusai, who had died by the end of the Edo period and therefore would not have been familiar with the principle of *kokutai*, might have been able to understand the form (*keishō*) of the mountain and thus render it visually in an impeccable manner, but not its spirit. Thus, while Taikan may not have depicted individual bodies of Japanese soldiers, his Fuji paintings visualized, in the metaphysical mode, *kokutai*, the collective, national body mediated by the emperor, which, the government explained, needed to be protected from the West by fighting a war with them.

The close connection between Taikan's art and emperor worship is also evidenced by where his painting *Japan, Where the Sun Rises* was submitted. The 1940 Celebration of Japanese Imperial Reign's 2600th Anniversary was arguably one of the most important and largest wartime cultural events organized by the state. Ideologically, the celebration was an extension of the *Kokutai no hongi*. Based on a religious myth, the nation celebrated the 2600th anniversary of the imperial dynasty: it was believed, in accordance with the mythologies, that Japan was founded in 660 BC by Emperor Jimmu, the great grandson of Ningi, who was the grandson of the sun goddess Amaterasu and the first imperial ancestor to descend from heaven.[44] The most important celebratory event took place in front of the Imperial Palace in Tokyo on November 10, 1940, with 50,000 people in attendance. The event started with Prime Minister Konoe Fumimaro's speech, followed by the national anthem, then Emperor Hirohito's speech, and then a performance of music specifically produced for the celebration. At 11:25 a.m., all participants shouted "Long Live His Majesty the Emperor" three times, which was broadcast over the radio and echoed by those who could not attend.[45] The way in which thousands of people were mobilized, gathered into ordered rows, and induced to practice mass rituals, echoes the mass gatherings in Nazi Germany and Fascist Italy, such as the Nazis' Nuremberg Rally in 1933.

Japan, Where the Sun Rises was displayed at the Celebration of the 2600th Anniversary of the Imperial Reign Exhibition (*Kigen nisen roppyakunen hōshuku bijutsu ten*), which took place twice in Tokyo, divided into two rotations: the first between October 1st and 22nd at the Tokyo Metropolitan Art Museum (*Tokyōfu bijutsukan*, today's *Tōkyōto bijutsukan*), and the second between November 3rd and 24th at the same museum.[46] All artworks were again exhibited at the Osaka City Art Museum (Ōsaka shiritsu bijutsukan) between December 1st and 15th of the same year. Artists' and visitors' participation was voluntary, but the exhibitions were nonetheless a remarkable success: no fewer than 306,681 people are thought to have visited the two exhibitions in Tokyo, double the number of visitors to the Exhibition of the Ministry of Education.[47] Given these numbers, those artists who submitted to the exhibition were praised for contributing to the state by uplifting the spirit of the Japanese nation and race.[48]

Taikan's paintings (or his discussions of them) resonated with the tenet of Japanese fascism that says that the Japanese people recognize spirits of living and non-living beings and that the Japanese themselves have a unique spirit. Taikan admired Fujita's poem "The Song of the Righteous Spirit," quoted earlier, because he thought it captured the sublime spirit of the mountain that Fujita called *seiki*, or "righteous spirit." His idea of "the spirit" of the mountain brings to mind the Shinto belief that sacred spirits reside in both human and non-human objects. The goal of the Fuji paintings, the artist declares, is to successfully communicate this spirit through his art.[49] He theorized the relationship between the spirit of Fuji and the art/artists in one of his major wartime writings, "The Spirit of Japanese Art" (*Nihon bijutsu no seishin*), published in different places in both 1938 and 1939.[50] An edited and translated version of the essay was also published in English in *Four Japanese Painters*, which was produced in 1939.

In "The Spirit of Japanese Art," Taikan argues that all artists should strive to understand the spiritual quality of an object in order to convey the object's true being. The artist's own attempt was acclaimed by art critics, who praised his Fuji paintings as successfully conveying the mountain's spirituality. Kawaji Ryūkō writes,

> His Mt. Fuji is not Mt. Fuji depicted simply as visual beauty, but rather as the "symbol of Japanese spirit." He is driven with an unstoppable spirit to paint this natural form as much more than nature, as an absolute, as the greatest symbol of his idealism . . . In all his various views of Fuji, what he tries to grasp is the energy [*shinki*] in an Oriental view of nature.[51]

Tōyama Takashi similarly noted that "spiritual aims underlie his work and whatever material subjects appear in his paintings are merely a means of projection into the spiritual."[52]

The spiritual life unique to Japan (or more broadly to Asia) was constantly compared to the "materialist" life of the West that put more value on reason and intellect. Taikan's statements were based on his understanding of the difference between "objective" Occidental art/culture and "subjective," "transcendental," "symbolic," Oriental art/culture. He writes,

One cannot fail to notice, for instance, a marked difference in the fundamental manner of expression between Oriental and Occidental art. I admit that there is room for argument, but roughly speaking, the latter attaches more importance to actual appearance and to the visual sensation of the observer. On the other hand, in Japanese painting, which has its foundation in the idealism of the Orient and is an outcome of many thousand years of study, the artist's attitude is strictly subjective as compared with the objective attitude of Western painters. The image created and purified in the artist's mind is given honest, straightforward expression. The material is turned into the transcendental in Japanese art. Not only the outward form, but the true nature of the object and its relative bearing to the world surrounding it, which are not perceptible to the originary eye, are given perfect, symbolic expression.[53]

His theory was highly indebted to the Pan-Asianism developed by Okakura Tenshin, Taikan's early mentor, who famously claimed "Asia is one" in his 1903 book *The Ideal of the East,* persistently insisting on the difference between "the East" and "the West." In his writing from 1911, Okakura states, "[T]he attitude of mind toward nature is not the same in the West and the East. To the Oriental mind nature is a mask under which reality is hidden. The outward form is only important in so far as it reveals the inner spirit."[54] This "spiritualization" of the country in a modern period in such a way as to contrast itself to the West, is not unique to Japan: the same phenomenon can be observed in other non-Western countries. As historian Partha Chatterjee observes in his study of Indian anti-colonial nationalism, modern non-Western nationalism developed around a notion of division between the "inner," "spiritual," "traditional" sphere, which the non-West was part of, and the "outer," "public," "material" sphere, which the West belonged to. Modern non-Western nationalism, he argues, centered upon the sphere where people could claim their autonomy, authenticity, and sovereignty, and where Western liberal-democratic states were theoretically unable to intervene.[55]

Both Okakura and Taikan called for the restoration of indigenous traditions in Asia. In the context of Western imperialism in Asia, Okakura ends the book *The Ideal of the East* on a political note by calling for a reunification of Asia, writing, "[T]he task of Asia today, then, becomes that of protecting and restoring Asiatic modes."[56] Conspicuously echoing his mentor, Taikan similarly ends the English version of his essay, "The Spirit of Japanese Art," by expressing alarm at the influx of Western culture and calling for a restoration and renewal of Japan's traditional ways:

During the past seventy years, European civilization has come pouring into Japan. While on the one hand it gave us valuable impetus for progress and a new standpoint, on the other hand it cannot be denied that not a few unsuitable ideas were introduced and welcomed simply because of their novelty. It is time now to decide what to take in and what to reject. It is also time for the re-establishment of the true Japanese spirit of righteousness in its new forms. The world of fine arts must regain the spirituality

which made it so great in the past and which must now set a lofty ideal for the present and the coming generations.[57]

Taikan acknowledges that Tenshin did not go so far as to clearly discuss "the spirit of Japanese art," but he states that Tenshin always said we should draw on tradition and our spirit. In the end, Taikan declares that the Great East Asia Co-Prosperity Sphere (*Daitōa kyōeiken*), which Japan was trying to establish, is what Tenshin had proposed forty years earlier.

The difference between Okakura and Taikan, however, is that Taikan was clearly using the cultural difference between Japan and the West as a way to justify violence in the war. In particular, Taikan was speaking of the spirit of Fuji as the spirit of the Japanese people, which, to him, makes the Japanese not only unique but also superior to Westerners. Taikan declares,

> Today, loyal citizens of this imperial country fight with China for the sake of peace in East Asia. They put into practice the loyalty demonstrated by Kusunoki Masashige, who fought for the emperor. We need to show our strong Yamato spirit. This spirit is the righteous spirit [*shōki*] that has covered the heaven and earth of this country since ancient times. In the field of art too, we think highly of only those artworks that show this spirit.[58]

In "The Spirit of Fuji," he similarly writes,

> The sublime spirit that Mount Fuji emits is the very spirit that prompted the attack on Pearl Harbor and occupation of Singapore. It's the spirit [*tamashii*]! The British army might have better weapons than ours. But they do not have spirit. What controls machines are people and their spirits. Machines will move with spirit, if the user has the spirit.[59]

Taikan closely adheres to the prevalent wartime idea, advocated everywhere—from government documents, newspaper articles, and magazines to educational materials—that Westerners might have bigger physiques, but they do not have strong mental spirit, or the Yamato spirit, and this will make the Japanese the war's victors. Through his paintings of Mount Fuji, Taikan strives to impart the Yamato spirit to Japanese citizens in order for them to fight and win against the West in the ongoing war. There can be no question that Taikan's concept of "Japanese spirit" was directly associated with violence.

During the war, Mount Fuji did indeed become a military symbol. This close relationship between Fuji and violence was also represented in other areas of wartime official culture. *Shashin shūhō* (*Weekly Pictorial*), a weekly photographic magazine targeted at domestic audiences and published by the Cabinet Information Bureau between 1938 and 1945, for example, often depicted soldiers and Mount Fuji together.[60] The magazine, which published photographs by many important Japanese modernist photographers, including Kimura Ihee (1901–1974) and Domon Ken (1909–1990), used photomontage, an advanced visual technique at the time.

Its October 4, 1944 issue presents a young soldier in a tank in focus in the right foreground and Mount Fuji in the lower left side of the background (Figure 3). The text on the cover reads, "Wings that soar to heaven. Iron bulls [*tetsugyū*] that kick up a hot wind. Compare our deeds to Fuji's lofty peak, and we grin. We rise to the national crisis. Army junior soldiers. Off we go. We boys, too."[61] The cover functions as an advertisement for volunteer soldiers, noting that the application deadline is the end of October. Not only the text but also the visual image convey both the resonance between the mountain and the boy in the uplifting posture and, supposedly, his spirit. He is placed in the foreground to look as if he is advancing away from the mountain in order to protect the country where it

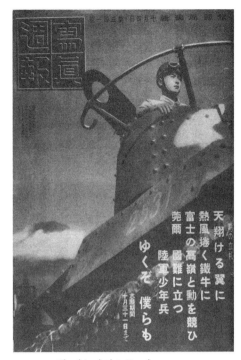

FIGURE 3. *Shashin shūhō*, October 4, 1944.

rises. Another issue of the same magazine published a month later shows a highly simplified shape of Mount Fuji painted on the wing of a battle plane with three figures working on the plane's construction. The text this time reads, "The righteous spirit [*seiki*] of the sacred country explodes in Leyte. Ah, Special Attack Forces." The association of Mount Fuji and militarism was also exemplified through the name of a weapon. The long-range heavy bomber designed to attack the west coast of the United States, which began to be conceived in 1942 but never materialized, was dubbed the Nakajima G10N Fugaku, with Fugaku meaning Mount Fuji.

TAIKAN AND CHINA

The success of Taikan's Fuji paintings in the discourse of Japanese fascism lies not only in the tireless association of Fuji with *kokutai* and Japanese spirituality, but also in the creation of a new visual language of Mount Fuji that he and others could claim as authentically Japanese. Specifically, Taikan moved away from Chinese models of landscape painting.

It is important to acknowledge that Taikan was strongly influenced by the style and subject matter of Chinese history and art. It is conventionally believed that both Okakura and his American mentor Ernest Fenollosa, a Harvard graduate and professor of philosophy and political economy at Tokyo Imperial University, renounced Chinese paintings, especially literati paintings, as anti-modern and backward. When they established Japanese-style painting in the late nineteenth century,

it was conceived as a synthesis of Japanese traditional paintings and Western academic paintings. Chinese ink paintings, which often had literary elements, such as poems, and avoided naturalism, were frowned upon in this context. Art historian Itakura Masaaki has recently observed, however, that the first generation of Japanese-style painters, especially Taikan, were interested in Chinese art and culture.[62] He also notes that many Chinese paintings previously held by royal families and temples were donated to the Tokyo National Museum (founded in 1872) and came to be displayed to the public, which contributed to the broad dissemination of Chinese ink painting. Taikan in fact collected many Chinese paintings from the Tang dynasty (618–907), the Five Dynasties and Ten Kingdoms (907–979), and the Song dynasty (960–1276). Chinese-style ink paintings could be seen in the Meiji period through Kanō school paintings that were fundamental to modern Japanese-style paintings envisioned by Fenollosa and Tenshin.

The Legendary Chinese Poet Qu Yuan (Kutsugen), which Taikan executed with color on silk in 1898, for example, is one of the paintings that attests to his profound knowledge of Chinese history. The subject of this painting is Qu Yuan, an ancient Chinese poet and government official from the Warring States periods who was unjustly expelled by King Huai, whom he served, and eventually committed suicide. The unfortunate fate of Qu Yuan is here analogized to the plight of Okakura Tenshin, Taikan's mentor, who had been expelled from the Tokyo National School of Art earlier that year.[63] Taikan was interested not only in Chinese subject matter, however, but also in the style of Chinese paintings. *Landscapes of the Four Seasons Copy, Original attributed to Sesshū (Shiki sansuizu mosha den sesshūhitsu*, 1897), now housed in the National Museum, Tokyo, makes this clear (see Plate 4). The work is painted after the original executed by Sesshū (1420–1506), a Japanese Buddhist monk and painter who traveled to China and whose style was profoundly influenced by Chinese Song dynasty landscape paintings. He was also, notably, instrumental in introducing Chinese literati-style ink landscape paintings to Japan. Taikan successfully adopted the swift, spontaneous qualities of the brush strokes and ink washes characteristic of Sesshū's work.

As art historian Aida Yuen Wong has demonstrated, Chinese literati paintings received renewed interest in the 1910s and 1920s. Both Japanese and Chinese painters of the early twentieth century found commonality between the literati tradition and European modernism, particularly impressionism, in their shared emphasis on art as subjective expression through brushstrokes.[64] Reflecting the new social trend of Taishō democracy, liberalism, and individualism, artists explored original, subjective expressions using the visual idiom of Chinese literati landscape paintings. Taikan's *The Wheel of Life (Seisei ruten)*, painted in 1923 and submitted to the 10th exhibition of the Resurrected Japanese Art institute (*Saikō inten*), could be contextualized within this shift of artistic discourse surrounding Chinese paintings in the 1920s (see Plate 2). The painting is in fact Taikan's most important mid-career work and dramatically changed the artist's reputation and status. It is the longest hand scroll painting ever produced in Japan and measures 55.3 cm x 4070 cm. In this monochrome landscape painting, executed with ink on silk, the artist paints a serene landscape, filled with tree-covered mountains and mists, which ends with a

mysterious seascape and a dragon-shaped swirl of misty air and clouds. Skillfully rendering the varying scenery of the landscape, the painting clearly displays the artist's mastery of techniques that create different visual effects through the manipulation of the brush and the tone of the ink. The ink wash that conveys the misty atmosphere and the dot techniques that render trees are unmistakably reminiscent of Chinese literati landscape paintings, though also inspired by the new artistic trend of European modernism.

Given the degree of Taikan's knowledge about the Chinese ink-painting tradition, it would not be surprising if his theory of spirituality derived directly from theories in Chinese painting. Taikan discusses the importance of understanding the fundamental principles of the world in order to represent it correctly. As I quoted earlier, Taikan remarks,

> The material is turned into the transcendental in Japanese art. Not only the outward form, but the true nature of the object and its relative bearing to the world surrounding it, which are not perceptible to the originary eye, are given perfect, symbolic expression.[65]

He also writes,

> In painting landscapes, the ancients left a wise saying that a mountain must appear to be smiling in spring, angry in summer, bedecked in autumn, and slumbering in winter. It is obvious that unless the painter's mind has fully responded to the spirituality underlying the natural features, he can never communicate the true phases of mountains in different seasons, however skillful he may be at using lines and colors.[66]

These statements echo the theory of *The Six Laws* (*liu fa*), developed in the sixth century by the ancient art critic Xie He, who regarded the Chinese term *qiyun shendon* as one of the most important components of art. *Qiyun shendon* is variously defined as "spirit resonance," "animation through spirit consonance," "engendering a sense of movement through spirit consonance," or "spirit harmony."[67] It would also be unsurprising if Taikan's theory were influenced by Su Shi (1037–1101), otherwise known as Su Dongpo, an elite intellectual, poet, and calligrapher of the Song dynasty, who famously declared that a painting should convey the artist's understanding of the fundamental structure of an object (as well as the artist's feeling), rather than just faithfully reproducing an object's external appearance.[68] These early theories about painting profoundly influenced the production and evaluation of not only later Chinese painting but also later Japanese painting, especially in the literati tradition.

Taikan must also have known about the significance of Chinese-style ink painting in other artists' visual representations of Mount Fuji. Given Taikan's familiarity with Tōyō Sesshū, it seems likely that he would also have been familiar with Sesshū's important painting *Mt. Fuji and Seikenji Temple* (*Fuji miho seikenji zu*) (Figure 4). The painting is a revolutionary work that portrays the Japanese subject, Mount Fuji, in a visual language primarily inspired by the Chinese landscape

FIGURE 4. Sesshū Tōyō, *Mt. Fuji and Seikenji Temple* (Fuji miho seikenji zu). 43.2 x 101.8 cm. Ink on paper. Eisei Bunko Museum, Tokyo.

tradition. Importantly, the painting, which includes the inscription of a poem by Chinese literati figure Zhan Zhonghe, uses the horizontal format, which Taikan also uses, to depict the mountain, and stands in contrast to Kanō Motonobu's *Fuji Mandala,* mentioned earlier.

The composition of Sesshū's *Mt. Fuji and Seikenji Temple*—which places the mountain left of center and above the surrounding area, the temple complex of Seikenji and the Miho Pine Forest in the lower left—was emulated numerous times by later painters. For example, Kanō Tan'yū's *Mt. Fuji* (*Fujisanzu*), executed in 1667, heavily draws on Sesshū's model (see Plate 5). Tanyū uses the horizontal format, and his evocative, misty, panoramic landscape rendered with skillful use of brush and ink unmistakably recalls the Chinese landscape tradition. Like Sesshū, Tan'yū places the mountain off center toward the left, and the temple complex of Seikenji and the Miho Pine Forest in the lower left. In Tan'yū's work, however, the mountain is counterbalanced by the moon looming on the right side. As Yukio Lippit's thorough research observes, the Kanō school established itself as the most dominant, successful school of art and won official support from the Edo government by claiming its artistic lineage descended from Muromachi ink paintings, such as works by Sesshū.[69]

Taikan's *Japan, Where the Sun Rises* strangely avoids the stylistic characteristics present in Sesshū's and Kanō Tan'yū's paintings that draw on Chinese ink-painting traditions. Unlike his predecessors, Taikan removes the panoramic view of the area; gone are the temple complex of Seikenji and the Miho Pine Forest. Instead, he focuses solely on the mountain, which occupies a large space—half of the visual field. Furthermore, the mountain is conspicuously juxtaposed to the perfectly circular sun on the right, colored in vivid red. In terms of the composition, Taikan's work is closer to Hokusai's *Red Fuji,* in which the triangular shape of the mountain dominates the pictorial field, although, unlike Hokusai, Taikan's painting does not show an interest in creating a strong graphic impact through geometric forms or stark

juxtapositions of colors. Unlike either the literati painters or Hokusai, and despite the idealism of Taikan's statements, his Mount Fuji actually looks quite realistic.

The political and military conditions of the 1930s explain Taikan's move away from China. Japan had had a relationship with China since ancient times, throughout which Japan admired and learned from its neighbor's language, culture, religion, and politics. The nature of the relationship changed considerably, however, in the nineteenth century. Thanks to limited foreign engagement, Japan maintained relative domestic peace and succeeded in quickly modernizing when it began diplomatic relations with modern Western nations in the late nineteenth century. China, in contrast, was suffocated both internally and externally by the Opium War, its war with Britain, and the Taiping Rebellion, a large uprising led by a Chinese Christian. In this context, Japan came to look down on China. The superiority of "modern" Japan over "un-modern" China was confirmed, for the Japanese, by the First Sino-Japanese War (1894–1895), which Japan won. In the 1930s, Japan expanded its territory into the Asian continent much more actively: it invaded Manchuria, in Northern China, in 1931, establishing the puppet government Manchukuo in 1932 and then starting an undeclared war with China in 1937.

Taikan's Mount Fuji painting is also decidedly modern for various reasons. The painting is reminiscent of the principle of modern Japanese-style paintings of the late nineteenth century—the amalgam of traditional Japanese art and Western academic paintings—which rendered a traditional subject in a naturalistic manner. It portrays the mountain much more truthfully, with careful rendering of the uneven surface texture and snow-capped summit, in such a way that any person would instantly recognize this mountain as Mount Fuji. The summit is carefully painted with light gray lines that describe the smooth texture of the mountain surface, and the bottom is covered by misty clouds, rendered with ink wash, that give the picture a naturalistic look.

In fact, Taikan's Fuji seems to be inspired by photographs. In particular, his painting is evocative of photographs of Mount Fuji taken by Okada Kōyō (1895–1972). Okada was a photographer and, like Taikan, obsessed with Mount Fuji during the war. Between 1938 and 1948, the government chose to print one of his photographs of Mount Fuji on the fifty-sen bill (see Plate 6). Interestingly, Taikan and Okada had a close relationship: when Okada published his photographic album of Mount Fuji in 1940 to celebrate the 2600th anniversary of the imperial reign, Taikan designed the cover for him.[70] In *Where the Sun Rises,* Mount Fuji has a gentler, gradual slope, which makes it much closer to the shape of the actual mountain.

Given Taikan's collaboration with Okada, Japanese art historian Kawata Akihisa's observation that his paintings are "montage-like" is compelling.[71] Just like Okada's photographic montage, Taikan's "montage-like" painting *Japan, Where the Sun Rises* adds another visual icon that was closely embedded with Japanese fascism—the sun—which has close association with Japan's Shinto myth: as has been previously mentioned, according to the eighth-century *Record of Ancient Matters* (*Kojiki*) and *The Chronicle of Japan* (*Nihon shoki*), the imperial family are direct descendants of the sun goddess Amaterasu.[72] The montage-like composition also characterizes a poster Taikan produced for the 1939 Japan Ancient Art Exhibition in Berlin, which will be discussed in more detail below. In this work, he combines the sun and cherry

blossoms (see Plate 7), which have a long history in Japan's cultural production as a visual and literary icon, and which became a national icon that evoked Japan's tradition and cultural authenticity during the Second World War. Taikan's works thus create new visual language to represent Mount Fuji by incorporating other national symbols, such as the sun and the cherry blossom, and by moving away, stylistically, from Chinese landscape paintings.

TAIKAN ON THE INTERNATIONAL STAGE

In the late 1930s and early 1940s, Taikan and his art came to represent Japan on the international stage. The artist played a prominent role, especially in Japan's diplomatic relations with Nazi Germany. When a group of Hitler Youth visited Japan in 1938, Taikan gave them a lecture about the spirituality inherent in Japanese art, titled "The Essence of Japanese-Style Painting" (*Nihonga no shinzui*).[73] At the event, Taikan presented his fan painting of Fuji to the leader of the youth group, Baldur von Schirach (1907–1974). A newspaper article explains that Taikan was very fond of Germany and that he and his wife prepared for the day's visit by waking up at three in the morning.[74] It also reproduces a photograph of a Japanese painter from the Japan Art Institute performing a demonstration of ink painting in front of the German visitors.

Taikan's connection with Nazi Germany was not limited to this event. He produced a poster for the Japan Ancient Art Exhibition (*Nihon kobijutsu tenrankai*), which took placed in Berlin in the spring of 1939.[75] The state-sanctioned exhibition, which was organized by the East Asian Art Association (*Tōa bijutsu kyōkai*), a group that included a number of government officials from both Germany and Japan, best represents the cultural exchange between Japan and Germany during the Second World War.[76] Art critic Maruo Shōzaburō would refer to this event in announcing the importance of the Axis Pact when it was signed in 1940: he declared that the alliance between Italy, Germany, and Japan should be not only political and economic but also cultural.[77]

As Yasumatsu Miyuki's recent and thorough research reveals, the Japan Ancient Art Exhibition was the first exhibition in Germany that showed a number of works designated as Japanese National Treasures or Works of Important Cultural Heritage, including *yamato-e*, Rimpa painting, Buddhist religious paintings and sculptures from the medieval period, and paintings by Sesshū and Maruyama Okyō.[78] The exhibition was widely advertised in magazines and newspapers both in Japan and Germany, and received considerable attention because Hitler went to see it (Figure 5). Between February and March, according to the East Asian Art Association, 70,000 people visited the exhibition.[79] Taikan's essay, "The Spirit of Japanese Art" was broadcast on the radio in Germany during the exhibition, on April 22.[80]

Taikan's wartime connection with Nazi Germany illuminates the way in which the nation presented different kinds of Japanese paintings to different audiences. War Campaign Record Paintings, mostly executed in oil and depicting soldiers and battles, were exhibited domestically within Japan and its colonies. The battle

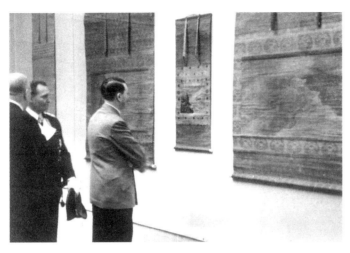

paintings never traveled to Western nations, whether Allied Nations or Japan's Axis allies, whereas Taikan, whose art strove to express the country's cultural uniqueness, took part in Japan's foreign diplomacy with Western nations.[81] As was briefly mentioned above, Taikan was featured, along with other Japanese-style painters including Uemura Shōen, in the 1939 English publication *Four Japanese Painters,* which was presumably produced for English-speaking readers.[82] Examining Taikan's art and activity allows us to understand the extensive artistic production that espoused Japan's state fascism and also to see how the state fashioned its self-image in its international communication.

◆ ◆ ◆

In this chapter, I situated the Japanese-style painter Yokoyama Taikan's Mount Fuji paintings in Japan's discourse of fascism in the 1930s and early 1940s. Taikan was a strong advocate of the state's official ideology of fascism, which was concerned with cultural authenticity and uniqueness in the modern time, and he was a proponent of restructuring the art world to make art fit the state agenda. By discussing several pre-modern Japanese paintings that show Mount Fuji, I demonstrated how Taikan's Fuji paintings are different in their meaning and style. Taikan's Fuji closely follows the fascist understanding of the imperial family and spirituality, and also differs considerably from previous Chinese models of Mount Fuji paintings by creating a different visual language based on photographs and montage techniques. In contrast to Alan Tansman's idea of the "fascist moment," my analysis shows how there was nothing inherently "fascistic" about the iconography or the style of Taikan's Mount Fuji paintings. Rather, it is the resonance between Japanese fascism and how Taikan's paintings were intended and received that is essential to our understanding of the art of Japanese fascism. Taikan's artistic activity also significantly expands our scope of knowledge about how battle paintings (most often Western-style paintings) and "traditional" paintings (most often Japanese-style paintings) belonged to different spheres, especially when it came to Japan's self-representation to Asia and the West.

3

YASUDA YUKIHIKO'S *CAMP AT KISEGAWA* AND MODERN AESTHETICS

In 1941, Yasuda Yukihiko completed *Camp at Kisegawa* (*Kisegawa no jin*, 1940–41) (see Plate 8). The left half of the painting portrays Minamoto Yoshitsune (1159–1189), a famous warrior from the Kamakura period (1185–1333), and the right, his older brother Yoritomo (1147–1199). Painted in ink on two paper folding screens, the work depicts the much-desired reunion between the two men before their battle against the rival Heike clan. *Camp at Kisegawa* received very favorable responses from contemporary critics: art critics such as Kanzaki Ken'ichi and Endō Motoo shared Yasuda's interest in historical subjects and declared that history paintings boosted the "spirit of the Japanese race" (*minzoku no seishin*).[1] In 1942, Yasuda also received the Asahi Culture Award (*Asahi bunka shō*) from the Asahi Newspaper Company for the painting, which testifies to its positive reception even outside of the art world.[2] The success of this painting is also demonstrated by the fact that *The Arrival of Yoshitsune*—the name initially given to the left-hand panel—was captioned "*shindō jissen*" ("practicing the way of loyalty") and reproduced and distributed by the Imperial Rule Assistance Association.[3] These posters would have been displayed in local schools and offices. Capitalizing on this success, Yasuda produced at least two more works about the brothers: one that depicts the meeting of the brothers, in 1943, now in a private collection, and the other showing Yoshitsune alone, in 1942, now housed at the Mitsui Memorial Museum.[4]

In this chapter, I explain how Yasuda's *Camp at Kisegawa* participated in the cultural discourse of Japanese fascism. While Taikan's paintings expressed and

claimed Japanese uniqueness and cultural authenticity through the natural motif of Mount Fuji, Yasuda employed historical myth, focusing on the twelfth-century Minamoto brothers, whose story featured prominently in Japanese history, litera-ture, and visual arts. As I will show, Yasuda's painting was understood as an exem-plary work of "Japanese" art not only because of its subject matter but also thanks to its style, which was based on medieval *yamato-e* paintings. At the same time, how-ever, his "traditional style" was highly informed by the modern aesthetics that were introduced to Japan during the 1910s and 1920s. In analyzing Yasuda's work, which is simultaneously both "Japanese" and "modern," this chapter engages with the larger theoretical issue of "fascist modernism"—the fascist appropriation of modern aesthetics—which has hitherto been addressed in the context of Italian and German fascist art.[5]

YASUDA YUKIHIKO AND *CAMP AT KISEGAWA*

Born Yasuda Shinzaburō in Tokyo in 1884, Yasuda Yukihiko studied at (though later dropped out of) the Tokyo School of Fine Arts, which in 1887 had become the first Japanese national art school founded by the Ministry of Education. Yasuda was inspired to become an artist by the first generation of *Nihon-ga* painters, such as Yokoyama Taikan and Hishida Shunsō. Yasuda maintained a close relationship with Okakura Tenshin (1863–1913) and the Japan Art Institute (*Nihon bijutsu in*), to which Yokoyama Taikan also belonged. Yasuda is often considered a second-generation artist of the Institute.

Yasuda might not have made explicit political speeches like his fellow Japanese-style painter Yokoyama Taikan, but during the Second World War he remained remarkably active: in addition to regularly submitting paintings to various exhibitions, he sold paintings at least four times at *kennō-ga ten* (Offering Painting exhibitions), the revenues of which were donated to the state for use in the war effort.[6] *Kennō-ga ten* functioned as an alternative venue for Japanese-style painters, who did not produce contemporary battle paintings, to express their patriotism. In 1943, Yasuda was commissioned by the Navy to produce a portrait of Yamamoto Isoroku, the commander-in-chief of the Combined Fleet during the Second World War, who had died that year. Yasuda exhibited *The Portrait of Admiral Yamamoto* in 1944 to the Ministry of Education Wartime Special Art Exhibition (*Monbushō senji tokubetsu bijutsu ten*). His wartime contribution was handsomely acknowledged by the state; in 1944, he was invited to work as a professor at the Tokyo School of Fine Arts, and in 1947 he received the Order of Culture from the emperor for his contri-bution to Japanese art.

Camp at Kisegawa was the most celebrated of all his works during the war. From the beginning, Yasuda conceived this painting as a portrayal of the meeting between the Minamoto brothers. However, he was only able to complete the left half, which portrays a fully armed Yoshitsune keeling over on the ground, for sub-mission to the 1940 Celebration of the 2600th Anniversary of the Imperial Reign Exhibition (*Kigen nisen roppyakunen hōshuku bijutsu ten*), where Taikan's *Japan,*

Where the Sun Rises, was also displayed.[7] *The Arrival of Yoshitsune* was then paired with the other half, which depicts Yoritomo, sporting an *eboshi* hat and beard, sitting quietly on tatami mats. The completed work was then titled *Camp at Kisegawa* a year later in 1941 and submitted to the 28th exhibition of the Japan Art Institute. The two panels together depict a meeting between the two brothers that took place at Kisegawa when Yoritomo was waging a battle against the rival Taira clan.

THE MINAMOTO BROTHERS AND JAPANESE HISTORY, LITERATURE, AND ART

By portraying these historical figures, Yasuda's work alludes to his country's history, gesturing to the past. Moreover, it depicts not just *any* historical figures, but specific individuals who were remembered as remarkable military warriors. As I will show, the portrayal of the Minamoto brothers resonated with Confucian ideals—namely, that Japanese society, and by extension the Japanese Empire, should be based on hierarchical relations between the superior and the inferior—and *bushido,* the samurai code, which dictated that all true Japanese find death honorable and even beautiful. Both of these notions were recurring themes in Japanese fascism. Although the Minamoto brothers were not in fact the most obvious vehicle for conveying these ideas, Yasuda's paintings were favorably received by both the state and art critics.

Yoritomo and Yoshitsune were from the Minamoto clan, one of the two military clans that became extremely powerful at the end of the Heian period (794–1185), the other being the Taira. Both clans belonged to collateral branches of the imperial line and initially served the Fujiwara family, who exercised their power over the court mainly by marrying daughters into the imperial family. Both the Minamoto and the Taira grew their power through military expeditions that they were assigned, and, starting with the Hōgen Rebellion in 1156, they also became involved in conflicts surrounding imperial successions. The lives of Yoritomo and Yoshitsune cannot be separated from the Heiji Rebellion of 1160, in which the Minamoto lost to the Taira clan, and Minamoto Yoshitomo (Yoritomo and Yoshitsune's father) and Yoshihara and Tomonaga (Yoritomo and Yoshitsune's older brothers) were killed. Yoritomo's and Yoshitsune's lives were spared, but they were brought up separately. Yoritomo, the older brother, was exiled to Hirugashima, an island in Izu province. Yoshitsune, who was referred to as Ushiwakamaru in his early years, was forced to enter a monastery, the Kurama Temple near Kyoto, and later lived under the protection of the powerful Northern Fujiwara clan in Hiraizumi, Mutsu province. In 1180, Yoshitsune heard about Yoritomo raising his army against the Taira clan and finally met his older brother when he went to join his forces. Eventually, during the Genpei War, which included the Battle of Ichinotani (1184) and the Battle of Dannoura (1185), Yoritomo and Yoshitsune together defeated the Taira clan, thereby avenging their father and older brothers. Yoritomo then established his government in Kamakura and became Japan's first shogun, or military governor.

Naturally, the Minamoto clan became the subject of much Japanese literature and art. Many works associated the clan, and especially Yoritomo and Yoshitsune,

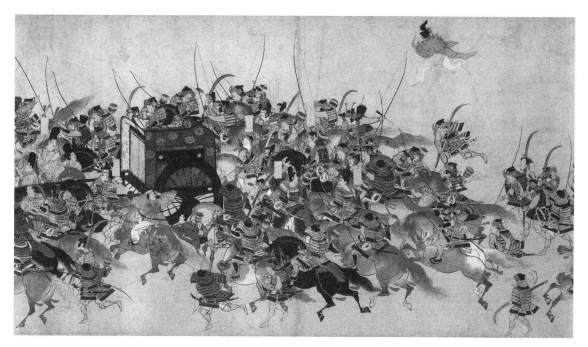

FIGURE 6. *Night Attack on the Sanjo Palace, from the Illustrated Scrolls of the Events of the Heiji Era* (Heiji monogatari emaki), second half of the 13th century. Ink and color on paper. 41.3 x 700.3 cm. Museum of Fine Arts, Boston.

with military prowess. *The Illustrated Scrolls of the Events of the Heiji Era* (*Heiji monogatari emaki*) from the second half of the thirteenth century, which are now housed at multiple institutions including the Museum of Fine Arts in Boston and the Tokyo National Museum, show dramatic sequences of battles from the Heiji Rebellion in which Yoritomo and Yoshitsune's father was involved (Figure 6).[8] The scroll, which participates in the genre of war pictures (*gassen-e*), provides pictorial illustrations of war tales (*gunki*) based on the thirteenth-century *Tale of Heiji* (*Heiji monogatari*). One section of the scroll, housed in Boston, shows an early episode of the rebellion in which Yoshitomo and Fujiwara Nobuyori stage a coup: armor-clad warriors carrying swords, bows, and arrows surround the palace at night, kidnap the emperor and place him on a cart, and then set fire to the palace. The long horizontal scroll condenses the dramatic narrative into one scene, showing both a bird's-eye perspective of the event and graphic details of violence.

The theme of military power continues in numerous literary and pictorial arts that represent the victory of the Minamoto brothers in the Genpei War, in which they defeated the Heike clan. Legendary stories about the brothers' military skills are recorded in literature from the time, such as *The Tale of Heike,* written during the thirteenth century, and *Azuma Kagami* (Mirror of the East), a historical chronicle that documents the genesis and history of the Kamakura government.[9] The brothers were regularly depicted in a later historical period, which is exemplified by two large screens that portray the battles of Ichinotani and Yashima, produced in the first half of the seventeenth century, now in the collection of John C. Weber (Figure 7).

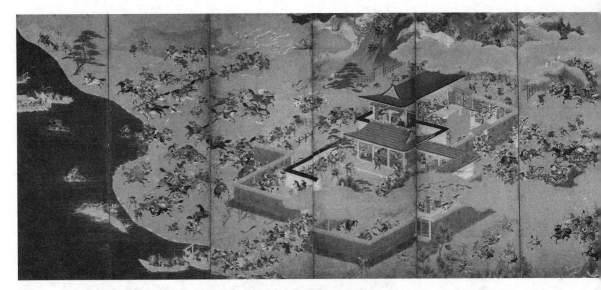

FIGURE 7. *Battle of Ichinotani and Yashima*, first half of the 17th century. Ink, color, and gold on paper. Photo Courtesy: John Bigelow Taylor. John C. Weber Collection.

The right screen shows the battle at Ichinotani, which took place in the spring of 1184 near present-day Kobe. Yoshitsune launched a surprise attack from the rear (the right of the screen) on the Taira, who had created a stronghold. On the left side of the work, the panicked residents are fleeing to boats in the sea. The two battles were considered proof of Yoshitsune's brilliant military tactics.

The left screen portrays the Battle of Yashima, which took place in 1185 on an island in Shikoku where the Taira had a new stronghold. While the Taira believed that the Minamoto would approach from the sea, Yoshitsune attacked again from the rear, forcing the Taira to their boats in the sea. The pictorial space is dominated by gold, which represents the land, and deep blue, which represents the sea. Hundreds of warriors, riding horses and boarding boats, are depicted in meticulous detail. The scale of the individuals is contrasted with the vast pictorial space and bold use of colors, and the stylized and decorative quality of the picture in general.

In the context of Japanese fascism, however, Yasuda's painting would have reminded the viewers of the importance of bushido, which state officials and mass media lauded as truly Japanese and an example for emulation.[10] This painting of a historical subject, in other words, would have had contemporary resonance. "Bushido" refers to the code of moral principles that Japanese samurai warriors in the pre-modern period were believed to have followed. Bushido was theorized and became well known in the modern Meiji period, both internationally and domestically, with the publication of *Bushido: The Soul of Japan* (1905) by Nitobe Inazō (1862–1933). In reality, however, as Oleg Benesch observes, there was no "single, broadly-accepted, bushi-specific ethical system at any point in pre-modern Japanese history."[11] The importance of the "imagined" warrior codes was constantly reiterated in the context of Japanese fascism. These were incorporated into *The Instructions for*

the *Battlefield* (*Senjinkun*), written by War Minister Tōjō Hideki in 1941, a copy of which was owned by every single soldier.

The most unique aspect of modern bushido is that it teaches that a samurai would find death honorable, that giving up on one's life is virtuous, and that this is a truly Japanese sentiment. The fact that many samurai, including Yoshitsune, did not resist their fate and willingly chose death was certainly idealized and indeed put into practice during the Second World War, especially toward the end. In the Battle of Attu in 1943, knowing that they would be outnumbered and defeated, the Japanese soldiers committed a collective suicide called *gyokusai* (literally, shattered jewels), while those who were unable to fight took their own lives to avoid humiliating capture by the enemy.[12] In 1944, in the Battle of Saipan, not only soldiers but also Japanese civilians, including women and children who had emigrated to the island, were asked to take their own lives when capture was imminent. In the Kamikaze Special Attack Units, formed in 1944, hundreds of young Japanese pilots "body attacked" (*taiatari*) American ships, turning themselves into suicide bombs. In these last battles, like Yoshitsune, soldiers and citizens graciously accepted their "fate" without ever questioning or resisting it. Yasuda's painting thus invites identification, asking its wartime viewers to *be like* Yoshitsune and practice in real life these virtues of loyalty, willingness to die, and acceptance of an unfortunate ending in defense of Japanese culture.

The fact that the paintings portray the younger brother serving the older brother would also have been important. The new society that the wartime Japanese state sought to establish was one based on hierarchical relations—clearly echoing the principles of the Chinese philosophy of Confucianism.[13] The fascist state narrative was that in traditional Japanese community, the superior would

control and protect the inferior, who in return would serve, obey, and remain loyal: the emperor would always be superior to his subjects, the older superior to the younger, and men superior to women. The Japanese state's vision of recreating this hierarchical society was clearly outlined in the 1937 *Cardinal Principles of the National Entity of Japan*:

> In each community there are those who take the upper places while there are those who work below them. Through each one fulfilling his portion is the harmony of a community obtained. To fulfill one's part means to do one's appointed task with the utmost faithfulness each in his own sphere . . . This applies both to the community and to the State. In order to bring national harmony to fruition, there is no way but for every person in the nation to do his allotted duty and to exalt it.[14]

The Confucian rhetoric of the superior and inferior was a central principle during the war: Japanese citizens were expected to fight and die for their superior, the emperor.[15] The analogy of the relationship between the older brother and the younger brother was also often used to justify Japan's expansion into Asia, and the Great Eastern Co-Prosperity Sphere was to be a harmonious community based on relationship hierarchies: Japan, being "the older brother," had the right to lead and control "the younger brother," variously China, Korea, and Southeast Asian countries, such as Indonesia and Burma. The relationship between the "superior" Yoritomo and the "inferior" Yoshitsune represented in *Camp at Kisegawa* would have functioned as a metaphor for, and a microcosm of, fascist Japan's ideal social relationships.

However, the Minamoto brothers were not without troubles. They were in fact chiefly known for their falling-out: Yoshitsune was eventually betrayed by his older brother, for whom he fought in the Genpei War. Regarded as a threat by Yoritomo, he was not permitted to enter Kamakura when Yoritomo established the Kamakura government. Yoshitsune was confronted and defeated at the Battle of Koromo River by Yoritomo's forces, against which he fought with Benkei. Benkei died in combat, and Yoshitsune was forced to commit suicide with his wife and daughter. The tragic fate of Yoshitsune stands in stark contrast to the successful political career of Yoritomo, who was appointed to the position of shogun by the emperor and became the first military ruler in Japanese history.

Yoshitsune's unfortunate ending, however, contributed to his popularity: he became more popular than Yoritomo in later cultural discourses. In fact, compared to other warriors in Japanese history, Yoshitsune's popularity stands out: Paul Varley, a specialist of Japanese history and culture and the author of *Warriors of Japan*, tellingly notes that "No hero in the war tales has been more dearly loved by readers and audiences over the centuries than Minamoto no Yoshitsune, who has also been regarded both in history and in the popular imagination as one of Japan's most brilliant field commanders."[16] The life of Yoshitsune was fictionalized and popularized through *The Chronicle of Yoshitsune* (*Gikeiki*), a Japanese war tale written around the fourteenth century. Varley explains, "[Yoshitsune] suffered the

fate of a martyr at the hands of Yoritomo, arousing a powerful sense of sympathy for him (sympathy for the underdog) among those who read or heard stories about him."[17] And indeed, Yoshitsune's experience generated the phrase "hōgan biiki" (literally, preference for the lieutenant), which means sympathy for the underdog.[18]

Numerous stories and plays were written about Yoritomo's betrayal of Yoshitsune. Several kabuki plays, for example, dealt with the theme. *Yoshitsune and the New Takadachi* (*Yoshitsune shin takadachi*, 1719) analogizes the conflict between Yoritomo and Yoshitsune after the Genpei War to the relationship between Tokugawa Ieyasu and his rival Toyotomi Hideyoshi. In *Yoshitsune and the Thousand Cherry Trees* (*Yoshitsune senbon zakura*, 1747), Yoshitsune searches for surviving Taira warriors with his wife and the loyal warrior-monk Benkei after being betrayed by Yoritomo. In a later narrative, *The Subscription List* (*Kanjinchō*, 1850), Yoshitsune and Benkei, disguised as traveling monks, are stopped by a gatekeeper who is under orders from Yoritomo to search for them. *Funa benkei* (1885) is about a fight that Yoshitsune and Benkei endure with ghosts of the sea after Yoritomo excludes Yoshitsune from his government.[19]

Yasuda's *Camp at Kisegawa* is radically new in the sense that is it a bold attempt to turn away from the well-known falling-out of the brothers, focusing instead on the moment when Yoshitsune appeared to help Yoritomo. While *Azuma Kagami* describes the meeting between the two that Yasuda portrays, it was never part of the popular understanding of the Minamoto brothers. Indeed, *Camp at Kisegawa* might even be the first visual representation of the meeting in Japanese art history. Yasuda certainly knew about the betrayal: Yoshitsune was his favorite subject, and he had produced at least two paintings of Yoshitsune, *Parting at Yoshino* (*Yoshino ketsubetsu*, 1899) and *The Farewell of Shizuka Gozen* (*Shizuka ketsubetsu no zu*, ca. 1907) earlier in his career, during the Meiji period (see Plate 9). Both depict scenes related to Yoshitsune's tragic fate: they show a devastated Yoshitsune being searched by Yoritomo's forces and deciding to hide on Mount Yoshino in Nara Prefecture, saying farewell to his wife.

While one might reasonably wonder how successful Yasuda's historical revisionism was in altering the public's view of the brothers, his painting was accepted by the state and received favorable reviews. It was displayed at the 1940 Celebration of the 2600th Anniversary of the Imperial Reign Exhibition (*Kigen nisen roppyakunen hōshuku bijutsu ten*). Art critic Kanzaki Ken'ichi praised Yasuda's work and imagined that the appearance of Yoshitsune would surely delight the yet-to-be-painted Yoritomo.[20] Viewed in 1940 and 1941, when war in the region had been dragging on for a decade and younger men were increasingly being drafted, the idealized depiction of Yoshitsune helping his brother at war would have served to spur viewers—particularly those who had not yet enlisted—to do the same. In fact, cultural critic Kawasaki Katsu explicitly referred to the social and political conditions of the time by saying that the brothers' expressions in Yasuda's painting "correspond with the Japanese people's readiness to establish a 'New Japan' on the occasion of a national emergency."[21] Though from a bygone age, the Minamoto brothers were treated as exemplary warriors that contemporary men should emulate.

Yasuda's *Camp at Kisegawa* participated in the discourse of Japanese fascism not only through its subject matter but also through its style. The painting was praised as embodying pictorial qualities that are uniquely Japanese, and indeed the artist seems to have modeled his work on paintings from the medieval period, such as *Portrait of Yoritomo* and *The Illustrated Account of the Mongol Invasion*. At the same time, as this chapter will demonstrate, *Camp at Kisegawa* also displays modern aesthetics. Yasuda's painting thus illuminates the complex, convoluted history of modern Japanese art during the 1930s and 1940s, in which Japanese artists discovered the value of their traditional art through modern art—which was largely inspired by non-Western art, including Japanese art.

Camp at Kisegawa was acclaimed for its formal characteristics and was considered particularly "Japanese." One of the art critics who articulated this idea was Okazaki Yoshie (1892–1982), a prominent writer and nativist scholar, who published "Contemporary Japanese-style Painting and its National Characteristics" in *Kokuga* in 1942. In this essay, Okazaki argues that Japanese art reflects qualities unique to Japanese people and culture, and that "poetic" Japanese art is fundamentally different from "materialistic" (*busshitsushugi*) and "scientific" Western art.[22] According to Okazaki, the two most important features of Japanese art are line drawing (*sen*) and two-dimensionality (*heimen*). The Japanese use of line, he suggests, is indebted to the Asian artistic tradition; however, implicitly echoing the oft-repeated wartime Pan-Asianist, colonialist rhetoric that Japan was meant to save other Asians from corruption, he argues that Japanese lines are unique because, unlike rigid Chinese lines and weak Indian lines, they are rather flexible. The line in Japanese art, the author contends, does not just indicate a boundary between objects or describe the shape of the object; it is also a "*koppō*" ("bone method"). Relating the quality of lines to specific Japanese aesthetics, he claims that Japanese lines evoke a sense of the varying and subtle feeling of *wabi-sabi* (incompleteness, impermanence), *aware* (the pathos of things), *iki* (chic), and *yūgen* (grace and subtlety).[23] While the author says these lines can be found in works by Kobayashi Kokei, Takeuchi Seihō, and Yokoyama Taikan, he argues that it is the use of line by artists such as Yasuda that functions as a textbook example of his point.[24]

At the end of his article, in a most curious way, Okazaki uses the stylistic uniqueness of Japanese painting to legitimize violence in war. He likens the difference between Japanese and Western art to a battle, and states that Japanese painting is not a "standard tactic of attack" (*seikō hō*), but rather a "surprise attack" (*kishū sakusen*). He writes, "If the paintings of trees and birds have the power of *koppō*, they will lead to the surprise attack's victory. Western paintings that apply paint all over the canvas will lose their power in front of Japanese art . . . I feel supernatural power in *koppō*."[25] Okazaki wrote this in 1942: there can be no doubt that he was referring to Japan's attack on Pearl Harbor the year before.

Okazaki's way of viewing Japanese-style paintings in relation to traditional Japanese art and its lines/two-dimensionality was not uncommon. Kinbara Seigo (1888–1958) reiterates the point made by Okazaki in his essay titled "Theory of

Contemporary Japanese-style Painting," which was published alongside Okazaki's essay. Kinbara also generalizes Japanese art by stating that it is characterized by the strong use of line, two-dimensionality, and negative space, while Western art uses perspective and other techniques to create spatial depth and contrasts between light and dark: in his opinion, Japanese art is plain, Western art expressive.[26] Like Okazaki, Kinbara analogizes the artistic difference between Japanese and Western paintings to differing soldierly attitudes. He declares that Japanese soldiers are calm and restrained, like Japanese art, even when facing death, whereas Western soldiers, who are expressive, like Western art, need to party.

Yasuda does seem to have modeled his painting on traditional Japanese art. *Camp at Kisegawa* is based on the artist's study of pre-modern Japanese works, notably *Portrait of Yoritomo* (*Den Minamoto no Yoritomo zō,* twelfth century) (see Plate 10). *Portrait of Yoritomo* is part of a group of three portraits now housed at Jingoji, Kyoto; the other two are believed to represent Taira no Shigemori and Fujiwara no Mitsuyoshi. It is a hanging scroll, executed with color on silk, and is an early-thirteenth-century copy of an original that is attributed to the artist Fujiwara no Takanobu (ca. 1146–ca. 1206), made in 1179.[27]

In this painting, Yoritomo sits on three layers of tatami mattress, holding a wooden tablet in a ceremonial setting. Following portraiture convention of the time, Yoritomo wears formal attire, sits against a blank background, and shows a frontal view. This work, one of the earliest warrior and court noble portraits in Japanese art history, is also one of the earliest examples of a portrait done in *yamato-e* style.[28] *Yamato-e,* which developed in the Heian period, was defined in opposition to Chinese painting or *kara-e. Yamato-e* is known for depicting landscapes specific to Japan and uses stylization and two-dimensional graphic expressions. Yoritomo's portraiture belongs to what is called *nise-e* (likeness pictures), a popular genre of the Kamakura period, which attempted to produce a truthful likeness of the individual in the picture.[29]

For *Camp at Kisegawa,* Yasuda uses *Portrait of Yoritomo* as a model for the warrior's posture and facial characteristics and composition. As with the portrait, Yoritomo in Yasuda's painting positions himself frontally to the viewer, sitting against a plain background. The remarkable use of negative space that almost dominates the visual field in both Yasuda's painting and *Portrait of Yoritomo* makes their pictorial spaces shallow. In the twelfth-century portrait, the black color of the garment is applied rather uniformly and there is no indication of lighting or shadowing, thereby emphasizing the garment's angular shape.

Another important pictorial work that depicted war in this period is *The Illustrated Account of the Mongol Invasion* (*Mōko shūrai ekotoba,* 1275–1293) (see Plate 11). This scroll, commissioned by a samurai called Takezaki Suenaga, a warrior from Higo who actually fought in the war, is a visual record of the historical battle fought between Japanese warriors and the Mongol forces during the Mongol invasions of Japan in 1274 and 1281. The scroll, divided into two parts, narrates the story of Takezaki fighting with Mongol forces on land and at sea in Southern Japan. The story has it that Takezaki fought mostly with arrows and won the war, and then went to Kamakura to ask for praise. The scroll ends with Takezaki showing the heads of the

enemies to Adachi Morimune and talking about the fight.[30] These paintings provide a visual record of a type of warfare and armor particular to the period. Samurais usually wore ōyoroi armor, designed for cavalry archers (large, heavy armor worn only by high-ranking samurai), and were equipped with a *tachi* sword (which was usually heavier than the *katana* that came to be more popular in later periods) suspended from the waist.[31] Battles during this period started with the cavalry shooting arrows, followed by close combat using swords.

That Yasuda used *The Illustrated Account of the Mongol Invasion* as a model is clear; he must have based the composition on the last scene of the scroll and referred to the picture scrolls for his rendering of medieval armor and fighting equipment. In fact, the composition is almost identical to that in the last scene of the scroll, where Takezaki Suenaga talks about the war to Adachi Morimune. The colors of the scroll, specifically the prominent red and green used throughout, are echoed in Yasuda's painting, while the conversation between Takezaki and Adachi is replaced by that of Yoshitsune and Yoritomo. The way they sit and look at each other is also very similar. It is also overwhelmingly likely that Yasuda based the appearance of his arrows and *kabuto* on this particular scroll scene. Yasuda's painting, however, enlarges these figures and removes other minor figures from the visual field.

Because of this turn toward works from the Kamakura period—*Portrait of Yoritomo* and *The Illustrated Account of the Mongol Invasion*—*Camp at Kisegawa* is much more stylized than *Parting at Yoshino*, which is naturalistic. In *Camp at Kisegawa*, the emerald-green tatami mat that Yoritomo sits on looks tilted forward, refusing to recede in space. Yasuda is certainly not concerned about creating the illusion of three-dimensional space in the paintings, but, rather, seems to be interested in stylizing shapes and forms of the depicted objects and subjects. Emphasis is on linearity of the contours of the figures and the tatami mat. The flat pictorial space that is created by the frontality of Yoritomo's body, for example, is further emphasized by the artist's focus on the decorative pattern of his garment and not the volume of his body. As Okazaki noted, Yasuda's painting emphasizes line drawing and two-dimensionality. The deliberate stylization of forms in *The Arrival of Yoshitsune/Camp at Kisegawa* thus becomes particularly obvious when compared to the naturalistic rendering of space and body in *Parting at Yoshino*.

Yasuda's *Parting at Yoshino* (1899), as mentioned earlier, depicts Yoshitsune and is a perfect example of the late-nineteenth-century history-painting movement. Both Western-style oil painters and Japanese-style painters in the Meiji period created history paintings, depicting iconic figures from Japanese history. The establishment of history painting (*rekishi-ga*) in Japanese-style painting was closely associated with the founding and development of modern *Nihon-ga* by Okakura Tenshin and his students.[32] Yasuda, who had submitted works to the Japan Art Institute ever since Okakura founded it in 1898, and who became a member in 1914, was part of this Japanese-style-painting-as-national-art movement that reached its height in the late nineteenth century and engendered many paintings focused on Japanese historical subjects. The painting, which portrays Yoshitsune in the center, standing in front of a statue of the Buddha and surrounded by two other figures kneeling in front of him, is a highly naturalistic painting. The work shows a realistic modeling of the figures and

firmly grounds them in an extensive architectural context rendered in substantial detail. The use of techniques associated with Western academic art, such as foreshortening and atmospheric perspective, helps to create an illusionistic space. The diagonal that is created by a wooden pillar in the left foreground, Yoshitsune in the middle ground, and the Buddha in the right-hand background creates a clear orientation and a stable and balanced composition. *Camp at Kisegawa*'s format—a *byōbu* folding screen—would without question have contributed to its reception as particularly "Japanese": *Parting at Yoshino,* in contrast, could have been framed and hung on a wall like Western-style paintings.

YASUDA'S "RETURN TO JAPAN" VIA MODERNISM

The striking stylistic differences between Yasuda's two paintings of Yoshitsune, the one produced in 1899 and the other in 1940, beg the following questions: What made the artist model his painting on medieval scrolls from the Kamakura period in 1940, but not in 1899? Why did he choose *yamato-e* as a model, and not another style? As I will explain, much as it was indebted to various specific examples of pre-modern Japanese art, Yasuda's work was also highly informed by the modern aesthetics that prevailed in the first few decades of the twentieth century. More specifically, the artist's attention to *yamato-e* was prompted by the popularity of the post-expressionist, machine aesthetics of international modernism. By examining the influence of modern aesthetics on Yasuda's painting, we will be able to see the complex trajectory in which modern aesthetics came to be understood as "Japanese" aesthetics and were appropriated by the wartime state.

Let us first look at the trend of international modernism in Japan that started in the 1910s, and then turn back to Yasuda's *Camp at Kisegawa.* Although Japanese-style painting was defined as "traditional-style" painting (as opposed to Western oil painting) in the Meiji period, there emerged a movement in which Japanese-style painters consciously tried to incorporate elements that they had learned from Western modern art.

During the 1910s, European modernism—which advocated transcendence from traditional academic art—was introduced, notably through *Shirakaba,* a magazine published between 1910 and 1923 that included photographs of modernist artworks and translated writing by the likes of Van Gogh, Gauguin, and Matisse.[33] This had an immediate effect: in 1914, a group of young Western-style painters, including Arishima Ikuma (1882–1974), Ishii Hakutei (1882–1958), and Umehara Ryūzaburō (1888–1986) established the Nikakai (Second Section Society), creating an alternative exhibition venue to the government-sponsored Bunten.[34]

A similar movement took place in the field of Japanese-style painting, and as John D. Szostak's recent monograph demonstrates, the group called the Society for the Creation of Japanese Painting (*Kokuga sōsaku kyōkai*), developed in Kyoto and led by Tsuchida Bakusen, Ono Chikkyō, Murakami Kagaku, Nonagase Banka, and Sakakibara Shinhō, brought together the foremost Japanese-style painters.[35] Being "modernist," they published a manifesto in January 1918 in which they declared,

"Art is something born, not produced by mechanism or institution . . . The creation of art must be practiced with complete freedom."[36] In their "Statement of Purpose," published the same year, the group made it clear that they opposed the ideal and practice presented by the government-sponsored exhibition:

> The Bunten has moved away from the attitude towards art that was in place at the time of its founding, and its recent tendencies have moved it further still from our own artistic conventions and opinions. If we adopted the attitude of the Bunten, the purity of our artistic production would be sullied, and our individuality would suffer injury. These things we could not endure. As our self-awareness became stronger, and our convictions grew firmer, we became more and more keenly aware that we could no longer remain associated with the Bunten.[37]

Bakusen and other Japanese-style modernist painters challenged the first generation of *Nihon-ga* paintings theorized and endorsed by Okakura and exemplified by Yasuda's late-nineteenth-century painting *Parting at Yoshino*. Bakusen's trip to Europe in 1921, during which the artist saw many contemporary Western paintings, ignited his interest in the works of Paul Gauguin (1848–1903). It is not difficult to see that Bakusen's painting *Island Women (Shima no onna)*, produced in 1912 as a folding screen with color on ink, is influenced by the famous *Where Do We Come From? What Are We? Where Are We Going* (1897) by Gauguin (see Plate 12). Both Bakusen's and Gauguin's paintings portray in a horizontal format several partially naked "primitive" women on a remote island. Both artists model the figures with visible black outlines and without much use of color gradation or shadowing. Though Bakusen's work belongs to the traditional genre of *bijin-ga*, it marks a new phase of Japanese-style painting that was informed by post-impressionist modern European art.

Around 1935, a slightly different artistic trend started to develop, a style that was closely connected to that in which Yasuda painted *Camp at Kisegawa*. In these works, painters portrayed modern girls with modern industrial products. *Tearoom*, painted by Japanese-style painter Saeki Shunkō, a painting of two café waitresses with bobbed hair, exemplifies this trend (see Plate 13).[38] The modern girls (*moga*) wear identical Western-style uniforms, their jackets and skirts in dark yet primary colors of red, blue, and yellow. They face the viewer, standing side by side in front of a bar counter and holding a stainless-steel tray. Next to them are a white concrete pedestal and an aluminum shelf that neatly holds variously shaped green cacti in separate vessels. The floor's diamond motif, the angular edges of the plants, and the round surfaces of the waitresses' faces and skirts add geometric harmony to the picture and signal the artist's interest in modern aesthetics.

While both Bakusen's and Saeki's paintings utilize narrow spatial representation and two-dimensional pictorial language, the spatial formation of Saeki's painting is much more regimented, rationalized, and mechanically coordinated. Similarly, whereas Bakusen uses organic, soft, round forms to stylize the shapes of the human figure and the national environment, Saeki's painting compares the contour lines of

the figures with streamlines of other objects. What emphasizes the firmness of the lines is a simplified composition that makes use of a large flat blank space and focuses on the horizontal and vertical qualities of the canvas. While Bakusen's painting shows a sense of movement and activity, Saeki's painting is utterly still, showing women who look like they are confined in the space. A number of Japanese-style paintings in a large scale like this one, which contrast "modern" subjects and objects against a predominantly white, blank background, were produced in the mid- to late 1930s.[39] Although it is clear that many Japanese-style paintings from this period share the same formal characteristics, there were no labels attached to this artistic trend either by critics or by the artists themselves. This is perhaps because the trend continued for only a few years and tended to be pursued by younger artists who had not yet established their names.[40]

What informed these Japanese-style paintings produced in the mid-1930s, like *Tearoom,* was the visual language of international modernism, which embraced the development of science and technology that had emerged in the previous decade. This school of international modernism, often called post-expressionism, and distinct from other forms of modernism such as primitivism and fauvism, celebrated ideas and aesthetics associated with modernization, such as rationality, efficiency, objectivity, mass production, and standardization. It was exemplified by various art movements including American machine art, Le Corbusier's rationalism in France, Bauhaus in Germany, and Art Deco.[41]

One art form that is particularly important to understanding 1930s Japanese-style paintings is machine art. An exhibition titled *Machine Art,* held at the Museum of Modern Art in New York in 1934, in effect established this style of art. Despite the title of the exhibition, it did not display machines: instead, it displayed mechanically mass-produced industrial objects ranging from forks and spoons to clocks and electric toasters, elevating everyday objects to the status of "fine art." Philip Johnson, who curated the show, stated that "the beauty of machine art is in part the abstract beauty of 'straight lines and circles' made into actual tangible 'surfaces and solids' by means of tools . . . Machines are, visually speaking, a practical application of geometry . . . The machine implies precision, simplicity, smoothness, reproducibility."[42] The aluminum shelf that appears in Saeki's *Tearoom,* the likes of which had never entered the Japanese-style pictorial field until this time, is a kind of modern material that would have been celebrated as "art" in the *Machine Art* exhibition. Many other Japanese-style paintings from the period incorporate objects like telescopes, microscopes, and laboratory flasks.

The subject matter of Saeki's painting could not be more different from that of Yasuda's. Saeki depicts *moga* ("modern girls") in a café, the typical symbol of modernity, while Yasuda paints historical warriors from the Kamakura period. However, upon close observation, it becomes clear that the two paintings, produced only four years apart, share stylistic characteristics. One of these characteristics is the dominating, large space left unpainted. Another commonality can be found in the flat, broad application of saturated vivid colors like yellow, red, orange, and green without much use of gradation. Both paintings show an interest in geometric patterns and linearity, with the space looking regimented and geometrically organized.

As I described above, *Camp at Kisegawa* certainly draws on the composition and color of *The Illustrated Account of the Mongol Invasion*. But Yasuda's work is much cleaner, uses perfectly straight lines, and applies colors in such a way that they stand out.[43] In the Mongol scroll, the figures look animated, as if in conversation, whereas in Yasuda's painting, the brothers look completely still, even frozen, like in Saeki's work.

Unfortunately, Yasuda left no statement about how the modern aesthetics of the 1930s influenced *Camp at Kisegawa*. It is likely that he would not have wanted to associate his paintings with "the modern," which was equated with the West, when the painting was specifically intended to be about Japan. However, there are reasons to believe that the work was stylistically influenced by international modernism and, certainly, that the trend of international modernism led the artist, even if indirectly, to turn to and draw on specific artworks from the pre-modern period.

There were Japanese-style painters in the late 1930s who pointed out the stylistic compatibility between the modern, geometric abstraction of machine aesthetics and certain pre-modern Japanese art. Among them was Fukuda Toyoshirō (1904–1970), a Japanese-style painter who called for the establishment of a "new Japanese-style painting" (*shin Nihon-ga*) that would transcend the boundary between Western-style and Japanese-style paintings. In a 1937 essay, he tries to bridge machine aesthetics and traditional Japanese art, stating,

> When I think of the spirit of Japanese-style painting, I think of planes and modern weapons. When we think of the plane as the most representative form of modern beauty, it strikes me that it is born out of highly developed technology but it also has the beauty of symmetry and simplicity in form. Superior beauty refers to formal simplification that removes unnecessary parts for the sake of pure art. I feel that we have to make use of commonality between the artist's sublime intuition and modern scientific principle in New Japanese-style Painting. The greatness of art by Sōtatsu, Kōrin, Sanraku, Eitoku lies in their expressions of strict simplification that pursue truth of nature . . . We must learn from classical art [*koten*].[44]

Fukuda here clearly highlights the commonality between machine aesthetics and traditional Japanese art, and specifically, the Rimpa and Kanō schools—the major art schools that flourished between the fifteenth and nineteenth centuries.

Fukuda was not the only painter who theorized an affinity between modern art and traditional Japanese aesthetics. Specifically focusing on modern abstraction, Hasegawa Saburō (1906–1957), a Western-style painter, pointed out that there are examples of geometric abstraction to be found in everyday life in Japan: sheets of *origami* paper are perfectly square, *ayatori* (string figures) form geometric shapes, and hopscotch (*ishikeri*) requires the drawing of circles.[45] Hasegawa reminds the reader that European modernism was in part inspired by Japanese culture: Le Corbusier's city plan draws on Heiankyō (the Heian capital in Kyoto), built in the eighth century, which was a square city laid out in a grid fashion; Bruno Taut (1880–1938),

a Bauhaus artist who fled from the Nazis and stayed in Japan between 1933 and 1936, also praised Japanese shrines, tea houses, and gardens from the perspective of modern architectural principles.[46]

Bruno Taut was in fact the most important figure in 1930s Japan to air the idea that Japanese traditional aesthetics were already and perfectly "modern." In his book *The Rediscovery of Japanese Beauty,* which was published posthumously, he writes about how he found the Bauhaus aesthetic principle in Japanese pre-modern architecture, especially at Ise Shrine and Katsura Rikyū, arguing that Japanese traditional art is not incompatible with such concepts as rationality, simplicity, and functionality.[47] He observes that "the taste for purity and simplicity in Japanese culture is exactly the same as our modern concepts . . . Japan has beautiful techniques and beautiful materials such as bamboo, metal, wood, lacquer, textile, pottery . . . It is not so difficult to create things both modern as well as quintessentially Japanese."[48] Taut's understanding of a certain tradition of Japanese art as "modern" fundamentally changed the way in which Japanese artists understood their country's traditional works.[49] In the preceding periods, especially during the Meiji period, "Western-style" meant European academic style, which was thought to be in conflict with "things Japanese"; in contrast, modernism—the formal characteristics of which were largely inspired by non-Western art, including Japanese art—could be brought into dialogue with a certain product of Japanese aesthetics and contribute to the creation of an essentially "Japanese" art. For Japanese artists, post-expressionist modernism offered a style that had already been recognized internationally and looked perfectly "Japanese."

The visual style that conflates the aesthetics of both international modernism and Japanese traditional art was prominently manifested in wartime architecture and best exemplified by Tange Kenzō's daring 1942 building design (Figure 8). Tange submitted his design to the competition for a project to commemorate the founding of the Great East Asia Co-Prosperity Sphere and won the first prize, but the structure was never realized because of the worsening of the war. For this competition, Tange designed a concrete shrine to be built at the bottom of Mount Fuji: it was closely

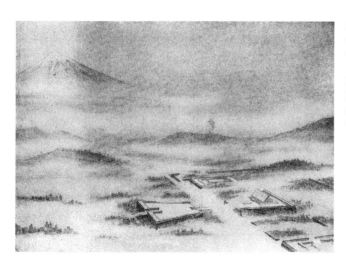

FIGURE 8. Tange Kenzō, Greater East Asia Co-Prosperity Sphere Memorial Hall (Daitōa kensetsu chūrei shin'iki keikaku), 1942. *Kenchiku zasshi* 56.693 (December 1942).

based on Ise Shrine, the most important shrine in Japan, which houses the spirit of Amaterasu, the Sun Goddess. The design, with two identical square buildings on either side of a main trapezoidal building, certainly recalls the Ise Shrine, which also has two identical structures side by side for the purpose of *shikinen sengu* (transferring the god-body to a new shrine).[50] Like Ise Shrine, Tange's design is simple, unpretentious, and primal.

It is clear, however, that Tange's design also draws on Le Corbusier's rationalism, which strips off unnecessary ornamentation and emphasizes straight lines and symmetry. Le Corbusier (1887–1965), a Swiss-born French architect, advocated mass production and the standardization of housing. Famously proclaiming that "a house is a machine for living in," Le Corbusier actively incorporated into his working principles the capitalist American models of Scientific Management such as Fordism and Taylorism, which emphasized industrial efficiency and mass production and aimed at greater productivity through the use of assembly lines and standardization.[51] Japanese architect Maekawa Kunio (1905–1986), Tange's mentor, had lived in France between 1928 and 1930 and been apprenticed to Le Corbusier, later producing Le Corbusier–like buildings in Japan.[52] Maekawa's designs show the profound influence of Le Corbusier in Japan. They consist of rectangular buildings that have a central axis and that emphasize centrality and formal symmetry, just like Tange's 1942 blueprint.[53]

The "Japanization" of modern aesthetics, which Tange's 1942 design exemplifies, is precisely what we see in Yasuda's *The Arrival of Yoshitsune/Camp at Kisegawa*. Tange's "return" to Ise Shrine was clearly prompted by his interest in Le Corbusier's rationalism and the idea that Japanese traditional architecture anticipates modern aesthetics. Yasuda's attention to *yamato-e* painting was also likely motivated by the trend of "machine-ist" paintings, which do indeed share stylistic characteristics with certain works of pre-modern Japanese art. The difference between them, however, is that while we have evidence that Tange admired and was knowledgeable about Le Corbusier's rationalism and Bauhaus through his mentor Maekawa Kunio, Yasuda's institutional affiliation and personal connection with machine aesthetics are more remote.

But why modern aesthetics? Does the modern style help the paintings to better communicate their point? Gennifer Weisenfeld's article "Publicity and Propaganda in 1930s Japan: Modernism as Method" has answered this precise question in connection with a different medium.[54] Examining Japanese photographs produced from the early 1930s to the early 1940s, Weisenfeld observes that despite our general assumption that modern aesthetics used in the context of avant-garde art movements such as Constructivism do not appeal to popular audiences, modernist photographers in fact worked in the commercial sphere, employing the same techniques to sell products—such as Morinaga chocolate and Kikkoman soy sauce—to the masses. The avant-garde, modernist visual language appealed to consumers' desire for something new, exotic, and visually stunning. Weisenfeld also demonstrates that it was these photographers with modern visual techniques who were later hired by the state to publicize Japan on the international stage. It was the power of "persuasion and the glorification of iconic symbols," according to Weisenfeld, that

made the dynamic visual language of modernism suitable for both commercial advertisement *and* state propaganda.[55] Political ideals were "sold" to consumers using the same visual language with which commercial products had previously been literally sold.[56] In light of Weisenfeld's research, one could argue that the visual impact of modern aesthetics that Yasuda employs in *Camp at Kisegawa* makes the painting effective in attracting modern viewers' interest and selling its political message.

Examination of the wartime state's appropriation of modern aesthetics clearly reveals that style and meaning do not have a one-to-one, fixed relationship: artistic modernism, which initially presented a challenge to authority and the establishment, could be appropriated by reactionary politics, which promulgates a completely opposite ideology. This finding ultimately undermines our assumption that modern aesthetics are always associated with progressive politics.

Indeed, the appropriation of modern aesthetics by the Japanese state resembles the way in which modernism was co-opted by fascist European nations.[57] The key artistic movement in this context was the European New Classicism of the 1920s and 1930s. New Classicism was a movement that was started in the 1920s by a number of European artists, including Pablo Picasso, who had produced radically experimental works in earlier decades. Departing from previous avant-garde practices that explored the new and the original, New Classicism displayed an interest in classical subjects, most prominently Greco-Roman antiquity, and expressed the artists' desire to "return to order" after the chaos of the Great War. Led by prominent modernists, New Classicism was a peculiar union of modernism and classicism. Writing about George de Chirico's New Classicist phase, art historian Emily Braun notes that

> elements of antiquity and modern industry meet in an illogical world without spatial or temporal coherence . . . The breaks in continuity and a sense of suspended time reveal the irremediable gap between the present and the past . . . Even his images of gladiators, nudes, horses on the beach of the following decade, painted at the height of Fascism, parody traditional values . . . ; their flaccid forms and garish colours resolutely refuse to bear the weight of any invested meaning.[58]

This style, however, as Braun indicates, was ultimately accepted and mobilized by the fascist regime in the 1930s; the 2011 Guggenheim exhibition *Chaos and Classicism: Art in France, Italy, and Germany, 1918–1936,* which examined the transformation of New Classicism from avant-garde classicism to fascist propaganda, made the same point.[59] Like German and Italian paintings of the period, wartime Japanese-style paintings like Yasuda's could be considered as modern art that had gone "classical." In fact, because his works with historical themes from the early 1940s were so imbued with modern aesthetics, they, along with works by other Japan Art Institute artists Maeda Seison and Kobayashi Kokei, are considered examples of Japanese New Classicism (*Shin kotenshugi*), the Japanese counterpart of European New Classicism.[60]

◆ ◆ ◆

Although Yasuda never spoke or wrote about politics to the extent that Taikan did, his *Camp at Kisegawa,* which was officially approved by the state and displayed at a state-sanctioned exhibition, mirrors and reinforces the ideology of Japanese fascism by alluding to the country's unique tradition of having a stratified community, *bushido,* and medieval paintings with indigenous characteristics. Significantly, the painting is also indebted to modern aesthetics, and asks us to consider "fascist modernism"—the appropriation of modern aesthetics by fascism. Fascist modernism invites us to reevaluate and challenge the fundamental assumption about modernism: that modernism challenges the establishment both stylistically and politically. It also asks us to rethink the generally accepted narrative of modernism in twentieth-century Japan, which is that modernism *disappeared* during the war. Rather, as we have seen, modernism—or more specifically, modern aesthetics—*transformed* and continued to exist under the fabric of different politics.

4

UEMURA SHŌEN'S *BIJIN-GA*

This chapter looks at paintings of beautiful women, or *bijin-ga*, produced by female Japanese-style painter Uemura Shōen (1875–1949), one of only a few successful female artists in modern Japan.[1] During the war, Shōen's work resonated with the ideology of Japanese fascism, which aspired, among other things, to articulate Japanese uniqueness. Specifically, Shōen's art expressed Japan's cultural authenticity through representations of women. The paintings were praised, for example, for capturing the "traditional aesthetics of the Japanese race" and as representations of archetypal "Japanese women" (*Nihon fujo*). It was even said that they contributed to wartime moral education in the same way as battle paintings.[2] Indeed, the artist herself described her paintings as portrayals of *yamato nadeshiko,* women who have a truly "Japanese" spirit, and as examples of *saikan hōkoku* (serving the nation through art).[3] This chapter will examine the link between her art and Japanese fascism through four of her works: *Sudden Blast* (Kaze, 1939), *Dance Performed in a Noh Play* (Jo no mai, 1936), *Late Autumn* (Banshū, 1943), and *Lady Kusunoki* (Nankō fujin, 1944).

By focusing on a female painter, this chapter also engages with the issue of gender and the role of women during the war. For several decades after the end of the war, it was believed that women and children in wartime Japan had chiefly been victims whose lives were profoundly affected by the decisions of male state authorities. As recent self-critical feminist scholarship observes, however, many women, including female artists, proactively collaborated with the wartime state. Even the recent

scholarship, however, has overlooked Shōen because, I suggest, her paintings do not depict explicitly militarist icons, such as soldiers, battles, or contemporary women engaged in militarist activities.

UEMURA SHŌEN

Uemura Shōen was born Uemura Tsune in Kyoto, which had long served as the imperial capital. Shōen studied with three teachers who were associated with the Maruyama-Shijō style, the local Kyoto style of realism developed in the Edo period. At the age of twelve, she entered the Kyoto Prefectural School of Painting, and there studied under Suzuki Shōnen (1849–1918), with whom she later had a son whom she raised as a single mother. After working with Shōnen, Shōen became a student of Kōno Bairei (1844–1895) in order to study figurative works; on Bairei's death, his student Takeuchi Seihō (1864–1942) took over the position at Bairei's private school. Seihō was the best-known of Shōen's three teachers, and was instrumental in introducing new, modernist artistic trends to the Kyoto circle of Japanese-style painters after he had returned from his travels and study in Europe in 1900.

Shōen became successful early in her career, both domestically and internationally. In 1890, when she was only fifteen, her *Beauties of Four Seasons* (Shiki bijin) received the first prize at the third annual Domestic Industrial Exposition (*Naikoku kangyō hakurankai*); a different version was purchased by Prince Arthur of England. Shōen regularly received prizes at exhibitions such as the Japan Art Association Exhibition (*Nihon bijutsu kyōkai ten*) and the Exhibition of New and Old Art (*Shinko bijutsuhin ten*), in addition to Domestic Industrial Expositions. Her works were also exhibited on the international stage, at the Chicago and St. Louis World's Fairs in 1893 and 1904, respectively. The 1910s and 1920s, when European modernism was introduced to the circle of Japanese-style painters through such artists as Tsuchida Bakusen (1887–1936)—another of Takeuchi Seihō's students—were a challenging time for Shōen, whose works were not experimental but rather drew heavily on traditional Japanese art. She executed a number of paintings whose themes were taken from *noh* plays or music, to add dramatic, emotional dimensions, but she submitted few paintings to public exhibitions.[4]

During the 1930s and early 1940s, Shōen was remarkably active and became a nationally acclaimed artist. Between 1935 and 1945, she completed at least ninety-five paintings; in 1941, she became a member of the Japan Art Academy (*Teikoku bijutsu in*), Japan's most prestigious art institution, run by the Ministry of Education. To celebrate this achievement, the art magazines *Bi no kuni* and *Kokuga* published lengthy special issues on the artist in 1941 and 1942, respectively, something exceptionally rare for a female artist around this time.[5] She was also frequently involved in state-sanctioned events, submitting at least four paintings to donation exhibitions (*kennō-ga ten*) such as the Military Donation Exhibition (*Rikugun kennō-ga ten*) in 1941 and the Japanese Artist Patriotic Society Donation Exhibition for Battle Planes (*Nihon gaka hōkokukai gunyōki kennō-ga ten*) in 1942, the proceeds of which were given to the military.[6] In 1941, at the age of sixty-six, she made her first trip abroad,

to China, visiting Shanghai and Hangzhou. She was invited by China's Central Railroad (*Kachū tetsudō*) to present a painting as a gift to Wang Jingwei, the leader of Japan's puppet government in Nanjing. The work in question was praised as exemplifying her passionate patriotism.[7] Shōen's success during this period led her to become the first female recipient of the most prestigious national award, the Order of Culture (*Bunka kunshō*), which she received from Emperor Hirohito in 1948, three years after the end of the war.

DANCE PERFORMED IN A NOH PLAY (1936)

In her works of the late 1930s and early 1940s, Shōen strived to articulate Japan's cultural uniqueness in various ways. Her 1936 painting *Dance Performed in Noh Play* references *noh* theater and the aesthetic of *yūgen,* at a time when they were fervently theorized as uniquely "Japanese" by intellectuals, cultural authorities, and the artist herself in the context of Japanese fascism. *Dance Performed in a Noh Play* (*Jo no mai*) is one of the most representative of Shōen's works. It was executed in 1936 and purchased by the Ministry of Education that same year (see Plate 14). The painting alludes to Japanese tradition through the subject matter of *noh* dance: Shōen portrays a young woman in a bright red kimono standing upright and extending her right arm forward with a folding fan in it. The woman is engaged in a *shimai,* a *noh* dance performed off stage without lavish costumes.

Referring to this painting, Shōen stated, "I wanted to express a sense of inner strength lodged within a woman, which cannot be violated by anything or anyone."[8] The dancer's firm posture and determined gaze certainly convey a sense of inner strength. Portraying a dance movement performed specifically in a *noh* play, the painting also expresses the cultural sophistication found in the stylized gestures of Japan's traditional theater. Although Shōen was interested in the classics throughout her career, her fascination with *noh* reached its height with this painting.[9] The artist's other paintings, such as *Flower Basket* (*Hanagatami,* 1915) and *Flames* (*Honō,* 1918), were also inspired by *noh* plays, but *Dance Performed in a Noh Play* is markedly different: whereas the other paintings were inspired by particular plays and meant to explore expressive potential, here the artist tries to capture the *essence* of *noh* theater: the expression of concealment.

Noh drama, which consists of dance, song, and dialogue, has a long history and is characterized by an aesthetics of extreme stylization. It originated in the Kamakura period (1192–1933) and evolved out of *sarugaku* ("monkey/comic art"), which includes mime and skits, and *dengaku,* a blend of musical accompaniment, acrobatics, and dance.[10] *Noh* developed into its current form during the Muromachi period (1336–1573) with official patronage of Kan'ami (1333–1384) and his son Zeami Motokiyo or Kanze Motokiyo (1363?–1443?) by the Ashikaga clan. Indeed, many plays performed exclusively by male actors today were written by Zeami. *Noh* plays, which often allude to classical literature and historical events and have religious overtones of Shinto and Buddhism, are characterized by the strictly choreographed movements of actors, which are slow, highly stylized, and even ritualistic.

This other-worldly quality of the performance is also reinforced by the use of masks that represent generic types, such as old male, ghost, and young woman, as well as by music (singing and instrumental), which emphasizes silence and long gaps between sounds.[11]

As Zeami writes, central to the *noh* play are the aesthetics of restraint and an abstract notion of *yūgen*, which can roughly be translated into English as "elegance." In *A Mirror Held to the Flower* (*Kakyō*), written in 1424, Zeami claims that an actor's restraint, both physical and emotional, is essential. His rule is, "When you feel ten in your heart, express seven in your movement ... In general stage deportment, no matter how slight a bodily action is, if the motion is more restrained than the emotion behind it, the body will become the substance [*tai*] and the emotion its function [*yū*], thus moving the audience"[12] Zeami finds beauty in not fully explaining oneself and in concealing what is being felt. In addition, the aesthetic quality of *yūgen*, Zeami posits, is of the highest importance. He vaguely defines the concept by stating, "We might say that *yūgen* is best represented in the character of the nobility, whose deportment is of such a high quality and who receive affection and respect not given to others in society."[13] *Yūgen*, he says, is possessed by only a handful of talented actors, but all actors must strive to grasp this aesthetic.

Shōen was clearly fascinated by the distinct aesthetic world of *noh* theater. She writes, "The *noh* offers us a completely different world. Especially in contemporary noisy society, *noh* provides us a world of illusion ... Once we enter the world of the *noh*, we hear the graceful tones of music, the lofty, refined, sophisticated gestures that subtly move. As we hear the music and see the play, we are invited into the world of history that we have never seen or heard of. We are pulled into the intoxicating world and we cannot tell if it is a dream or reality."[14] At the same time, the artist understood *noh* as an embodiment of the nation's unique aesthetic sensibility that stood in stark contrast to Western cultural values. Shōen stated in 1937, "The Western ways of expression that explicitly show emotions could be one way of art, but subdued restrained emotions in the *noh* is conceptual and contains the ambience of the ultimate art. For this reason, I think the *noh* is truly the art of the nation [*shin no kokusui*]."[15] *Noh* had been understood as Japan's "national theater" since the Meiji period, but in the 1930s and early 1940s, *noh* received particular attention from artists and intellectuals.[16]

One of the intellectuals who theorized *noh* plays as the most representative of Japanese aesthetics is Tanizaki Jun'ichirō (1886–1965), a popular novelist of the prewar era. In his novel *Naomi* (*Chijin no ai*), a serial first published in 1924 and the writer's most representative work, a Japanese man and a Caucasian-looking woman named Naomi end up in a sadomasochistic relationship. *Naomi* is about urban modern life and the transgression of traditional gender roles that characterized the period. It also reflects the trend of "*ero guro nansensu*" (erotic grotesque nonsense) during the Taishō period, and the main character, Naomi, is often cited as an ultimate, if excessive, example of a *moga* (modern girl). By the early 1930s, however, Tanizaki came to bemoan the consequences of Japan's modernization. In his essay *In Praise of Shadows* (*In'ei raisan*, 1933), Tanizaki analogizes Japan as a shadow, which, he argues, Western electric lights are trying to destroy. Referring to *noh*, Tanizaki writes, "The

darkness in which the *noh* is shrouded and the beauty that emerges from it make a distinct world of shadows which today can be seen only on the stage; but in the past it could not have been far removed from daily life . . . The *noh* sets before us the beauty of Japanese manhood at its finest."[17] He considered *noh* theater as distilling the specific aesthetics of the Japanese and the epitome of the virtue of shadow.[18]

The aesthetics of *noh* was further theorized by intellectuals in the late 1930s. Art critic Ōnishi Yoshinori (1888–1959) published the article "On yūgen" in the journal *Shisō* in 1938, which became the basis for his book *Yūgen and Aware* (*Yūgen to aware*), published in 1939 by Iwanami.[19] In the article, Ōnishi explores the history of *yūgen*, the aesthetic that he defined as uniquely Japanese. He claims that the concept was first related to *waka* poetry in the Heian period (794–1185), especially by Fujiwara no Shunzei (1114–1204), but its popularity declined in the Muromachi period, only to be revived by Zeami in the context of *noh* theater.[20] Fully literate in European philosophy, Ōnishi employed the Heideggerian notion of "Being" and argued that *yūgen* was a Japanese version of "the sublime" (*Erhabene*). He writes that, with true experience of the *yūgen* aesthetic, "nature and the human mind, or the object and the subject, merge into one and allow him a momentary glimpse of the Being in its totality; at that moment 'the individual' is absorbed into 'the whole.'"[21] Despite using the "universal" system of Western philosophical method, the aim of his intellectual exercise was to prove that *yūgen,* an authentic Japanese aesthetic and unique expression of the Japanese "race," was only accessible to the Japanese.[22] While listing several related words to describe the properties of the word *yūgen*—concealment (*inpei*), crepuscularity (*hakumei*), calm (*seijaku*), depth (*shin'en*), fullness (*jūjitsusō*), mystery (*shinpisei*), and indescribability (*fukasetsu*)—he asserts that the word is not translatable into other languages.

Hasegawa Nyozekan (1875–1969) also theorized *noh* as an essential aspect of Japanese culture. In the 1910s and 1920s, during the Taishō period, he was a leading leftist intellectual and advocate of democracy, but in the 1930s he radically changed his political orientation. During the war, he published numerous texts supporting the state and theorizing Japanese culture. In a 1943 essay titled "Noh and Japanese Life" (*Nōgaku to Nihonteki seikatsu*), he claimed that *noh* was a true embodiment of Japanese life. First of all, *noh* was enjoyed by both upper- and lower-class people, not just by aristocrats.[23] Furthermore, the extremely stylized, slow quality of *noh* reflected the unique temporality of Japanese life: the Japanese language, unlike Western ones or Chinese, is elongated by honorific forms and lacks logic. The speed of *noh,* he suggests, corresponds with the speed of Japanese life, much slower than the pace of modern life.[24] *Noh* theater, therefore, for Nyozekan, was a cultural product fundamentally rooted in Japanese life.

Although not necessarily discussed as *noh* aesthetics, related aesthetics such as the appreciation of restrained, concealed expressions, which Shōen clearly strived to articulate in her painting, were highly valued as "Japanese" (as opposed to "modern" or "Western") in other disciplines as well. In the field of literature, Kamei Katsuichirō (1907–1966), who was a member of the Japan Romantic School and also participated in the seminal 1942 "Overcoming Modernity" symposium, advocated subtle, quiet expressions in "Memorandum on the Contemporary Spirit"

(*Gendai seishin ni kansuru oboegaki*), published in *Bungakukai* in September 1942.[25] Severely criticizing the effect of Western culture on the "Japanese" way of representation, he asserts that modern, standardized literary expressions, exemplified by slogans, are trampling on the subtle, delicate expressions that had characterized the Japanese culture before the Meiji period.[26] Healthy language, he argues, depends on healthy pauses and silence, but people today are afraid of saying nothing.[27] Kamei's aesthetics clearly echo the principle of *noh* theorized by Zeami, that is, that there is beauty in not fully expressing one's emotions and thoughts. This exploration of "under-expression" can be also seen in the realm of film. As Darrell William Davis observes, some wartime propaganda *kokusaku* (national policy) films, such as *The 47 Ronin* (*Genroku chūshingura*), directed by the renowned filmmaker Mizoguchi Kenji (1898–1956), are extremely stylized, slow, and subtle.[28] Davis describes Mizoguchi's film as expressing "the primacy of perception over narrative," "poverty of drama," "a sacred, deliberative aura," and "a sense of restraint and decorum."[29]

Shōen's attempt to represent *noh* aesthetics through a female figure begs attention, since *noh* is performed exclusively by male actors. Tsukioka Kōgyo (1869–1927), a Meiji printmaker who produced numerous *noh*-related works, only depicted female *characters* played by—supposedly male—actors wearing masks.[30] Admittedly, Shōen does not portray *noh* as played in a theater: *shimai*, the kind of dance the woman performs in *Dance Performed in Noh Play*, was practiced off stage and could be performed by women. It is not unreasonable to suggest, however, that Shōen's association of Japanese aesthetics and women reflects the nationalist gender discourse that had been prevalent since the Meiji period. As I mentioned in Chapter Two, historian Partha Chatterjee has observed that modern, non-Western nations perceived a division between the "public," "outer," and "Western" and the "private," "inner," and "traditional." Furthermore, this division, as Chatterjee points out, was *gendered*.[31] Men were supposed to take care of the "modern," the "Western," and the public sphere, while women were expected to be responsible for the "traditional," the "pre-modern," and the domestic sphere.[32] Although Chatterjee's study focuses on India, his observation resonates with Japan's case as well. The same gender dichotomy was symbolically embodied by the "sacred pictures of the emperor and the empress" (*goshin'ei*), photographed by Uchida Kuichi and made publicly available in 1872. In the official photograph, the emperor wears Western clothes but the empress wears a kimono. Given the aforementioned association between women and tradition, it is not surprising that women were the signifiers of national tradition of *noh* in Shōen's paintings.

SUDDEN BLAST (1939)

In the pursuit of authentic Japanese culture, Shōen alluded not only to *noh* but also to Edo-period *ukiyo-e*. This is exemplified by *Sudden Blast* (*Kaze*), produced in 1939 and exhibited at the private Sansankai exhibition (see Plate 15). The genre of *bijin-ga* in Japan can be traced back as far as the Nara period (710–784) but was primarily popularized in *ukiyo-e* in the Edo period (1601–1868).[33] *Ukiyo-e* was a mainstay of

Edo-period commercial and popular visual culture that was primarily made by and for the merchant class, a class that was becoming increasingly wealthy. *Ukiyo-e* was central to two main entertainment industries in the cities of the time—pleasure quarters and kabuki theater—and many prints portrayed popular courtesans and kabuki actors. As with *noh,* Shōen took inspiration from *bijin-ga* of Edo-period *ukiyo-e* throughout her career, but her Edo-inspired paintings of the 1930s should be contextualized within the specific cultural discourse surrounding the Edo period at that time.

In the early Meiji period, when the Japanese government began radical Westernization, the culture and customs of the Edo period were generally frowned upon. Edo-period pictorial art was repudiated as commercial, reproducible "non-art" by Ernest Fenollosa and Okakura Tenshin, who together founded Japanese-style *Nihon-ga* painting. Yet, as historian Carol Gluck argues, the Edo period gradually came to be viewed with nostalgia, starting in late Meiji. Gluck writes, "Edo-as-tradition offered a cultural space, timeless and unchanging, where the spirit abraded by the masses, machines, and modish modernism could 'return' to be refreshed and re-Japanized."[34] By the same token, in the early twentieth century, *ukiyo-e* came to be viewed positively, partly as a result of the prevailing nationalism. Shōen was largely inspired by eighteenth-century prints, most prominently those of Suzuki Harunobu (1724–1770) and Kitagawa Utamaro (1753–1806).[35] Not always, but in many cases, Shōen's model can be located in specific works of *ukiyo-e.* Her 1907 painting *Long Autumn Night,* which was submitted to the first state-sanctioned exhibition (Bunten) and shows two kimono-clad women spending a quiet night together, sitting directly on the floor, is most likely inspired by prints designed by Harunobu. Harunobu often produced indoor scenes of women reading, such as "Priest Jakuren" from *Three Evening Poems* (see Plates 16 and 17).

In the 1930s and early 1940s, the discourse of cultural nationalism centering on the Edo period developed even further. The most important intellectual who theorized the relationship between the uniqueness of the Japanese people and Edo-period culture is Kuki Shūzō (1888–1941). Kuki was a Japanese philosopher, trained in Europe, who held a post as professor at the University of Kyoto. He was especially literate in Heidegger's works. In his 1930 book *The Structure of "Iki,"* he investigated the linguistic and cultural properties of the Edo-period aesthetic concept of *iki,* which can be translated as "chic," carrying connotations of quiet elegance and subtlety.[36] In his somewhat convoluted theory about this single term, he explains how *iki* is related to coquetry (*bitai*), pride and honor (*ikiji*), and resignation (*akirame*), and compares and contrasts it with other "tastes," such as "sweet" (*amami*), "boorish" (*yabo*), and "quiet" (*jimi*).[37] Kuki argues that *iki,* which is associated with, for example, a woman right after bathing, an informal hairstyle, or the thin application of cosmetics, is a feature of *ukiyo-e* by Harunobu, Kiyonaga, and Utamaro.[38]

The goal of Kuki's book was not just to define the term, but also to claim the culturally specific nature of the aesthetic concept and, however indirectly, to point to the damage done by modernization. Employing, like Ōnishi, the Heideggerian notions of "Being" and "lived experience," Kuki ultimately asserts that the Japanese

lived experience is essentially different from that of Westerners, and that Japan and the West are inherently incompatible. He writes, "In summary, words that carry meaning similar to that of *iki* can be found in European languages, but none has the same semantic value of *iki*. It then follows that *iki* can be safely considered to be a distinct self-expression of an oriental culture, or, no, more precisely, a specific mode of being of the Yamato people [Japanese people]."[39] Leslie Pincus claims that, although Kuki wrote this in 1930, twelve years earlier than the landmark 1942 "Overcoming Modernity" symposium, it belongs to the same intellectual discourse of Japanese fascism in which the state and cultural authorities advocated the country's return to authentic Japanese tradition. Pincus writes, "Kuki turned to an indigenous tradition in order to reclaim cultural authenticity from the clutches of Enlightenment history. On this common ground, Kuki's project contributed to a larger enterprise aimed at replacing the rootlessness of modern urban-industrial society with an organic community grounded in national soil."[40]

Sudden Blast recalls Harunobu's "Autumn Wind" from *The Six Elegant Poets* (*Fūryū rokkasen*) series executed around 1768 (see Plate 18). Harunobu's print contains a poem by Bunya-no Yasuhide (active in the ninth century) about a melancholic feeling caused by autumn wind. Although the facial characteristics and body types of the women are somewhat different, their gestures and settings are almost identical. The women in both Shōen's and Harunobu's prints lean forward and look as if they are rushing, protecting their hair with their left hands, each slightly exposing a leg through their kimono, which are rolled up by the wind. The paintings of Shōen's that draw on specific works from Japanese art history were deemed "essentially Japanese" by the art critic Okazaki Yoshie, who also praised Yasuda Yukihiko's *yamato-e*-inspired *Camp at Kisegawa,* as discussed in the previous chapter.[41]

That Shōen sincerely admired and emulated Edo-period prints becomes clear when we compare her to other artists in the early twentieth century who referred to *ukiyo-e* only to mock it. There was a surge of interest in Edo-period art among Japanese-style painters in the 1910s and 1920s in Kyoto, where Shōen was also active. This discursive, renewed interest in *ukiyo-e* was prompted by the introduction of European modernist art that had been influenced by Japanese art, including *ukiyo-e*. In the context of modernism, which pursued individualized, creative, original artistic expression and challenged the establishment and authorities, some Japanese-style painters in Kyoto parodied idealized representations of beautiful women in Edo art by reworking the *bijin-ga* tradition. In what art historian John Szostak calls the discourse of "anti-bijin" (anti-beauty), artists painted women who did not conventionally fall into the category of "beautiful women"—lower-class, ugly, and mad-looking women—shocking viewers.[42] As Szostak writes, through the use of anti-bijin images, progressive Japanese-style painters evoked Japan's traditional past while simultaneously radically rejecting the artistic conservatism of their colleagues—most likely including Shōen.

One of the representative artists of the "anti-bijin" movement was Kajiwara Hisako (1896–1988), who, like Shōen, was a female Japanese-style painter in Kyoto. Having studied under Japanese-style painter Kikuchi Keigetsu (1879–1955), Kajiwara submitted works to the Association for the Creation of Japanese Painting

(*Kokuga sōsaku kyōkai*). This organization was established in 1918 by Tsuchida Bakusen, who was heavily influenced by European post-impressionist artists such as Van Gogh and Gauguin and became a pioneering artist of modernism in Japanese-style painting. Kajiwara's works, considered part of the Humanist School (*Jinseiha*), often broached the issue of hardship experienced by women.[43] For example, her *Sisters* (*Shimai*, ca. 1915) depicts siblings, a woman and an adolescent girl, both of them mentally disabled (Figure 9). With their deformed faces and shabby clothes, the sisters in Kajiwara's painting stand in stark contrast to the idealized, culturally sophisticated, doll-like women in fashionable kimono portrayed in Shōen's works. Indeed, as if to refer to the art Shōen was producing, Kajiwara stated, "I had no intention of painting a pretty woman in the traditional style, which was precisely what I wanted to break away from."[44]

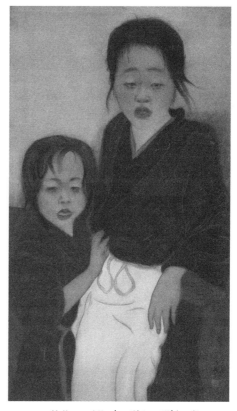

FIGURE 9. Kajiwara Hisako, *Sisters* (*Shimai*), ca. 1916. Kyoto Municipal Museum of Art.

The most extreme examples of "anti-bijin" are perhaps the works by Japanese-style painter Kainoshō Tadaoto (1894–1978), who also submitted works, as a guest, to the exhibition organized by Bakusen's Association for the Creation of Japanese Painting. His *Nude* (*Rafu*), painted around 1921, depicts a very full-figured woman whose body does not fit the frame of the canvas (Figure 10). The kind of female body he depicts in this painting—almost grotesquely plump and fleshy, with a hint of sensuality resulting from the glittering surface of her skin and a hand on her nipple—had never been used as a subject in the history of Japanese-style painting or Japanese art at large. Kainoshō's painting, which is brutally realistic and honest, must have appeared shocking to the viewers of his time. Ultimately, his work was removed even from the "modernist" exhibition of the Association for the Creation of Japanese Painting, when he submitted *Woman with Balloon* (*Onna to fūsen*), a painting of a semi-nude woman that was described by Bakusen as a "filthy picture" (*kitanai e*).[45] Shōen's paintings could not have been more different from those of Kajiwara and Kainoshō. Unlike the "anti-bijin" painters, Shōen's reference to the Edo artistic heritage was her attempt to reclaim, not challenge, the cultural legacy of of *bijin-ga*.

Shōen's painting is not a simple copy of *ukiyo-e,* however. Her paintings were inflected with cultural discourse on gender representations in the 1930s and early 1940s. The important difference between Edo-period *ukiyo-e* and Shōen's

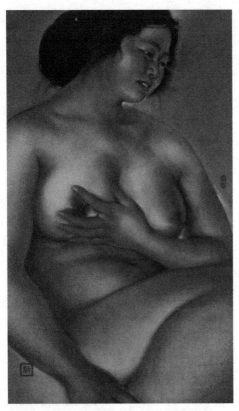

FIGURE 10. Kainoshō Tadaoto, *Nude* (*Rafu*), ca. 1921. The National Museum of Modern Art, Kyoto.

paintings is that the latter "desexualize" female figures. The sexualization and eroticization of women was an important aspect of the *bijin-ga* genre in *ukiyo-e,* which was closely connected to the culture of pleasure quarters. Edo-period *bijin-ga* most often represented courtesans (and in some cases advertised specific ones) as the object of sexual desire to be visually (and in some cases physically) enjoyed by men.[46] In contrast, Shōen's paintings conspicuously remove erotic connotations from the female figures. In *Sudden Blast,* for example, the figure exposes her leg only slightly, in contrast to Harunobu's work, which shows a significant amount of the figure's bare leg and evokes a greater sense of voyeurism and eroticism.

Feminist art historian Wakakuwa Midori understands Shōen's desexualization of female figures as evidence of a feminist impulse.[47] I would suggest, however, that it is more appropriate to examine the paintings in terms of how the artist coded women to signify "traditional Japan," as opposed to the "modern West," than to understand the works in terms of a (difficult to discern) feminist agenda. In other words, Shōen's paintings reclaim "Japanese" women, who were, in the context of the 1930s and early 1940s, understood to be different from Westernized and more explicitly sexual modern girls, who had become cultural icons during the Taishō period. Miriam Silverberg bluntly calls *moga* "sex workers," as they sold sexual fantasies to male customers (without necessarily sleeping with them) while working at cafés, a typical social venue for bachelors in the early twentieth century.[48] Kendall Brown also writes that *moga* displayed "the promise or threat of cultural and sexual liberation and the possibility of militant social action."[49] One could therefore argue that, however untruthful to *ukiyo-e,* Shōen desexualized women to make them "more Japanese," with the understanding that, in contrast to *moga,* Japanese women would not show explicit signs of sexuality.

As her 1937 publication attests, Shōen was disgusted by the Western appearance of modern girls, who, she noted, imitated American Hollywood actresses by drawing lines on their plucked eyebrows and having their hair permed. For the artist, permed hair was a "trace of electricity" that looked just like a "sparrow's nest."[50]

She even went so far as to say that she would question the nationality of those women, and bemoaned that she could not paint them because they were not *Yamato nadeshiko* ("Japanese women"). Modern girls, Shōen claims, should pay more respect to Japan's traditional customs: in the past, she points out, Japanese women shaved their eyebrows when they married and had a child. Indeed, the title of her 1937 book *The Blue Eyebrows* refers to the shaven eyebrows of married women. While the state never specifically encouraged women to follow the customs of the Edo period, the strong resonance between Shōen's 1937 statements and state policies around that time should not be overlooked. Westernized appearances were later banned, as hostility toward the Allied nations grew. In 1939, perms were banned, along with other "Western" imports such as dance halls, jazz, baseball, and English loan words.[51]

Shōen's paintings are also different from *ukiyo-e* at the stylistic level. Although Shōen's paintings are celebrated for being particularly "Japanese," *Sudden Blast*, like Yasuda's *Camp at Kisegawa*, was inspired by modern aesthetics. As Michiyo Morioka writes, "Pursuing her traditional ideal, she achieved a surprisingly *modern* visual statement during the last decade of her life. In such highly acclaimed works as *Late Autumn*, Shōen demonstrates her sensitivity to formal design."[52] Shōen's stylistic turn to modern aesthetics comes to the fore through comparison between *A Long Autumn Night* (1907) and *Sudden Blast* (1939). The kimono of the two women in *A Long Autumn Night* are meticulously detailed and delicately textured, but those of the women in *Sudden Blast* are plain and bold. More obvious differences can be seen in the use of color. Shōen mostly uses brownish, subdued colors in *A Long Autumn Night*, whereas she applies thick paint in vivid, strong red and blue in *Sudden Blast*. It is the saturated nature of the colors, the minimized, bold composition, and the visual impact that characterize *Sudden Blast*. The difference between *A Long Autumn Night* and *Sudden Blast* recalls the comparison between Yasuda Yukihiko's *Parting at Yoshino* and *Camp at Kisegawa*, in which the latter was, as I argue, influenced by the machinist aesthetics of international modernism. As with Yasuda's *Camp at Kisegawa*, then, Shōen's *Sudden Blast* also exemplifies fascist appropriation of modern aesthetics.

LATE AUTUMN (1943) AND LADY KUSUNOKI (1944)

Toward the end of the war, Shōen produced prescriptive paintings about the social roles of women on the home front. Using the classicizing aesthetic language she had established in the late 1930s, she painted the kind of women idealized during the war. *Late Autumn* (*Banshū*), which she executed in 1943 and submitted to a local exhibition in Kyoto, shows a contemporary woman engaging in housework (see Plate 19). The woman wears a kimono, has her hair arranged with accessories, and is tending to a paper screen: it is a subject that one might easily find in *ukiyo-e* or illustrated books from the Edo period. However, there is reason to think that this painting relates to women's roles during the war. In order to elucidate the link between this painting of a traditional-looking woman and wartime politics, we must first examine what women were expected to do and be like during the war.

In Japan during the Second World War, men's and women's gender roles were clearly demarcated. While men fought on the battle front (*zensen*), women were expected to protect the "homefront" (*jyūgo*). Battle front and home front were conceptualized as complementary, and whether they were at home or in battle, citizens were supposed to make their best effort toward the war. Specifically, women belonged to local and community organizations, such as a Neighborhood Associations (*tonarigumi*), which were closely associated with large women's organizations such as the National Defense Women's Association (*Kokubō fujinkai*) and the Greater Japan Women's Association (*Dai Nihon fujinkai*).[53] Members of these organizations engaged in such activities as organizing parties to celebrate drafted soldiers and sending comfort bags (*imonbukuro*) to the battle front to raise their spirits, and participated in domestic campaigns about hygiene.

One of the domestic campaigns for which women were extensively mobilized was the Frugality Campaign. As the state needed all possible resources to try to win the war, they asked citizens to give up their previous capitalist lifestyles, in which individuals had freely pursued their needs and desires. The National Spiritual Mobilization Movement (*Kokumin seishin sōdōin undō*) of 1938 called for "spiritual" devotion to the war, with slogans like "Extravagance is the enemy" (*zeitaku wa tekida*), "Waste not, want not, until we win" (*hoshigarimasen katsumadewa*), and "You won't live an extravagant life if you are really Japanese" (*Nihonjinnara zeitaku wa dekinai hazuda*).[54] To help citizens avoid having to spend money on fashion, it was stipulated in 1940 that men wear a national civilian uniform (*kokumin fuku*) and women wear *monpe* (peasant trousers). By the end of the 1930s and the beginning of the 1940s, one could barely find luxury items in stores.[55] Foods such as sugar came to be rationed in 1940, and everyday goods were increasingly made with substitute materials: slate and charred wood was mixed into coal, while clothes were made of staple fiber (bark and wood pulp woven with small amounts of wool and cotton).[56] In this context, women were specifically asked to save and be frugal at home.

Shōen's *Late Autumn* refers, I would argue, to the important wartime theme of domestic frugality. The condition of material deprivation in this painting is quite clear compared to, for instance, *Dance Performed in Noh Play*, produced seven years earlier. While the dancing woman in the 1936 painting wears a red kimono beautifully decorated with cloud-like motifs, a carefully embroidered gold *obi* sash, and splendid hair accessories, the woman in *Late Autumn* is in a simple, humble garment. Her undecorated blue kimono is accentuated only by the minimally decorated striped green *obi*. She lacks the kind of glamor that the dancing woman displays, and the sense of modesty she conveys is reinforced by the activity that she engages in: repairing a *shōji* paper screen, rather than replacing it with a new one.

Shōen's attempt to convey the wartime state ideology through her art becomes more pronounced in her 1944 painting *Lady Kusunoki* (*Nankō fujin*) (see Plate 20). Only a year before the end of the war, the artist portrays Kusunoki Hisako (1304–1364), the wife of Kusunoki Masashige—briefly examined in the previous chapter—and a woman famous in Japanese history for having offered not only her husband but also her son to the emperor. The portrait was commissioned by Kyoto Reizan Gokoku Shrine, which enshrines the spirits of warriors who sacrificed their

lives for the country. The shrine also commissioned Yokoyama Taikan to paint a portrait of Masashige, which was meant to be paired with Shōen's *Lady Kusunoki*.

The Kusunoki story does not end when Masashige dies at Minatogawa, fighting for the emperor. Masashige's head was allegedly delivered to his wife Hisako and son Masatsura. Distraught, Masatsura attempted to commit suicide. Hisako's fame comes from how she scolds Masatsura, reminding him of his father's words; she is believed to have said, "As soon as you hear of His Majesty's whereabouts, you must pay stipends to our surviving kinsmen and retainers and, once having raised an army, vanquish the Emperor's enemies and restore him to the Throne."[57] Grown-up Masatsura later attempts to avenge his father's death, but, replicating what happened to his father, Masatsura also dies fighting against Ashikaga.

In her writing, Shōen calls Hisako a "great Japanese mother" (*idai naru Nihon no haha*) and states her intention to support the war through a portrait of this respectable woman, describing her production and donation of *Lady Kusunoki* as an act of *saikan hōkoku* (serving the nation by art).[58] Shōen's *Lady Kusunoki* therefore cannot be discussed separately from the ideological construct of the role of women with "unique Japanese qualities" during the war. Just as Yasuda's *Camp at Kisegawa* reinforced ideals advocated during the war by depicting medieval samurais who embodied them, Shōen's decision to paint Hisako in 1944 was highly political: the artist dealt with a historical figure whose life exemplified the virtues of the ideal Japanese woman during the war, using the past to justify the present.

Hisako was also considered a paragon for giving birth to sons. In the 1930s and early 1940s, in addition to protecting the "home front," women were supposed to bear children for the nation.[59] The private, reproductive aspects of women's lives—including marriage, pregnancy, labor, and child rearing—came under control of the state, which encouraged women to be prolific by giving prizes to mothers with many children and celebrating their achievements through Mother's Day (established in 1931).[60] In 1941, the government, through the Ministry of Welfare, announced the "Outline for Establishing a Population Growth Policy" (*Jinkō seisaku kakuritsu yōkō*), which aimed to increase the Japanese population, popularizing the slogan "Bear more children and multiply" (*umeyo fuyaseyo*).[61]

Hisako, importantly, also represented a mother who is willing to dedicate her son to the emperor, a highly regarded ideal in the 1930s and early 1940s. Women were expected to dedicate their sons as soldiers to the state, and sending one's son(s) to the war was considered "honorable." The subject was featured in numerous stories in various media—magazines, newspapers, films, literature, *kamishibai* ("paper drama"), and songs. There are countless examples of "beautiful stories" (*bidan*) about mothers to be found in magazines and newspapers, but more poignant, in many cases, are military songs such as *Mothers of a Military Nation* (*Gunkoku no haha*, 1937):

> At the train station this morning, I sent off my own son
> Cheerfully, without showing tears
> I ask him to die honorably at the front
> For the country, without reserve

Be scattered, young cherry blossom
Born as a boy
It is Japanese men's ambition to
Hold a sword for the Emperor

Don't expect to come home
I will be proud of you
When you return home
In a plain wooden box

I am a brave, strong Mother
I protect the home front of a military nation
Even as a woman
Traditional loyalty does not change
Traditional loyalty does not change.

The lyrics of this song present a strong mother as an ideal woman; she sends her son, without regret, to die at the front for the nation and emperor and is staunchly proud to fulfill her national responsibility. This model of woman and mother became the subject of wartime visual culture as well. An illustration by Western-style painter Kitō Nabesaburō (1899–1982), published in the women's magazine *Shufu no tomo* in 1941 and titled *Shiny Encounter,* shows a beautiful, caring mother with two children, an infant boy and slightly older girl, coming to Yasukuni Shrine to pay a visit to the spirit of her husband who has died in the war: the mother is ready to offer her infant son as well to the nation, though he is still too young (see Plate 21).[62]

Whether *Late Autumn* or *Lady Kusunoki,* Shōen's paintings are different from images circulated in popular mass media, such as Kitō's *Shufu no tomo* image, as her art uses classicizing aesthetics and communicates wartime slogans such as "Extravagance is the enemy," "Waste not, want not, until we win," or "Bear more children and multiply," only subtly. The artist sublimates these political ideals with artistic tastefulness and sophistication, placing the contemporary woman in a classical context. Indeed, that is exactly what the artist aimed to do, as her statement from 1932 makes clear: "I have a desire to paint contemporary life only when I am ready . . . but what would it be like if I were to paint it? . . . I do not think I would render the modern as modern. Rather, I would steep the modern in the aura of the classics [*kotentekina kūki*]."[63] This classicization ostensibly functions to mask the ideological content of the painting.

FEMINIST (ART) HISTORY IN JAPAN

Despite the close relationship between Shōen and the state, her life and works have not, on the whole, been critically examined. This is largely because Shōen was a woman.[64] Postwar feminist art historians treated her as one of the very rare examples of successful women artists in Japanese art history mostly as a way to empower and

celebrate her female peers. At the same time, the visual language the artist used, which makes the work historical, traditional, and classicizing, thereby obscuring its politics, has prevented critical investigations of her art. It is useful here to review the historiography of scholarship on Shōen's works and other female artists' wartime production and to explore how we might understand the role of women in Japanese fascism and war.

Accounts of Shōen most often hinge upon her life as a female artist. The most popular representation of Shōen is probably the fictionalized biography *Jo no mai* written by Miyao Tomiko in 1983.[65] Miyao's novel won the Yoshikawa Eiji Award, and the film adaptation won an award at the Asia-Pacific Film Festival in 1984. *Jo no mai* focuses on Shōen's relationship with her teacher Shōnen and the birth of her son, Shōkō, satisfying the curiosity of the general public. More specifically, the film poses the question of how Shōen's relationship with her teacher affected her work, that is, whether it enabled her to establish her career or, conversely, ruined it. Although *Jo no mai* exposes the patriarchal nature of the Japanese art community, it represents Shōen as an innocent girl who was unable to resist the sexual advances of her teacher.

This portrayal clearly does not do justice to Shōen's art, but it is a reading that echoes previous art historical interpretations of her work. In other words, the model for analysis of her works has remained largely biographical. This approach was further entrenched by postwar feminist art history. One critic who wrote about Shōen was Wakakuwa Midori (1935–2007), the pioneer of feminist art history in Japan. Closely following the first wave of feminist art history and Linda Nochlin's seminal 1971 essay "Why Have There Been No Great Women Artists?," Wakakuwa locates commonalities among three successful women artists of the Meiji period. For Wakakuwa, who argues that successful female artists are those who have "escaped from the strong paternalism of Japanese society," Shōen, who was herself raised by a single mother and who raised her own child by herself, presented a perfect model for this claim.[66] In Wakakuwa's words, Shōen's family "did not have a patriarch" and the artist was "the 'man' in the family."[67]

Wakakuwa's scholarship gives the impression that Shōen herself was a politically progressive, feminist artist. She considers the relationship between Shōen and Shōnen as embodying the unequal power relationship between the genders. "Shōen and her teacher may have loved each other, but their relationship was basically one in which the man dominates the woman. To contemporary eyes it may seem a form of sexual harassment . . . Without a father or a suitable guardian to support her financially, a woman artist had to accept a teacher or an art dealer as her patron."[68] Using the gender-power dichotomy as her underlying framework, Wakakuwa praises Shōen's work as a female artist's attempt to desexualize the artistic gaze on women, who are always the object of sexual interest when painted by men.[69] Wakakuwa's interpretations of the artist's works are thus consistently celebratory. She refers to *Late Autumn* as the first painting about "the reality of working women," calling it as "significant as the works of Millet, who painted working women instead of bourgeois women."[70] Significantly, Wakakuwa is not the only female art historian who interprets Shōen's wartime works favorably. Shiokawa Kyōko goes so far as to describe

Late Autumn as a piece of "anti-war" (*hansen-teki*) art. Shiokawa writes, "What the artist presents in the painting is praise of everyday life. To cherish everyday life is to cherish life . . . [T]he women in Shōen's paintings loathe war and look for a bright future. It was exactly the opposite of what militarists wanted."[71]

Art historian Michiyo Morioka's scholarship is probably the most critical among studies of the artist. Morioka challenged the scholarship on Shōen by previous art historians in her 1990 PhD dissertation, "Changing Images of Women: Taishō Period Paintings by Uemura Shōen (1875–1949), Itō Shōha (1877–1968), and Kajiwara Hisako (1896–1988)." Analyzing various statements made by the artist, Morioka contends that Shōen actually supported the patriarchal status quo. Shōen's image of the ideal woman is resonant with the Confucian text *Onna daigaku*, which places women in the domestic sphere as subordinate to their "master" (husband). Morioka is unequivocal: "Thoroughly traditional-minded, Shōen embraced the *Onna daigaku* without ever recognizing its oppressive and discriminatory definition of women's role."[72] Thus, differing from other art historians, Morioka claims that Shōen was not a feminist who fought for women's rights or freedom from patriarchy. Although Morioka's scholarship maintains a tone critical of Shōen, she does not—curiously—investigate the artist's wartime works despite noting that "the last two decades of Shōen's life—the 1930s and 1940s—witnessed the maturity of her art."[73]

Wakakuwa's uncritical reading of Shōen is also somewhat surprising, as she has in fact examined the wartime role and representations of women generally quite critically. Her 2000 book, *Sensō ga tsukuru josei zō* (Female Imagery that War Creates) specifically scrutinizes women's involvement in war and visual construction of ideal women during the war (see Plate 21).[74] Why, in this book, did Wakakuwa overlook Shōen, one of the most active wartime female artists? The answer is related to the fact that Shōen's works do not exhibit palpably militaristic iconographies. Wakakuwa's approach also characterizes recent scholarship on wartime female artists, such as Kira Tomoko's 2013 book *War and Women Artists: Another History of Modern "Art"* (*Sensō to josei gaka: mōhitotsu no kindai "bijutsu"*).[75]

Kira's book focuses on a group of female artists called the Women Artist Patriotic Group (*Joryū bijutsuka hōkōtai*), which was organized under the supervision of the Military Information Bureau (*Rikugun jōhōkyoku*) in February 1943. The group included approximately fifty members and was led by Hasegawa Haruko, the daughter of the prewar feminist author Hasegawa Shigure (1879–1941). The Women Artist Patriotic Group included major women artists, such as Fujikawa Eiko (1900–1983), Nakada Kikuyo (1902–1995), and Katsura Yukiko (1913–1991, known as Katsura Yuki in the postwar period).[76] One of the group's major achievements examined by Kira is *All Women Work for the Imperial Nation in the Great East Asia War* (*Daitōasen kōkoku fujo mina hataraku no zu*), an artwork completed in 1944 and displayed at the Army Art Exhibition (*Rikugun bijutsu ten*) (see Plate 22). Consisting of two panels (one representing spring and summer, the other, fall and winter), the work was conceived as a "record painting" (*kirokuga*) that memorializes the "home front" (*jūgo*), thereby complementing the War Campaign Record Paintings that Western-style male painters produced.[77] Katsura developed the idea of putting together various images of women from different media (such as newspapers,

magazines, and graphic magazines). The result was a "collage" of working women: women practicing military drills, woman engaging in farming, women at a factory, women delivering mail, women in the mining industry, women doing housework, women working at a daycare, women in the fishing industry, and so on. The panel that shows the fall and winter seasons is now stored at the Yasukuni Shrine.[78]

Whether their paintings are explicitly militaristic or not, it is important to consider not only the role of women artists during the war but also that of women more broadly. Scholars now understand that a large number of women, including prewar feminists, were actively involved in promoting the state agenda. As historian Sheldon Garon explains, when women's independence became impossible in the 1930s, they found an alternative way to participate in the public sphere by taking part in wartime politics. Many women, even rural and lower-class ones, participated in women's patriotic organizations, and, as Garon states, "[their] appeal was unquestionably related to the growing aspirations of ordinary women to undertake public roles as the nation's mothers and housewives."[79] Kanō Mikiyo's edited volume *Women on the Home Front* (1995) and Okano Yukie's *War Responsibility of Women* (2004) demonstrate that leading prewar feminist writers such as Ichikawa Fusae (1893–1981), Hiratsuka Raichō (1886–1971), and Hasegawa Shigure (1928–1929), who had previously advocated women's rights—rights to be free from the patriarchal family structure, to marry a partner based on a romantic relationship, to participate in politics—headed various women's organizations sanctioned by the wartime state and actively supported the war.[80]

But precisely how do we make sense of the wartime collaboration between the state and women, who were in general marginalized, underrepresented, and politically oppressed? Historian T. Fujitani offers a useful theoretical framework to answer this question, although the focus of his study is another group of marginalized subjects, Koreans. In his 2011 book, *Race for Empire: Koreans as Japanese and Japanese as Americans during World War II,* Fujitani explains that the previously excluded "secondary citizen" gradually came to be considered as "Japanese" under the total war regime, while differences between indigenous Japanese and ethnic Koreans were nonetheless maintained. With total mobilization, the Japanese wartime state moved away from the use of violence and brutality that characterized its colonialism in Korea prior to the Independence Movement of 1919, which Fujitani calls "vulgar racism," and turned instead to a rhetoric of inclusion and assimilation, which he calls "polite racism." Racism against Koreans existed in Japan throughout the first half of the twentieth century, but its form changed significantly over time. Koreans came to have an unprecedented degree of political say and range of opportunities in the 1930s and early 1940s, which, Fujitani argues, forces us to reconsider the degree of Korean political agency in Japan's wartime politics. For instance, a number of Koreans volunteered to serve the Japanese state for the war effort, and, as Fujitani writes, "the weak term 'collaborator' is insufficient to characterize figures so actively involved in figuring the contours of Japanese national/colonial discourse."[81]

Fujitani's model of analysis helps us to understand the inclusive nature of Japan's total war state and seems applicable to the issue of gender. Women were previously excluded from the public domain but they came to be assimilated into the

state structure, which allowed them to participate in public discourse and enjoy political involvement and agency more than in the previous decades. Women and wartime state authorities came to share a common goal in the 1930s and developed a symbiotic relationship: the government gave women an unprecedented degree of social responsibility; in return, women were publicly recognized for their achievements for the first time in their history.

◆ ◆ ◆

This chapter has examined the resonance between Uemura Shōen's paintings and the cultural and intellectual discourses and state policies of the 1930s and early 1940s. *Dance Performed in a Noh Play* strives to articulate the aesthetic of *yūgen*, which was heavily theorized by intellectuals as a manifestation of Japan's unique sensibility. With *Sudden Blast*, we see the artist's interest in emulating Edo-period prints and reclaiming the "traditional" Japanese women yet to be exposed to modernity and Westernization. While Shōen's paintings are clearly modeled on examples of pre-modern Japanese art, as with Yasuda Yukihiko's *Camp at Kisegawa*, I argued that her art was also influenced, if indirectly, by modern aesthetics introduced and celebrated in the first two decades of the twentieth century. Shōen's early 1940s paintings *Late Autumn* and *Lady Kusunoki*, which use classicizing aesthetics, portray women considered ideal during the war and indicate the artist's more active engagement with state politics. Hidden behind Shōen's tasteful use of Japan's pictorial tradition are strong political ideals advocated by the state: frugality at home and dedication of sons to the country. Her active support of the war through her artistic expressions has not hitherto received substantial attention from scholars who examine wartime art, but a case study on her art gives us an opportunity to probe the question of gender and Japanese fascism.

5

FUJITA TSUGUHARU
AND *EVENTS IN AKITA* (1937)

This chapter looks at *Events in Akita*, a large mural painting executed by Western-style painter Fujita Tsuguharu (1868–1968) in 1937 (see Plate 23). Carefully contextualizing his painting within the broader wartime discourse of "finding Japan" in the snow regions (*yukiguni*) of Tohoku, I will show that Fujita participated in the cultural production of Japanese fascism that sought to reclaim the country's cultural authenticity by directing attention to the country's periphery.[1]

I began this book by discussing the discrepancy in postwar scholarship between explicitly militaristic battle paintings, which were most often produced by Western-style painters, and the "rest"—non-battle paintings executed by Japanese-style painters. While one can draw a loose association between battle paintings and Western-style paintings on the one hand, and non-battle paintings and Japanese-style paintings on the other hand, this binary is not entirely accurate. There were in fact Western-style painters who were interested in Japanese uniqueness and sought to reclaim the country's cultural traditions. This chapter, which looks at a painting executed in oil on canvas that alludes to Japan's distinctive culture, thus complicates our understanding of wartime art and seeks to develop a more comprehensive analysis of wartime paintings that is not divided along the lines of medium.

FUJITA TSUGUHARU

The trajectory of Fujita Tsuguharu, who occasionally called himself Tsuguji and is known in France as Léonard Tsugouharu Foujita, is truly curious and exceptional.[2]

He was born in Tokyo in 1886. His father, Fujita Tsuguakira, served as a military doctor and was an acquaintance of the Meiji intellectual Mori Ōgai (1862–1922), an army surgeon and novelist. In 1905, when Fujita Tsuguharu was nineteen, he entered the Western-style painting department of the Tokyo School of Fine Arts, which was then headed by Kuroda Seiki (1866–1924). Though married in 1912 (to Tomiko Tokita, the first of three wives), Fujita departed for France by himself in 1913 in order to study in Paris.

Fujita's global fame stems from his success in Paris. He experienced financial difficulty during the Great War when his father could not send him checks from Japan, but in the late 1910s and early 1920s Fujita firmly established his career, networking with major modernists such as Pablo Picasso (1881–1973), Amedeo Clemente Modigliani (1884–1920), and Diego Rivera (1886–1957). Around this time, he secured contracts with private galleries, began receiving monthly paychecks, and started exhibiting in Belgium, the Netherlands, and Germany. His paintings were purchased by the Belgium Royal Museum in 1922 and the French government in 1926. In 1925, he received both the Belgian Order of Leopold and the French Legion of Honor, attesting to his very high status in Europe. In his private life, he enjoyed the Parisian lifestyle, which was of course not favorably written about in Japan. Having divorced his first (Japanese) wife, he married Fernande Barrey, whom he would divorce in 1924. When he returned to Japan temporarily in 1929, he was treated as a celebrity and received substantial media attention. Fujita lived in the Americas—Brazil, Argentina, Cuba, Mexico, and the United States—for two years between October 1931 and November 1933, but then returned to Japan again in 1933.

With the exception of a brief trip to China in 1935 and a year-long stay in Paris in 1939, Fujita remained in Japan from 1933 until 1949, the year that he left Japan for good. In 1936, he married a Japanese woman named Kimiyo with whom he would spend the rest of his life. In the ensuing years, during the late 1930s and early 1940s, Fujita remained productive and worked closely with the Japanese state. As early as 1937, he exhibited a war-related painting titled *The 1000-stitch belt* (*Senninbari*) at the annual exhibition of the Second Section Society (*Nikakai*), a group of Western-style painters who initially challenged the state-sponsored exhibitions.

Between 1940 and 1943 he was dispatched by the army to the China–Russia border, Southeast Asia, and the Pacific islands with fifteen other painters, and from 1940 on, he painted War Campaign Record Paintings, exemplified by *The Battle of Nomonhan* (1940)—specifically commissioned by the military—and worked with large-scale canvases to present scenes of Japanese soldiers to a large number of public audiences (see Plate 24). The paintings were shown at the Great Japan Sea Art Exhibition and the Second Holy War Art Exhibition. It is believed that some of his wartime paintings were lost, but in the collection of 153 war paintings that were later to be confiscated by the United States, Fujita's work makes up the largest share. Although the American Occupational government did not list him as a war criminal, he was labeled as such by other artists when the war ended. Fujita decided to leave for France in 1949, never to return to Japan. In 1955, he obtained French citizenship and renounced his Japanese one. In France, he converted to Catholicism and was

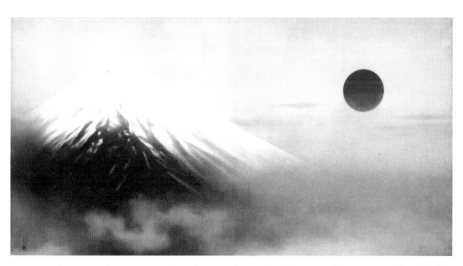

PLATE 1. Yokoyama Taikan, *Japan, Where the Sun Rises* (Nihon hi izuru tokoro), 1940. Ink and color on paper, 94.0 x 128.9 cm. The Museum of the Imperial Collection / Sannomaru shōzōkan.

PLATE 2. Yokoyama Taikan, *The Wheel of Life* (Seisei ruten), 1923. Ink on silk, 55.3 x 4070.0 cm. The National Museum of Modern Art, Tokyo. Photo: MOMAT / DNPartcom.

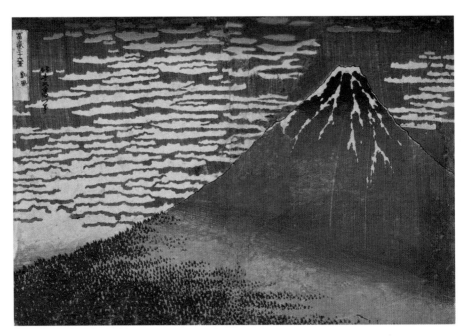

PLATE 3. Katsushika Hokusai, "Fine Wind, Clear Weather" (Gaifū kaisei), also known as "Red Fuji," from the series *Thirty-Six Views of Mount Fuji,* 1830–31. Woodblock print, 23.9 x 36.5 cm. Royal Ontario Museum.

PLATE 4. Yokoyama Taikan, *Landscapes of the Four Seasons Copy, Original Attributed to Sesshū* (Shiki sansuizu mosha den sesshūhitsu), 1897. Ink and color on paper. Tokyo National Museum. Image: TNM Image Archives.

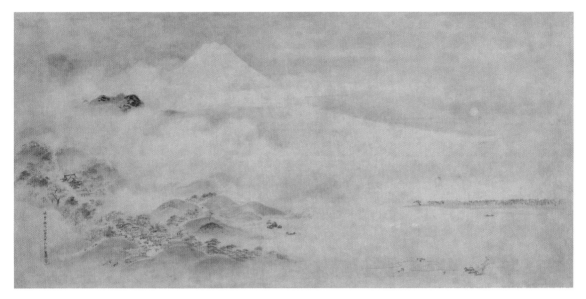

PLATE 5. Kanō Tan'yū (1602–1674), *Mt. Fuji* (Fujisan zu), 1667. Ink on paper, 56.6 x 118.4 cm. Shizuoka Prefectural Museum, Shizuoka City.

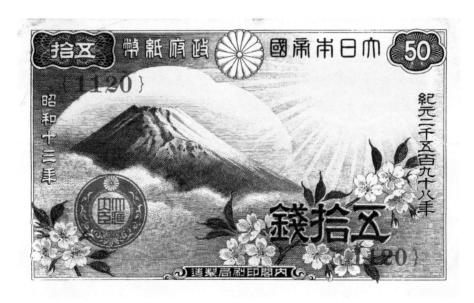

PLATE 6. Fifty sen bill, in circulation between 1938 and 1948, incorporating a photograph by Okada Kōyō. 6.5 x 10.5 cm. Photo Courtesy: Uemura Takashi.

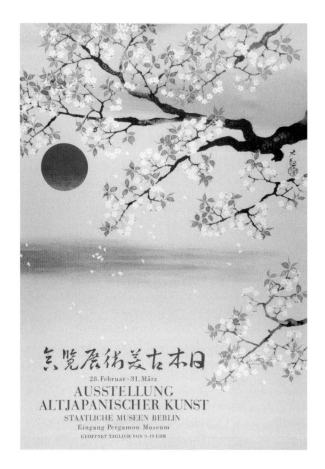

PLATE 7. Yokoyama Taikan, poster for the 1939 Japan Ancient Art Exhibition in Berlin. 59 x 42 cm. Kunstbibliothek, National Museums in Berlin.

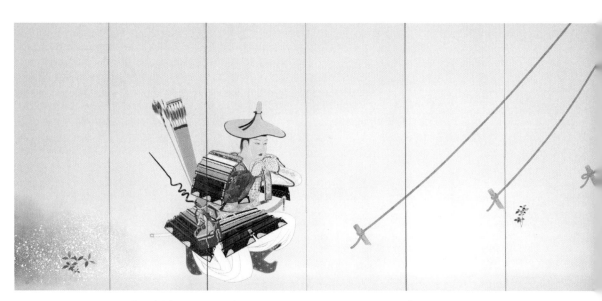

PLATE 8. Yasuda Yukihiko, *Camp at Kisegawa* (Kisegawa no jin), 1940–41. Color on paper, 167.7 x 374.0 cm (each screen). The National Museum of Modern Art, Tokyo. Photo: MOMAT / DNPartcom.

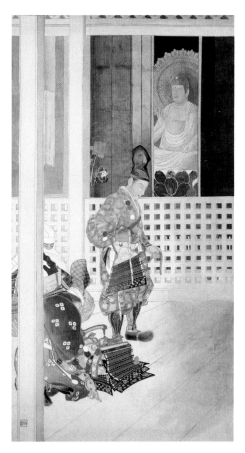

PLATE 9. Yasuda Yukihiko, *Parting at Yoshino* (Yoshino ketsubetsu), 1899. Color on silk, 146.3 x 94.5 cm. City of Izu.

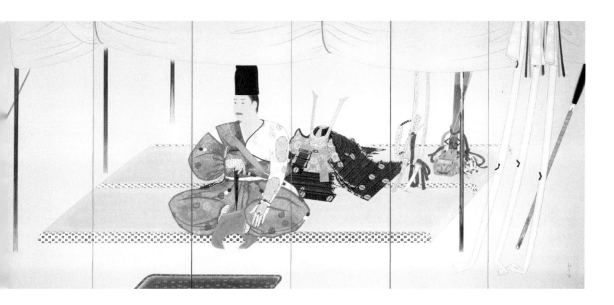

PLATE 10. *Portrait of Yoritomo* (Kenboku chakushoku den Minamoto no Yoritomo zō), 1179 (?). Color on silk, 143 x 112.8 cm. Jingoji, Kyoto.

PLATE 11. *Illustrated Account of the Mongol Invasion* (Mōko shūrai ekotoba), 13th century. Color on paper. 2 volumes (39.8 x 2351 cm; 39.8 x 2013.4 cm). Museum of the Imperial Collection.

PLATE 12. Tsuchida Bakusen, *Island Women* (Shima no onna), 1912. Ink on silk, 2 screens (166.5 x 184 cm each). The National Museum of Modern Art, Tokyo. Photo: MOMAT / DNPartcom.

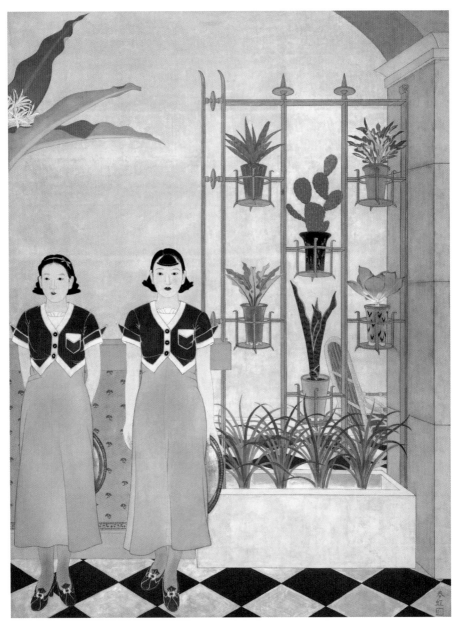

PLATE 13. Saeki Shunkō (1909–1942), *Tearoom*, 1936. Panel; ink, color, and silver on paper. 264.2 x 198.1 cm. Museum of Fine Arts, Boston.

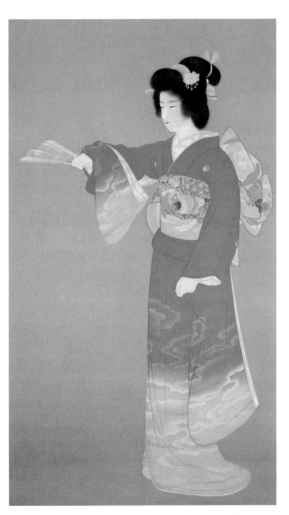

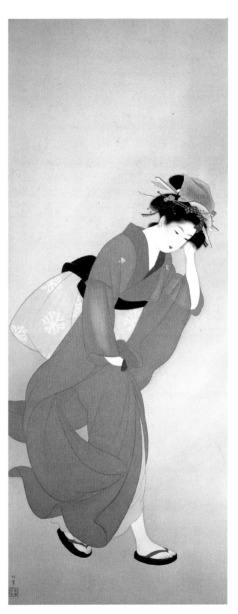

PLATE 14. Uemura Shōen, *Dance Performed in a Noh Play* (Jo no mai), 1936. Color on silk, 233 x 141.3 cm. The University Art Museum, Tokyo University of the Arts.

PLATE 15. Uemura Shōen, *Sudden Blast* (Kaze), 1939. 163 x 65 cm. Kitano Museum of Art.

PLATE 16. Uemura Shōen, *A Long Autumn Night* (Nagayo), 1907.

PLATE 17. Suzuki Harunobu, *Poem by Jakuren Hōshi, from an untitled series of Three Evening Poems (Sanseki)*, 1766–67. Woodblock print, 27.8 x 20.6 cm. Museum of Fine Arts, Boston.

PLATE 18. Suzuki Harunobu, *Autumn Wind,* from the *Six Elegant Poets* series (Fūryū rokkasen), ca. 1768. Woodblock print, 26.99 x 20.8 cm. University of Michigan Art Museum, Bequest of Margaret Watson Parker, 1948 / 1.156.

PLATE 19. Uemura Shōen, *Late Autumn* (Banshū), 1943. Color on silk, 182 x 86 cm. Osaka City Museum of Fine Arts.

PLATE 20. Uemura Shōen, *Lady Kusunoki* (Nankō fujin), 1944. Original lost.

PLATE 21. Kitō Nabesaburō, *Shiny Encounter* (Kagayaku taimen), *Shufu no tomo*, May 1941. Reproduced in Wakakuwa Midori's book cover.

若桑みどり

第二次世界大戦下の日本女性動員の視覚的プロパガンダ

戦争がつくる女性像

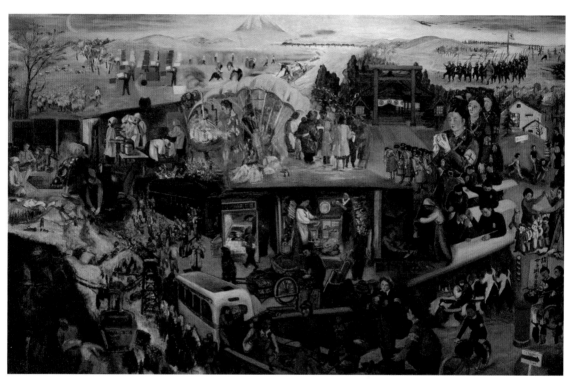

PLATE 22. Women Artist Patriotic Group (*Joryū bijutsuka hōkōtai*), *All Women Work for the Imperial Nation in the Great East Asian War* (Daitōasen kōkoku fujo mina hataraku no zu), 1944. Yasukuni Shrine.

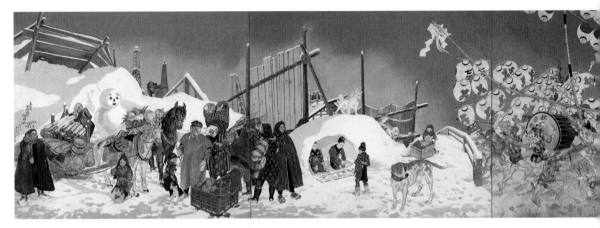

PLATE 23. Fujita Tsuguharu, *Events in Akita* (Akita no gyōji), 1937. Oil on canvas, 365 x 2050 cm. Hirano Masakichi Foundation. Tsuguharu Foujita © 2016 Artists Rights Society (ARS), New York / ADAGP, Paris.

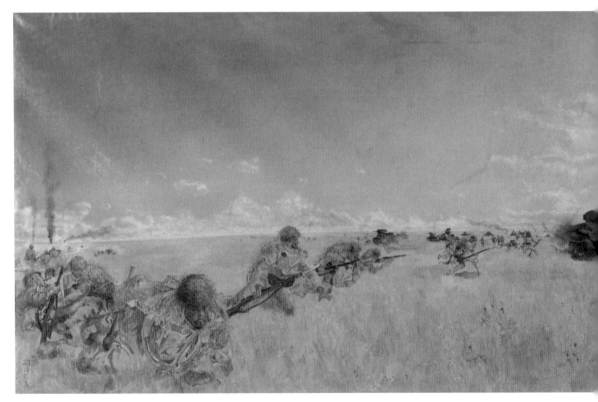

PLATE 24. Fujita Tsuguharu, *The Battle of Nomonhan* (Haruha kahan no sentō), 1940. Oil on canvas, 140 x 448 cm. The National Museum of Modern Art, Tokyo. Tsuguharu Foujita © 2016 Artists Rights Society (ARS), New York / ADAGP, Paris. Photo: MOMAT / DNPartcom. Photographed by Ichirō Ōtani.

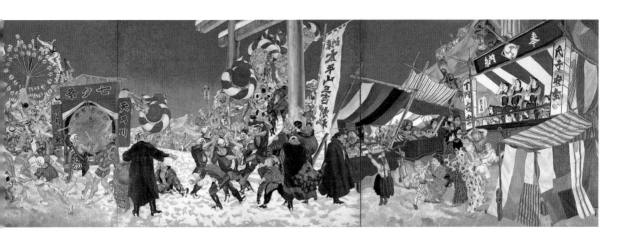

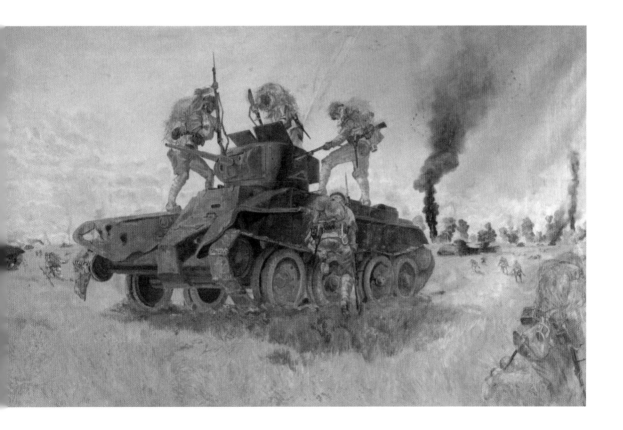

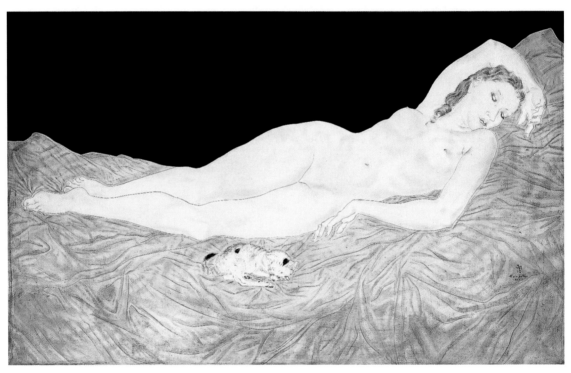

PLATE 25. Fujita Tsuguharu, *Sleeping Beauty* (Nemureru onna), 1931.Oil on canvas, 74.4 x 125 cm. Hirano Masakichi Foundation. Tsuguharu Foujita © 2016 Artists Rights Society (ARS), New York / ADAGP, Paris.

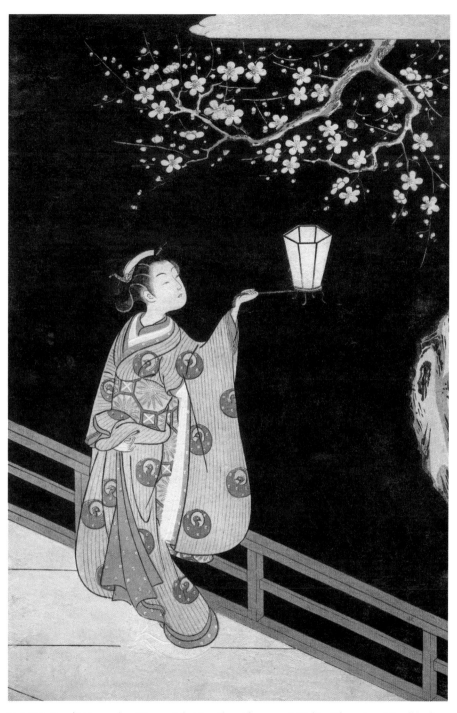

PLATE 26. Suzuki Harunobu, *Woman Admiring Plum Blossoms at Night,* 18th century. Woodblock print, 32.4 x 21 cm. The Metropolitan Museum of Art, New York.

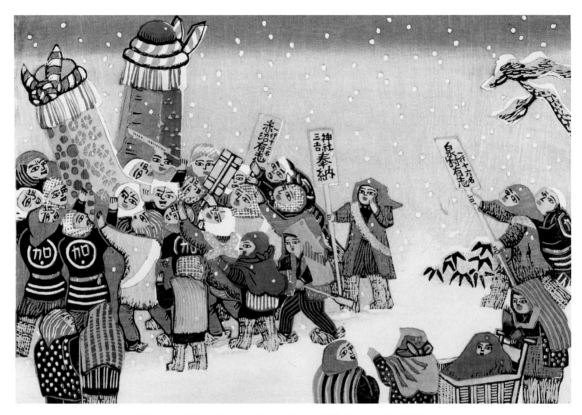

PLATE 27. Katsuhira Tokushi, *The Composition of Bonden Offering* (Bonden hōnō no zu, 1931). Woodblock print. Katsuhira Tokushi Memorial Museum.

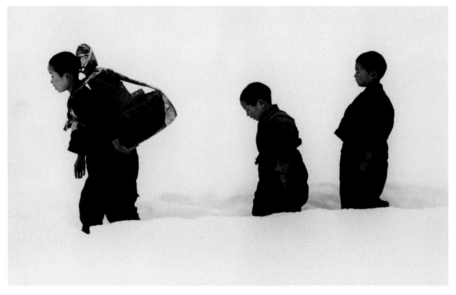

PLATE 28. Hamaya Hiroshi, *New Year's Visit with Jizo, Niigata Prefecture,* 1940. Gelatin silver print, 20.1 x 30.2 cm. The J. Paul Getty Museum, Los Angeles © Keisuke Katano.

PLATE 29. Fukuda Toyoshirō, *Vegetable Sellers* (Sansai uru hitotachi), 1932. Color on paper, 168 x 381.6 cm. Akita Museum of Modern Art.

PLATE 30. Mitani Toshiko, *Morning* (Asa), 1933. Color on silk, 166.5 x 203.5 cm. The National Museum of Modern Art, Kyoto.

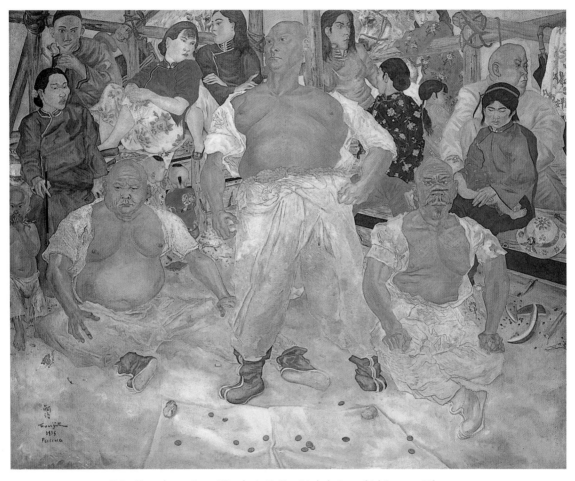

PLATE 31. Fujita Tsuguharu, *Sumo Wrestler in Beijing* (Hokuhei no rikishi), 1935. Oil on canvas, 189.9 x 225.4 cm. Hirano Masakichi Foundation. Tsuguharu Foujita © 2016 Artists Rights Society (ARS), New York / ADAGP, Paris.

baptized in Reims cathedral in 1959. He devoted the rest of his life to creating paintings on Christian themes.

Ozaki Masaaki, curator at the National Museum of Modern Art, Tokyo, calls Fujita "the only Japanese artist acknowledged by the world" before the Second World War, but it was not until 2006 that Fujita and his works reentered the popular discourse in Japan.[3] Between 1945 and 2006 there were Japanese exhibitions that displayed his works, but they did not receive much public or scholarly attention. The landmark exhibition in 2006 was organized by the National Museum of Modern Art, Tokyo, where the previously confiscated collection of 153 wartime paintings had been returned "on loan" from the US government. The exhibition celebrated the 120th anniversary of Fujita's birth and displayed around one hundred works by the artist, including five War Campaign Record Paintings. This retrospective, which was a big success, with 290,000 visitors in Tokyo alone (the exhibition toured Kyoto and Hiroshima, which added 300,000 more visitors), was widely advertised by magazines and on television and was followed by a series of exhibitions about Fujita.[4]

EVENTS IN AKITA

Events in Akita was produced a few years before Fujita became intensively involved in producing battle paintings commissioned by the military. The work was commissioned by Hirano Masakichi (1895–1989), a wealthy rice seller in Akita, who was a big fan of the artist and even promised to build a Fujita museum, though the plan was never realized because of the war's intensification in the late 1930s. The monumental painting, which measures 365.0 x 2050.0 cm and therefore can only be seen by walking across the canvas, captures both the liveliness of seasonal events and the tranquility of everyday life in Akita. The signature's location on the far left indicates that the painting is supposed to be "read" from right to left, following the convention of traditional vertical Japanese text.

The Akita mural depicts four famous festivals in Akita. Painted on the far right is the Sannō festival, held annually in early spring at the Hiyoshi Shrine. Festivalgoers pray for peace and a good harvest, performers of *Akita ondo* dance to music on stage, and visitors enjoy the entertainment as well as food and goods they purchase from vendors. The second festival, held in midwinter, is the Bonden festival at the Miyoshi shrine. At this festival, various groups of people carry their *bonden*—long sacred wands made of bamboo and decorated with colorful fabric—inscribed with their wishes, rushing to the shrine to be the first to offer theirs to the gods. In the painting, a dozen men energetically carry large *bonden* colored with red and white just under a *torii* gate. Toward the middle of the painting is a depiction of the Kantō festival, which takes place in summer and is now designated as an Important Intangible Cultural Property by the Japanese government. At the festival, lanterns hanging from long bamboo poles are carried through the streets at night in prayer for a good harvest. Toward the left, we then see a scene from the Yokote Kamakura festival, where igloo-like snow houses called *kamakura* are built throughout the city. *Kamakura* enshrine the water god, and in them children serve rice and *sake* to guests.

The painting "ends" with a portrayal of local people wearing clothes and practicing customs unique to the area: a man wears a winter jacket made of straw, while children wear extensively patterned *hanten* winter jackets and *bōkan zukin* hooded tops; they stand next to a baby-carrying *hakosori* box sled and horse-drawn sleigh. The dark grayish blue of the cloudy sky and the white of the snow on the ground dominate the picture, accentuated by the use of a strong, vivid red, creating a sense of uniformity and spaciousness in this otherwise crowded picture.

The work attests to the artist's interest in large-scale paintings that started in the 1920s. Particularly around 1928, Fujita produced a number of mural paintings, including *Battle* (*Tōsō*, 1928), *Battle II* (*Tōsō II*, 1928), *Composition with Lion* (*Raion no iru kōzu*, 1928), *Composition with Dog* (*Inu no iru kōzu*, 1928), *The Arrival of Occidentals in Japan* (Ōjin Nihon e tōrai no zu, 1929), and *Uma no zu* (*Les Chevaux*, 1929).[5] Whereas in these murals—and in almost all his paintings prior to these works—Fujita painted figures modeled on Caucasians, the Akita mural unmistakably deals with Japanese figures.[6] His Akita painting thus poses important questions, not least why this Western-style painter, who had spent many years in Europe, had suddenly become interested in Japanese subject matter.

FUJITA'S INTEREST IN "THINGS JAPANESE"

That Fujita established himself in Paris's artistic circle during the 1920s, at the height of modernism, seems at odds with his interest in Japanese tradition, evident in *Events in Akita:* modernism is generally understood as an artistic movement that questions authority and establishment and departs from tradition. As a "Japanese" artist active in France, however, Fujita's national identity was an essential element in his art, which had been inspired by Japan's artistic tradition and become popular in Paris.

From the beginning of his career in France, Fujita had to compete with other international artists who were fully integrated into the French culture and artistic community, and constantly tried to distinguish himself from other Japanese artists active in the same city. In his writing from this period he noted that there were many Japanese artists living in Paris, but that they socialized only among themselves and sold paintings only to Japanese collectors.[7] Fujita, on the other hand, felt that artists needed to forge their own paths; to his mind, those Japanese artists painted only as they were taught and their art therefore lacked originality.

Fujita's integration into the French art community does not mean that he completely abandoned his Japanese identity. Rather, in contrast to other Japanese artists in the city, Fujita targeted his paintings to French audiences by successfully negotiating the artistic heritage of his country and making something original from the perspective of European art history. We can see Fujita's use of techniques and the visual qualities found in the Japanese pictorial tradition, for example, in his *Sleeping Beauty* (*Nemureru onna*), executed in his signature style (see Plate 25). This is a sensuous painting of a naked blonde woman lying on a bed with a cat. Completely relaxed, the woman boldly stretches her right arm beside her head. Remarkable is the tactile quality of the woman's pale body, which was celebrated in France as "grand

fond blanc" ("great milk white" in English and *subarashiki nyūhakushoku* in Japanese).[8] The artist explores the surface quality of the canvas in order to recreate the quality of human skin. The sleek, soft, almost moist quality of her white skin makes the undressed sleeping woman look particularly sensual and almost invites the viewer to touch the painting. The soft quality of the white is reinforced by its juxtaposition with the wrinkled texture of the bed cover and the hair of the cat sleeping beside her. The woman's body is clearly outlined by delicate yet decisive thin, sharp black lines that do not vary in width, and is juxtaposed to a black background, which might suggest the deepness of her sleep.

Fujita's "grand fond blanc" was evidently inspired by works of *ukiyo-e* masters such as Harunobu and Utamaro (the same artists whose work became an inspiration for Uemura Shōen, as discussed in the previous chapter).[9] Active in the mid-eighteenth century, these particular masters whom Fujita names are famous for their production of "beautiful people pictures" (*bijin-ga*), in which they portrayed beautiful courtesans and merchant girls. Working with the medium of woodblock, the Edo-period masters left the faces and bodies of their female subjects uncolored, thereby rendering each woman's skin in the uniform, unchanging white color of the paper. The substantial black background, which Fujita used in *Sleeping Beauty* as well as in works such as *Lying Nude* (1922, now at the Musée des Beaux-Arts, Nîmes) and *Naked Woman and Cat* (1923, Hiroshima Museum of Art), also seems to be inspired by the *ukiyo-e* masters. It recalls prints such as *Woman Admiring Plum Blossoms at Night* at the Metropolitan Museum of Art in New York, which incorporates a prominent black pictorial space to suggest that it is a night scene (see Plate 26). Fujita's line drawing technique could also have been motivated by the black outlines of figures in Edo-period woodblock prints.

Fujita's interest in the Japanese artistic tradition is even more evident in other works he produced in the 1920s, such as *Kachō-zu mizudori* (Flower-Bird Painting: Waterfowl, 1929). This was painted on the wall at *Cercle de l'Union Interalliée,* a social and dining club located in Paris, and is only viewable by members of this exclusive club, but the mural was photographically reproduced and exhibited in Akita in 2013.[10] It alludes to the Japanese artistic tradition in many ways. As the title indicates, it belongs to the genre of flower-bird painting (*kachō-ga*), which originated in China. The painting, consisting of two panels (one on water birds and the other on land-based birds), depicts a variety of species, including sparrows, swans, and geese, as well as flowers such as the chrysanthemum. Using the foreign medium of oil paint, Fujita clearly alludes to the tradition of *kinpeki shōhekiga. Kinpeki shōhekiga,* which became popular in the late medieval period, is a painting on gold-foil-pressed sliding doors and screens made of paper, which uses strong, bright pigments of ultramarine and malachite over a gold background.[11] As *kinpeki shōhekiga* belongs to a broader category of *yamato-e* (Japanese picture), Fujita paints this work in the *yamato-e* style, with highly stylized cloud-like shapes to demarcate land and water. In light of his interest in Japanese art, including *ukiyo-e* and *yamato-e, Events in Akita* is not a deviation, but rather a continuation of his works of the 1920s.

In the 1937 Akita mural, Fujita turned to Japanese tradition for subject matter in addition to style: this change is subtle but significant. Fujita's attempt to

boost nationalistic sentiment in *Events in Akita,* which was not evident in his 1920s works, can be explained by his trip to South America in the early 1930s, a few years before he became engaged with the projects about Akita. His writings from this period make it clear that while in Mexico he was profoundly influenced by the Mural Movement of the 1920s led by Diego Rivera, whom Fujita had befriended in Paris.[12] Rivera and others produced mural paintings for the Mexican government, in places such as schools and public buildings, by incorporating the local artistic heritage of the Aztec and Maya; thus the movement was instrumental in helping to form Mexico's national identity. Fujita was impressed by this collaborative relationship between the govern-

FIGURE 11. Fujita Tsuguharu, *Picturesque Nippon* (Gendai Nippon), 1937. Reproduced in *Atorie,* May 1937, p. 65.

ment and artists: inspired by Mexican muralists, Fujita claimed that art should not be produced just for wealthy individuals but also for the masses and the general public. In other words, his trip to South America made him aware of the social and political roles that large public art could play.

Fujita did indeed develop a close relationship with the Japanese government in the 1930s. Essential to our understanding of *Events in Akita* is the fact that he was involved with another project related to Akita, which was sponsored by the state (Figure 11). In September 1935, Fujita was appointed as a film director by the International Cinema Association of Japan (*Kokusai eiga kyōkai*), an organization that was supervised by the Ministry of Foreign Affairs (*Gaimushō*) and that aimed to produce state policy films (*kokusaku eiga*).[13] Fujita directed five of the ten sections that comprised the film *Gendai Nippon* (1935), whose English title is *Picturesque Nippon*—Fujita's sections were collectively titled "Japanese Customs" (*Fūzoku Nippon*)—and were meant to portray a "correct image of Japan" (*tadashii Nippon no sugata*) to Western audiences.[14] Importantly, while shooting the film in Akita, Fujita indicated to public media that his mural painting would draw on his film, stating, "For the mural, I would like to incorporate winter customs I shot for the film:

Kantō, Tanabata Festival, Bonden, which I've seen. I also took hundreds of photographs of Akita. I have purchased a great deal of interesting-looking kimono too for reference."[15] While *Events in Akita* was commissioned by an individual, the fact that his film, which included much footage of Akita, was sanctioned by the state indicates the connection between the state ideology and the artist's representation of Akita.

TOHOKU AS "JAPAN"

Fujita saw Akita as the least modernized part of the country and therefore the most authentically "Japanese." Talking about his 1935 film *Picturesque Nippon,* he contrasted the customs and people of Akita with those in modern, urban areas: "Today we see imitation of Western things even in places outside Tokyo, but Akita was different: it felt traditional and resembled the culture in Kyoto. Also, it was a unique feature of the place that I could detect a lively yet modest feeling that symbolized 'advancing Japan' [*yakushin Nippon*]."[16] The artist's preoccupation with "things Japanese" found in Akita can be also gleaned from an episode of the film production reported by the *Asahi shimbun,* in which, for the main roles, they tried to find girls who were authentically Japanese and could be introduced to the West as "Miss Nippon." The two fourteen-year-old girls finally selected wore *monpe* (farmer's trousers) and *chigo mage* (children's hairstyles) and had never eaten fish, meat, or eggs. The girls ate only *tsukemono* (pickles), the newspaper article claims, and were true Japanese village daughters.[17] When Fujita painted *Events in Akita,* there were thus discursive cultural practices—some of them sanctioned and sponsored by the state—that saw Tohoku as the most untouched part of the country and therefore the most genuinely "Japanese."

Fujita was not alone in asserting that Akita—or more broadly, Tohoku—was the repository of traditional Japanese culture. There was also a discursive cultural practice that equated the region with Japan's cultural authenticity. In order to situate Fujita's *Events in Akita* in a broader ideological context, it is therefore imperative to examine the intense interest in Tohoku expressed around that time by intellectuals, cultural authorities, and visual artists—some of whom were closely connected with the government.

Attraction to the countryside predated the 1930s. Good examples of early-twentieth-century interest and investment in regional socio-economic reforms—some of which were inspired by a socialist vision of agricultural community—include Mushanokōji Saneatsu's intentional community, Atarashiki Mura (New Village) of 1918, Yamamoto Kanae's Farmer's Art movement, or *Nōmin bijutsu undō,* of 1919, and Arishima Takeo's farm, Kaributo Farm (*Kaributo nōen*), created in Hokkaido in 1920.[18] The discourse about Tohoku in the 1930s and early 1940s, however, was distinct from earlier movements, as it was characterized by an interest in *cultural* aspects of Japan's periphery and by the sense of nationalism that sought to articulate national identity through the use of local customs. Two of the most influential movements that defined the discourse were Yanagi Sōetsu's *mingei* and Yanagita Kunio's *minzokugaku.*

Mingei, the Japanese Arts and Crafts Movement, was founded and theorized by Yanagi Sōetsu (1889–1961) in 1926. Yanagi was one of the leading figures of *Shirakaba* (White Birch), the important journal that published both translations of theories and reproductions of visual arts by Western postimpressionist artists. Informed by theories of nineteenth-century British intellectuals John Ruskin (1819–1900) and William Morris (1834–1896), who nostalgically looked back to non-modernized, rural villagers for inspiration, Yanagi conceptualized *mingei* as crafts that are created by anonymous people with their intuition, such as farmers, contrasting them to "fine art" or *bijutsu*—the "Western" concept introduced in the Meiji period and inseparable from artistic individualism. Yanagi praised ordinary handicrafts made of simple natural materials that do not necessarily have a beautiful appearance.

The importance of *mingei* lies not only in that it came to form a close relationship with the state in the 1930s and early 1940s, but also in that it inspired interest specifically in Tohoku. As Yuko Kikuchi and Kim Brandt have recently observed, during the 1930s the *mingei* intellectuals also became particularly interested in Tohoku crafts such as woodwork, weaving, and embroidery such as *mino* (straw capes) and *kabazaiku* (birch craftsmanship). Yanagi organized a number of exhibitions displaying Tohoku *mingei* products: the "Tōhoku no minorui ten" (An Exhibition of Various Types of Mino of Tohoku) and "Tōhoku mingei ten" (An Exhibition of Folk Crafts of Tohoku) in 1939 at the Japan Folk Crafts Museum, and the "Dai ikkai Tōhoku mingei ten" (First Exhibition of Folk Crafts of Tohoku) and "Dai nikai Tōhoku mingei ten" (Second Exhibition of Folk Crafts of Tohoku) at the Mitsukoshi department store in Tokyo in 1940 and 1941, respectively.[19]

The *mingei* movement was meant to help Tohoku financially. Since the 1900s Tohoku had endured serious economic difficulties. As early as 1913, there emerged a group of people who were concerned about economic development and social issues in the region. By the 1930s, their concerns were widely shared by local authorities and recognized by the central government. Politician Matsuoka Toshizō (1880–1955) from Yamagata was instrumental in starting the Snow Damage movement (*setsugai undō*) in the 1930s, which led the country to acknowledge that snow country regions were significantly handicapped by their weather.[20] Natural disasters (frigid weather, floods, and tsunami) burdened the local people, he argued, and often resulted in poor harvests that quickly devastated the local economy. The Great Depression of 1929 added even more financial difficulty to their already arduous lives. Tohoku suffered substantially, and there were countless reports of girls being sold to brothels when their families ran out of money and people starving because of famine. The region thus came to be perceived by the rest of the country as "backward" and "poor." In 1933, the Ministry of Agriculture founded The Snowfall Region Farm Village Economic Survey Institute (*Sekisetsu chihō nōson keizai chōsajo*), which aimed to revitalize the economy of rural villages in these regions. The *mingei* group worked with the government-sponsored Snowfall Institute, asking farmers to create crafts during winters, their "off-season," which would create extra income for poor villagers. The Snowfall Institute and the *mingei* group also organized juried exhibitions for farmers and sold their products in Tokyo.

More important than their financial contribution was the *mingei* group's theorization of Tohoku's regional culture as representative of Japan's *national* culture: Yanagi considered that Tohoku's people and lifestyle showed innate and unique Japaneseness.[21] Locating "Japan" in Tohoku, Yanagi stated in 1939,

> The region of Tohoku gives everyone the impression of a poor place. But even if this is true, a defect of outlooks to date on Tohoku has been that they overlook one aspect of its abundance . . . One must be glad of the recent trend to recognize the value of such things as the language and folklore [of Tohoku]. Also I think that there are many splendid elements that we must study in terms of the correctness and simplicity of its way of life, the quality of its material substance, and its characteristic practices. Here one recalls Ryūkyū, but I think that in future the Tohoku region will be seen as Japan's most important cultural property.[22]

Yanagi's sentiment was echoed by Yamaguchi Hiromichi, the first director of the Snow Fall Institute, who promoted *mingei* production in Tohoku. He wrote in 1940,

> I have come to consider the daily life of Tohoku farmers, which until now I had seen only in terms of poverty, as the original, correct daily life of the Japanese. What is Japanese culture? Is it modern urban culture, or is it this Tohoku culture—Tohoku, which has only had its faults pointed out? But can we not point out even greater faults in modern urban culture?[23]

As historian Kim Brandt points out in her study of *mingei*, regionalism is most often associated with cultural diversity and is thus in opposition to nationalism; however, the *mingei* movement in Tohoku reveals that regionalism can be subsumed by nationalism.[24]

Equally as important as *mingei* in the discourse on Tohoku and its "Japaneseness" is Yanagita Kunio's *minzokugaku,* which can be translated into English as folk studies or ethnology and which is a semi-academic discipline that closely overlaps with ethnography and anthropology.[25] It is generally considered that Yanagita established *minzokugaku* in 1935, the same year he published his book *The Way to Examine Local Culture* (*Kyōdo seikatsu no kenkyūhō*).[26] While anthropology and ethnography were about studying the cultures of "Others" and were often heavily entangled with colonialism, Yanagita's *minzokugaku* was, as Yanagita himself claimed, about studying the culture of "the Self."[27]

While Yanagita's publication of the seminal 1912 *Tale of Tono,* a record of folk stories in Iwate, signaled his early interest in Tohoku, he became even more involved in Tohoku in later years. Notably, he led a large project about the "snow country" in Akita in the early 1940s that resulted in the publication of *The Customs of Snow Country* (*Yukiguni no fūzoku*) in 1943. Along with photographs of Akita taken by filmmaker Miki Shigeru (1905–1978), the book publishes Yanagita's writings about the lifestyles of people in Tohoku, which offers detailed descriptions of farmers'

outfits, hairstyles, rice cultivation processes, houses, sleds, and religious faith, including photographs of the Bonden festival, *kamakura*.[28] The book starts out with excerpts of *Be Not Defeated by the Rain* (*Ame ni mo makezu*) by Miyazawa Kenji (1896–1933), a Tohoku-born farmer, educator, and social reformer:

> Not losing to the rain
> Not losing to the wind
> Not losing to the snow nor to summer's heat
> With a strong body
> Not fettered by desire
> Never losing temper
> Always quietly smiling . . .
> I want to become such a person.[29]

Framing Miyazawa's resilient spirit as representative of Japanese culture, Yanagita writes, "Miyazawa Kenji must have been in genuine communication with the people of Tohoku, who lived from the harsh soil, engaging in farming . . . *People in Tohoku still persistently maintain qualities that people in cities have long lost. This is the true expression of the Japanese people.*"[30] Yanagita's *minzokugaku* research on Tohoku thus clearly echoes ideas shared by the *mingei* group, that is, that Tohoku boasts the richest and purest culture of Japan in modern times.

The discursive interest in Tohoku expressed by seminal cultural figures such as Yanagi and Yanagita was broadly shared by visual artists and literary figures. The people and customs of the countryside, especially Tohoku, were taken as subject matter by woodblock printers, photographers, painters, and novelists, some of whom had a direct connection with Fujita, *mingei,* and *minzokugaku.* Arguably the most important figure in our understanding of how Fujita belongs to the same cultural circuit as Yanagi and Yanagita is Akita-born woodblock print maker Katsuhira Tokushi (1904–1970), who was keen on developing Tohoku socially, economically, and culturally, and popularized particular cultural items of Akita such as *bonden, kamakura,* and sleds through his extensive network with urban cultural authorities of the time.[31] Katsuhira met Fujita, for example, when he visited Akita for the film shooting.[32] Katsuhira's works, such as *The Composition of Bonden Offering* (*Bonden hōnō no zu,* 1931), *Yukimuro* (1932), *Kantō festival* (1931), and *Sleds* (1937), which depict local people and local festivals and artifacts, clearly show an overlap with Fujita's mural and reveal that visual depictions of these local customs already existed (see Plate 27).[33]

Katsuhira also worked with the *minzokugaku* founder Yanagita Kunio: Katsuhira contributed dozens of prints portraying people in Akita to Yanagita's 1943 book *The Customs of Snow Country,* mentioned earlier.[34] Although his connection with Yanagi, the *mingei* founder, is unknown, Katsuhira had a close relationship with German Bauhaus artist Bruno Taut, who belonged to the *mingei* group. While living in Japan between 1933 and 1936, Taut visited Akita twice, in May 1935 and February 1936. During both trips, Taut met Katsuhira, who showed him Bonden festivals, sleds, and *kamakura,* and as a result of their friendship in Akita, Katsuhira

contributed prints to Taut's book *Japanese Houses and Lifestyle* (*Nihon kaoku to seikatsu,* 1936).[35]

The most significant photographer to be fascinated by the snow country was Hamaya Hiroshi (1915–1999), a modernist who collaborated with the state during the war.[36] Having worked at Orientaru Shashin Kōgyō (Oriental Photography), he was invited to work with Kimura Ihee (1901–1974) and produced photographs for the magazine *Front,* a propaganda magazine targeted at audiences outside Japan and published by Tōhōsha, a press run by the army.[37] His assignment to photograph the winter training of army troops in the snow country for *Gurafuikku* (Graphic) magazine in 1939 initially brought the artist to Northeast Japan. When he visited the city of Takada in Niiagata Prefecture (which, technically speaking, is not in Tohoku but is nonetheless considered snow country), as he would recall later, he was struck by the countryside's environment, which was so different from that of Tokyo.[38] It is notable that one of the people who encouraged Hamaya to take photographs of the local people was Shibusawa Keizō (1896–1963), the governor of the Bank of Japan between 1944 and 1945, whose love for Yanagita Kunio's *minzokugaku* was publicly known.

Hamaya shot *New Year's Visit with Jizo, Niigata Prefecture* in 1940 (see Plate 28). It captures a tranquil moment when three children walk through the snow, one of them carrying a Buddhist statue on his back. Hamaya would continue taking photographs of snow country even after the war, and his wartime and postwar photographs were published together in 1956 as the photo book *Yukiguni* (Snow Country). Like other figures, including Fujita, Yanagi, and Yanagita, Hamaya most likely sought to photographically capture the timeless "Japaneseness" found in the snow country—at least, that is how his works were received. Shibusawa, the above-mentioned banker and *minzokugaku*-lover, described Hamaya's works as capturing "the hearts of the common people of Japan," and Horiguchi Daigaku (1892–1981), a novelist who studied in Paris and was a good friend of Fujita Tsuguharu, wrote, "This is a book which has recorded the ancient life of the Japanese people."[39] As art historian Jonathan Reynolds succinctly states in his study of Hamaya, "In a time of war, the nationalist implications of Japanese ethnographic studies' single-minded efforts to document the distinctive qualities of traditional Japanese culture have political implications that cannot be ignored."[40]

Yukiguni (Snow Country) was also the title of a novel by Kawabata Yasunari (1899–1972), the first Japanese winner of the Nobel Prize for Literature. The story was serialized between 1935 and 1937 in various magazines including *Bungei shunjū* and *Chūō kōron,* and was subsequently published as a book by Sōgensha in June 1937. Tellingly, the 1937 book was illustrated by Serizawa Keisuke (1895–1984), a textile designer and *mingei* artist, which implies Kawabata's connection with the *mingei* movement. The novel is about a man from Tokyo, Shimamura, who has a love affair with a female geisha named Komako at a hot spring in the snow country, Yuzawa in Niigata. Alan Tansman's reading of *Yukiguni* notes that Kawabata was also interested in articulating Japan's cultural authenticity and beauty through the snow country—specifically, through the metaphors of whiteness and innocence. Tansman claims,

Whiteness covered the landscape of literature and the arts in Japan in the 1930s, an aesthetic response to a deep cultural malaise. It suggested a moment of authenticity or purity beyond the fractured space of modern life . . . For a number of writers in the 1930s, whiteness represented a moment of simultaneity that cut across linear time, tacitly refuting the dictates of Western historiography in favor of an aesthetic of Japanese authenticity.[41]

Japanese-style painters also visualized villagers in the countryside, if not specifically snow country, which is exemplified by such paintings as Fukuda Toyo-shirō (1904–1970)'s *Those Who Sell Vegetables* (*Sansai uru hitotachi*, 1932) (see Plate 29). While the location of the scene is not clearly indicated, Fukuda was an Akita-born painter, so it would not be surprising if the painting depicts his home-town in Tohoku. The painting shows families of farmers who spread out straw mats to sell crops they have grown, standing passively and quietly behind their goods. The farmers' wives and small children—one of whom is back-carried by his older brother while another is being breastfed—are all in simple clothes, with rosy cheeks, brown skin, and plump faces. Contrasted to people in cities in Western/modern outfits, these farmers look "primitive." They are poor farmers in a not-yet-modernized village, who could, when confronted by the "modern" viewer, either avert their eyes or stare at them, not knowing what else to do. *Morning (Asa)* by Japanese-style painter Mitani Toshiko (1904–1992) depicts similar subject matter (see Plate 30).[42] The painting was executed in 1933 and received a special award (*tokusen*) in the government-sponsored *Teiten* exhibition the same year. It is a poetic image of quiet life in rural Japan. In it, the young kimono-clad girl warms her bare feet by rubbing them together and tucking her hands into her sleeves; similarly, the rabbits curl their bodies to stay warm.

JAPAN'S FASCISM AND COLONIALISM

The branch of Japanese fascism that located national identity in the local traditions of Japan's periphery gives us an opportunity to think about the potential relationship between Japanese fascism and the country's colonial discourse in Asia. More specifically, the gaze toward and interest in Tohoku seem to replicate Japan's colonial gaze toward such places as Korea and Taiwan. The colonialist, "Othering" gaze toward Tohoku eventually contributed to form the sense of "Self" and national identity and to articulate Japan's cultural authenticity. However, it is this inherently primitivist gaze, I argue, that made this particular practice of Japanese fascism more susceptible to criticism than others that I have examined in the previous chapters.

Historian Stefan Tanaka's influential 1993 book *Japan's Orient: Rendering Pasts into History* has established that Japan's early-twentieth-century colonialism led the country to "Orientalize" the cultures and people of the Asian continent by studying, observing, and recording them.[43] Closely following the model of Orientalism

famously theorized by Edward Said, Tanaka makes visible Japan's Orientalist attitudes in the discipline of *Tōyōshi,* or Oriental/Eastern history.[44] Japan's Orientalism was also prevalent in visual arts—Japanese painters represented Asian people, especially Japan's colonial subjects in Taiwan and Korea, as "pre-modern," insinuating their inferiority in comparison with fully modernized Japan. In addition, scholars such as Yen Chuan-Ying, Kim Hyeshin, and Hong Kal subsequently observed that Japan's colonialist articulations about distinct "local colors" (*kyōdo shoku*) were later internalized and appropriated by colonial subjects—Korean and Taiwanese painters—to claim their cultural difference (which later contributed, in the case of Korea, to postwar nationalism, as Kal claims).[45]

The process by which Taiwan and Korea—the peripheries of Japan's empire—first attracted the colonial gaze (with an Orientalist understanding of the local culture that ultimately helped to assert the cultural uniqueness of the region) parallels the way in which Tohoku was initially seen rather negatively as "pre-modern" and "backward" but was later understood in a positive light as a repository of Japan's unique cultural tradition, uncontaminated by the West and modernity. Indeed, some even pointed to the affinity between Japan's colonies and its own northeast. Satō Shōsuke (1856–1939), the first dean of Hokkaido University, remarked as early as 1915 that "despite the fact that our country's culture has progressed from the southwest to the northeast since the state was founded 2,500 years ago, it still feels like the Tohoku region is an internal colony [*naikokuteki shokuminchi*]."[46]

The close connection between Japan's colonialism and fascism is most evident in the case of Yanagi Sōetsu, the *mingei* founder, whose interest in Tohoku was preceded by an interest in Korea. Yanagi's fascination with arts and crafts started in Korea in 1916, and his interest in Tohoku, which began only later, would have been sparked by the same kind of rustic aesthetics that local tradition in the region displayed. Fujita was not, admittedly, involved in Japan's colonial cultural discourses to the degree Yanagi was, but Fujita nonetheless began his Akita project right after his trip to China, which indicates that his interest in Tohoku might have been inspired by his encounter with the Asian "Other."[47] The artist made a two-month trip to China in 1934, about which he produced a number of paintings and drawings. One of them is *Sumo Wrestler in Beijing* (*Hokuhei no rikishi,* 1935) (see Plate 31), submitted to the Second Section Society that year, which shows "traditional" Chinese culture by portraying three large sumo wrestlers, partially naked, bald, and dark skinned. Fujita's China works were evidently the artist's attempt to show "races that surround the Pacific" by comparing and contrasting different cultural customs, according to a newspaper article from 1935, which is not at all at odds with his exploration of local customs in Akita.[48]

The practice of observing Japan's *local* culture with an Othering gaze and reclaiming it as Japan's *national* culture, however, was not without its critics. It risked representing the country as "pre-modern," "primitive," and therefore "inferior," within the rhetoric of Western Orientalism, which would have undermined Japan's self-representation as a fully capable modern nation. This danger of succumbing to Western Orientalism was apparently keenly feared, it seems, especially when the artist was closely connected with Western culture.

Events in Akita did not cause controversy, but Fujita's 1935 state policy film, *Picturesque Nippon,* did. Despite the fact that Fujita had been invited to direct the film, the Ministry of Foreign Affairs called the finished version "a national shame" (*kokujyoku*), imposing a ban on its export to the West as well as on its screening within Japan.[49] Although the precise reason it was considered a national shame is unknown, newspaper and magazine articles of the time imply that the film, which mostly portrayed the countryside, represented Japan as entirely pre-modern and uncivilized, removing *all* Western influences and technologies. One critic, Hosaka Fujio, notes, for example, that there are problematic scenes that show "primitive" folk dancing in Tohoku that looks as if it is performed by "indigenous people in the South Pacific or somewhere" and that Fujita failed to represent Japan as a fully modernized country.[50]

Interestingly, a similar debate took place in the field of *mingei.* A Tohoku-related exhibition organized by French architect and designer Charlotte Perriand (1903–1999)—who was in Japan as an official advisor on industrial design to the Ministry for Commerce and Industry between 1940 and 1941—was criticized for misrepresenting the country. Perriand, a prominent student of Le Corbusier, shared Bruno Taut's belief that Japanese pre-modern tradition was compatible with modernist aesthetics. Unlike Taut, who was interested in rationalist art that pursues simplicity, functionality, and geometric forms, Perriand focused on the primitivist school of modernism that sees beauty in natural and organic qualities and medieval aesthetics. In 1941, Perriand organized an exhibition called "Selection, Tradition, Creation" at the Takashimaya department store, which featured traditional Japanese crafts from Tohoku, such as a *mino* straw peasant raincoat, a bamboo chair, a black-lacquered dining table, a bamboo tray, lacquered bowls, and a bamboo table.[51] It received severe criticism from a number of Japanese artists. For example, at a roundtable organized by the Industrial Arts Research Institute, Yamawaki Iwao (1898–1987), Taut's student, criticized "her excessive attention to folk crafts" and "her anachronism and her sensibility, which is too far detached from the majority of ordinary urban Japanese people."[52] The roundtable eventually concluded that her exhibition represented a foreigner's view of Japan and exoticism toward Japanese tradition. Design critic Katsumi Masaru, in another instance, opined that he was "greatly annoyed by the fact that foreigners encourage the people indulging in nostalgia."[53]

Perriand was obviously a "foreigner," and Fujita was often perceived as internalizing the Western point of view due to his long stay in France. Rather than being seen as identifying with the "pre-modern" people in Akita, both Fujita and Perriand were apparently perceived as representing Japan from the privileged perspective of the West, simply replicating a Western Orientalist attitude toward Japan. It is also likely that many Japanese intellectuals living in Tokyo felt no connection with the local tradition of Tohoku and resisted the nationalization of the area-specific customs. After all, more than any other region, Tohoku was associated with poverty and "backwardness," which explains why not all Japanese people wanted to identify with it.

An examination of Fujita's 1937 mural is important for several reasons. First, looking at *Events in Akita* contributes to our understanding of the artist and his works, since scholars have largely focused on his War Campaign Record Paintings, such as *The Battle of Nomonhan,* in their overall examination of his wartime paintings. Fujita's project in Akita reveals that the artist was able to contribute to the state through non-battle paintings by espousing the state ideology of Japanese fascism, which was primarily concerned with the country's cultural authenticity. As I have shown, this was a method deployed in *mingei, minzokugaku,* prints, photography, literature, and paintings.

By illuminating the relationship between Fujita's Western-style painting and Japanese fascism, this chapter also complicates the study of Japanese war art. While it would have been easier for Japanese-style painters—such as Yokoyama Taikan, Yasuda Yukihiko, or Uemura Shōen—to turn to the country's myths and traditions, it was *not* impossible for Western-style painters to participate in the discourse of Japanese fascism. In fact, in the 1930s, a group of Western-style painters explored how oil painting, an essentially foreign medium, could merge with Japan's national identity. For example, Kojima Zenzaburō (1893–1962), who studied in Paris from 1924 to 1928, proposed a reconciliation between oil painting and the Japanese spirit, calling for "New Japanism" (*Shin Nihonshugi*). In the May 1935 edition of the art magazine *Atorie,* he claimed, "If the Japanese have an extraordinary beauty in their racial blood, tradition, and country, a special technique has to be employed in order to express that beautiful climate and character. [. . .] Our mission is to blend Western materialism and Oriental spirit to create a new world, in which mind and matter are united."[54] Another Western-style painter, Uchida Iwao (1900–1953), was also keen to "Japanize" Western-style paintings. He tried to capture "the spirit of ink with oil" in his rock paintings of the late 1930s and early 1940s.[55] With a similar intent, Umehara Ryūzaburū (1888–1986) used a bright palette and dynamic brushstrokes in his oil paintings, which was often understood as evoking the traditions of Japanese decorative arts. The examination of Fujita's work and career thus calls for a more systematic inquiry into Western-style paintings produced during the war in relation to Japanese fascism.

CONCLUSION

This book has looked at paintings produced in Japan during the Second World War that do not depict contemporary battles and soldiers and therefore have not received critical scholarly attention. Seemingly unproblematic non-battle paintings did serve the state by embodying the state ideology of the time, that is, that the country needed to reclaim the national culture that had been destroyed by modernity. The four artists examined—Yokoyama Taikan, Yasuda Yukihiko, Uemura Shōen, and Fujita Tsuguharu—alluded to Japan's traditions through portrayals of Mount Fuji, the Minamoto Brothers, "traditional" women, and unmodernized rural Japan, reflecting the broader cultural discussion of the time centered on cultural authenticity.

Studying the four artists and their works points to, on the most fundamental level, the importance of historical specificity in interpreting artworks. There are countless paintings of Mount Fuji, historical figures, beautiful women, and Japan's rural areas in the history of Japanese art, but their meanings are remarkably different depending on the context in which they were produced, circulated, and received. In the case of paintings produced during the 1930s and 1940s, where culture was highly politicized, we must develop a nuanced reading that brings the politics back into art rather than categorizing works into either "art" or "propaganda."

One way to illuminate the ostensibly obscure connection between the Japanese non-battle paintings of the Second World War and their politics is through the lens of fascism, which has been theorized by scholars such as Roger Griffin, Mark Antliff, Harry Harootunian, and Alan Tansman as a reactionary response to modernity and as an ideology that denounces individualism, rationalism, and materialism, espousing instead collectivism, spiritualism, and national myth. Understanding wartime art in relation to Japanese fascism allows us to perceive the degree to which modernity became the central issue to state politics and culture, and importantly,

to maintain a clear distinction between the cultural nationalism of the earlier Meiji period and that of the 1930s and early 1940s. It also opens up the possibility for comparative studies with other fascist nations. In fact, as I showed in the chapter on Yokoyama Taikan, Japan had a great deal of dialogue and exchange with Nazi Germany and Fascist Italy, and, as I noted in the chapter on Yasuda Yukihiko, the way in which Japanese fascism appropriated modern aesthetics is comparable to the idea of "reactionary modernism" and "fascist modernism" that have been discussed in the field of German and Italian fascist art. We must place Japanese wartime art of the 1930s and early 1940s into the narrative of global art history, within which both pre-war and postwar modern art have increasingly been situated.[1]

After the unconditional surrender of Japan, announced on August 15, 1945, the American government occupied Japan from September 1945 to April 1952. The occupational government, known as the Supreme Commander for the Allied Powers Japan (SCAP) and led by General Douglas MacArthur, carried out a reorganization of the political, economic, and cultural institutions of Japan in an attempt to democratize the country. None of the paintings examined in this book—Yokoyama Taikan's *Japan, Where the Sun Rises,* Yasuda Yukihiko's *Camp at Kisegawa,* Uemura Shōen's *Dance Performed in a Noh Play,* and Fujita Tsuguharu's *Events in Akita*—were in the collection that was confiscated by the United States in the 1950s. Why did the American occupation officers not consider these wartime paintings to be problematic? Most likely because they are not noticeably different from the traditional Japanese art that the works draw on, and without knowledge of Japan's domestic discussions about reclaiming Japan's cultural authenticity and its relationship to the war, it would have been hard to perceive their ideological resonance. The Japanese works could not have looked more different from Italian and German fascist art, which unsurprisingly alludes to their own "classics": the perfectly proportioned, muscular nude figures of Greco-Roman classical antiquity. Alternatively, one could also imagine that American officials were reluctant to question Japanese traditions with which the citizens felt deeply connected because they wanted to win support from the Japanese public. This was, after all, the reason why the American occupational government did not hold the emperor legally or morally responsible for the war despite his central presence and authority.

Examining wartime paintings outside the confiscated collection through the lens of Japanese fascism, however, raises a question: how could one then understand the battle paintings? The paintings that depict contemporary soldiers and battles do not seem to evoke Japanese cultural authenticity in the same way as the paintings discussed in this book. Here, I am inclined to propose that militarism is an important part of fascism that justifies its violence as defense against homogenizing modernity, and the battle paintings functioned to reinforce that particular aspect of fascism. This point may be effectively addressed by looking at Leni Riefenstahl's infamous films *Triumph of the Will* (1935) and *Olympia* (1938), both produced under the Nazi regime.[2] *Triumph of the Will,* which portrays marching soldiers and Hitler's speech, is more militarily oriented, just like the confiscated Japanese battle paintings. In contrast, her *Olympia,* which evokes the ancient Greek and Roman Classical culture through iconographies of athletes' beautiful bodies and movements, is seemingly

non-militaristic and subtle in its political connotation. Yet, just like the non-battle paintings discussed in this book, *Olympia* advocates a return to the past and embodies the ideal of cultural authenticity. Both films thus operate within the realm of fascist ideology.

If we can accept that militarism was *part* of fascism, we can indeed begin to examine wartime Japanese-style and Western-style paintings—and battle paintings and non-battle paintings—together, rather than separately, in future scholarship; this will make any inquiry into wartime paintings more inclusive and comprehensive. There are many other Japanese paintings and artworks produced during the Second World War that have not received art historical attention. I hope this book offers useful research and a theoretical model that spurs interest in, and expands the investigation of, the growing field of Japanese war art.

NOTES

INTRODUCTION

1. The Asia-Pacific theater of the Second World War is often referred to, especially by leftist scholars, as the "Fifteen-Year War" (*jūgonen sensō*). The Manchurian Incident is important as it marked the Imperial Army's seizure of control over the government and the beginning of Japan's aggressive foreign policies toward Asia, as well as state surveillance of those who held different opinions, such as Marxists. The Manchurian Incident was followed by the Second Sino-Japanese War (1937–1945) and the Pacific War (1941–1945). In this book, as I explain in depth in the first chapter, I use the term "Second World War" to maintain the resonance of Japan's war vis à vis global politics.

2. For the discussion that took place among artists after Nakagawa's finding of the paintings, see "Ushinawareta sensō kaiga: Nijyūnenkan beikoku ni kakusarete ita taiheiyō sensō meiga no zenyō" [Lost war paintings: The whole story behind the Pacific War art masterpieces that were hidden in the United States for twenty years], *Shūkan Yomiuri*, August 18, 1967. For the complicated postwar history of the war paintings, see Ikeda, "Japan's Haunting War Art: Contested War Memories and Art Museums."

3. "Henkan no sensō-ga, totsuzen kōkai chūshi" [The exhibition of repatriated war paintings, suddenly cancelled], *Asahi shimbun*, March 8, 1977.

4. Sawaragi, *Bakushinchi no geijutsu*, p. 390.

5. The collection was initially formed immediately after the war by the leading war artist and Western-style painter Fujita Tsuguharu, who, with his personal friend, the American military artist Barse Miller, tried to help organize an exhibition called "Conquest of Japan" that was to be held at the Metropolitan Museum of Art, New York, and the National Military Museum in Washington, D.C. The collection was brought to the attention of the American Occupational government a year later, which ultimately decided that it constituted a group of propaganda paintings without any artistic value (Ikeda, "Japan's Haunting War Art," pp. 11–12). For archival research on this topic in Japanese, see Kawata, "Sorera wo dō sureba iinoka"; Hirase Reita, "Sensō-ga to America" [Sensō-ga and the United States], *Himeji shiritsu bijutsukan kenkyō kiyō* 3 (1999): 1–45.

6. Benjamin, "The Work of Art in the Age of Mechanical Reproduction."

7. H. W. Janson, *Janson's History of Art: The Western Tradition*, 7th ed. (Upper Saddle River, NJ: Pearson Education, 2007).

8. Brandon, *Art & War*.

9. Other examples include Adam, *Art of the Third Reich*; Dawn Ades et al., *Art and Power*; Foss, *War Paint: Art, War, State and Identity in Britain 1939–1945*. Other scholars and curators have explored the link between art and various ideologies that underlie global conflicts, such as fascism, socialism, and democracy. See, for example, Cécile Whiting, *Antifascism in American Art* (New Haven,

CT: Yale University Press, 1989); Golomstock, *Totalitarian Art: In the Soviet Union, the Third Reich, Fascist Italy, and the People's Republic of China*; Julia Andrews, *A Century in Crisis: Modernity and Tradition in the Art of Twentieth Century China* (New York: Guggenheim Museum, 1998); *Kunst und Propaganda: Im Streit der Nationen 1930–1945*; Jean et al., *The 1930s: The Making of "The New Man"*; *Chaos and Classicism: Art in France, Italy, and Germany, 1918–1936*.

10. Jeff Kingston, "Historian Battles to Redeem the Past," *The Japan Times*, April 7, 2001, http://search.japantimes.co.jp/cgi-bin/fb20010407a1.html (accessed November 9, 2010).

11. Hiroko Tabuchi, "Soldier Confirms Wartime Sex Slavery," *Japan Times*, March 4, 2007, http://www.japantimes.co.jp/news/2007/03/04/national/soldier-confirms-wartime-sex-slavery (accessed May 4, 2015); Reiji Yoshida, "Sex Slave History Erased from Texts; '93 Apology Next?" *Japan Times*, March 11, 2007, http://www.japantimes.co.jp/news/2007/03/11/national/sex-slave-history-erased-from-texts-93-apology-next (accessed May 4, 2015).

12. Igarashi Yoshikuni, *Bodies of Memory* (Princeton, NJ: Princeton University Press, 2000), pp. 19–28.

13. Lisa Yoneyama, *Hiroshima Traces: Time, Space, and the Dialectics of Memory* (Berkeley: University of California Press, 1999). Emperor Hirohito's active involvement in the decision-making process during the war was revealed by a recently released 12,000-page document about the emperor's life. Herbert P. Bix and David McNeill, "Selective History: Hirohito's Chronicles," *Japan Times*, October 11, 2014. http://www.japantimes.co.jp/news/2014/10/11/national/history/selective-history-hirohitos-chronicles (accessed October 17, 2014).

14. Mimi Hall Yiengpruksawan, "Japanese Art History 2001: The State and Stakes of Research," *Art Bulletin* 83, no. 1 (2001): 166.

15. Yokoyama Taikan's involvement in the war is well known, but how exactly his paintings served the state has not been fully explored, especially in English-language scholarship.

16. The examples that predate 1995 are Tanaka, *Nihon no sensōga: sono keifu to tokushitsu*; Tsukasa Osamu, *Sensō to bijutsu*.

17. Kawata and Tan'o, *Imēji no nakano sensō: Nisshin, nichiro sensō kara reisen made*.

18. Hariu Ichirō et al., *Sensō to bijutsu 1937–1945/Art in Wartime Japan 1937–1945*. This book was followed by other publications on the topic: Morita, *Sensō to geijutsu: jūgun sakka gaka tachi no senchū to sengo*; Kōsaka, *Gaka tachi no "sensō"*; Nomiyama Gyōji et al., *Sensōga unda e, ubatta e*; Mizoguchi et al., *Enogu to sensō*; Shibazaki, *Efude no nashonarizumu*; Kira, *Sensō to josei gaka*; Kawata, *Gaka to sensō: Nihon bijutsushi no kūhaku*.

19. Ikeda, "Fujita Tsuguharu Retrospective 2006: Resurrection of a Former Official War Painter."

20. Winther-Tamaki, "Embodiment/Disembodiment: Japanese Painting during the Fifteen-Year War."

21. Tsuruya, "Sensō Sakusen Kirokuga [War Campaign Documentary Art Painting]: Japan's National Imagery of the 'Holy War' 1937–1945"; Kaneko, "Art in the Service of the State: Artistic Production in Japan during the Asia-Pacific War."

22. Ikeda, Tiampo, and McDonald, eds., *Art and War in Japan and Its Empire: 1931–1960*.

23. Rimer, "Encountering Blank Spaces: A Decade of War, 1935–1945." For more on Japanese-style painting and nationalism, see, for example, Weston, *Japanese Painting and National Identity: Okakura Tenshin and His Circles*; Clark, "Okakura Tenshin and Aesthetic Nationalism"; Yamanashi, *Egakareta rekishi: Nihon kindai to "rekishiga" no jijō*.

24. Wattles, "The 1909 Ryūtō and the Aesthetics of Affectivity"; Ikeda, "The Allure of Women Clothed in Chinese Dress"; Weisenfeld, "Touring 'Japan-as-Museum': *NIPPON* and Other Japanese Imperialist Travelogues"; Shepherdson-Scott, "Fuchikami Hakuyō's Evening Sun: Manchuria, Memory, and the Aesthetic Abstraction of War"; Brown, "Out of the Dark Valley: Japanese Woodblock Prints and War, 1937–1945."

25. Aida Yuen Wong has explored the issue of fascism in her examination of paintings in colonial Taiwan. Wong, "Art of Non-Resistance: Elitism, Fascist Aesthetics, and the Taiwanese Painter Lin Chih-chu."

26. Harootunian, "Overcoming Modernity," in *Overcome by Modernity: History, Culture, and Community in Interwar Japan*.

27. Tansman, *The Aesthetics of Japanese Fascism*; Tansman, *The Cultures of Japanese Fascism*.

CHAPTER ONE: JAPANESE PAINTINGS, FASCISM, AND WAR

1. Literary figure Hagiwara Sakutarō coined the term in his 1938 essay "Return to Japan" (*Nihon e no kaiki*), published in the magazine *Shin Nihon* (New Japan).

2. Kawata Kazuko, *Senjika no bungaku to Nihonteki na mono: Yokomitsu Riichi to Yasuda Yojūrō* [Wartime Literature and Things Japanese: Yokomitsu Riichi and Yasuda Yojūrō] (Fukuoka: Hanashoin, 2009), pp. 7–8.

3. Dōmei gurafu henshūbu, ed., *Hōsyuku kigen nisen roppyakunen* [The Celebration of the 2600th Anniversary] (Tokyo: Kōdō shinkōkai, 1941); Ruoff, *Imperial Japan at Its Zenith.*

4. Doak, *Dreams of Difference.*

5. For more about the embrace of modernity in the Taishō period, see Tipton and Clark, *Being Modern in Japan.*

6. Walter Skya, *Japan's Holy War: The Ideology of Radical Shintō Ultranationalism* (Durham, NC: Duke University Press, 2009).

7. For a history of how American scholars came to call wartime Japan "militarist" rather than "fascist" in the context of the Cold War and the U.S.–Japan "democratic" alliance, see McCormack, "Nineteen-Thirties Japan: Fascism?"

8. O. Tanin and E. Yohan, *Militarism and Fascism in Japan* (New York: International Publishers, 1934); Hasegawa Nyozekan, *Nihon fashizumu hihan* [The Critique of Japanese Fascism] (Tokyo: Ōhata shoten, 1932); Imanaka Tsugimaro and Gushima Kanezaburō, *Fashizumu ron* [The Theory of Fascism] (Tokyo: Mikasa shobō, 1935); Sassa Hirō, *Nihon fasshizumu no hatten katei* [The Process of Development of Japanese Fascism] (Tokyo: Asano Shoten, 1932); Tosaka Jun, *Nippon ideologī ron* [The Theory of Japanese Ideology] (Tokyo: Hakuyōsha, 1935).

9. George Macklin Wilson, "A New Look at the Problem of 'Japanese Fascism,'" *Comparative Studies in Society and History* 10.4 (July 1968): 402–403.

10. Maruyama Masao, "The Ideology and Dynamics of Japanese Fascism," in *Thought and Behaviour in Modern Japanese Politics*, ed. Ivan Morris (Oxford: Oxford University Press, 1969), p. 35. The essay was first delivered as a lecture at Tokyo University in 1947.

11. Yoshimi Yoshiaki, *Kusano ne no fashizumu: Nihon minshū no sensō taiken* [Grassroots Fascism: War Experiences of the Japanese Masses] (Tokyo: Tokyo daigaku shuppankai, 1987). Other postwar scholarly works that touch on Japanese fascism include William Miles Fletcher, *The Search for a New Order: Intellectuals and Fascism in Prewar Japan* (Chapel Hill: University of North Carolina Press, 1982); Gordon, *Labor and Imperial Democracy in Prewar Japan*; Joseph P. Sottile, "The Fascist Era: Imperial Japan and the Axis Alliance in Historical Perspective," in *Japan in the Fascist Era*, ed. E. Bruce Reynolds (New York: Palgrave Macmillan, 2004).

12. Peter Duus and Daniel Okamoto, "Fascism and the History of Prewar Japan: The Failure of a Concept," *Journal of Asian Studies* 39, no. 1 (November 1979): 65–76; George Macklin Wilson, "A New Look at the Problem of 'Japanese Fascism,'" 401–412; Shillony, *Politics and Culture in Wartime Japan.*

13. Gilbert Allardyce, "What Fascism Is Not: Thoughts on the Deflation of a Concept," *American Historical Review* 84, no. 2 (April 1979): 367–388.

14. Walter Benjamin's "The Work of Art in the Age of Mechanical Reproduction" (1936) and Susan Sontag's "Fascinating Fascism" (1974) are influential and useful works whose observations of fascism are still in many ways compatible with recent fascism studies.

15. Griffin, "Introduction," in *Fascism; A Fascist Century: Essays by Roger Griffin.*

16. Griffin develops a list of the "fascist minimum," in which (1) fascism is anti-liberal, (2) fascism is anti-conservative, (3) fascism tends to operate as a charismatic form of politics, and so on, which ultimately led him to conclude that Japan was not fascist. While I do not agree with all the elements listed by Griffin in his checklist, for the most part I agree with his broader understanding of fascism as a reaction against modernity. Griffin, *The Nature of Fascism*, p. 153.

17. Griffin, *Fascism*, p. 3.

18. Falasca-Zamponi, *Fascist Spectacle*; Schnapp, "Epic Demonstrations: Fascist Modernity and the 1932 Exhibition of the Fascist Revolution"; "18 BL: Fascist Mass Spectacle"; Kaplan, *Reproductions of Banality: Fascism, Literature, and French Intellectual Life*; Foster, "Armor Fou"; Herf,

Reactionary Modernism; Hewitt, "Fascist Modernism, Futurism, and 'Post-Modernity'"; Affron and Antliff, Fascist Visions: Art and Ideology in France and Italy; Antliff, "Fascism, Modernism, and Modernity"; Braun, "Mario Sironi's Urban Landscape"; Gordon, "Fascism and the Female Form: Performance Art in the Third Reich"; Whyte, "National Socialism and Modernism"; Nerdinger, "A Hierarchy of Styles: National Socialist Architecture between Neoclassicism and Regionalism"; Koepnick, "Fascist Aesthetics Revisited"; Buck-Morss, "Aesthetics and Anaesthetics: Walter Benjamin's Artwork Essay Reconsidered."

19. Harootunian, Overcome by Modernity: History, Culture, and Community in Interwar Japan, p. xxx. Other recent books on the topic of Japanese fascism that offer method and arguments similar to Harootunian include Pincus, Authenticating Culture in Imperial Japan: Kuki Shūzō and the Rise of National Aesthetics; Brandt, Kingdom of Beauty: Mingei and the Politics of Folk Art in Imperial Japan.

20. Tansman, The Aesthetics of Japanese Fascism; The Cultures of Japanese Fascism.

21. Tansman, The Aesthetics of Japanese Fascism, p. 3.

22. Wilson, "Rethinking Nation and Nationalism in Japan," pp. 3–9.

23. On the (re)invention of the tradition of emperor worship, see T. Fujitani, Splendid Monarchy: Power and Pageantry in Modern Japan (Berkeley: University of California Press, 1996).

24. Wilson, "Rethinking Nation and Nationalism in Japan," p. 7.

25. Washburn, Translating Mount Fuji, p. 137.

26. Yamanouchi Yasushi, "Total-War and System Integration: A Methodological Introduction," Total War and 'Modernization,' pp. 3–4. For more on technology and science during the Second World War, see Hiromi Mizuno, Science for the Empire: Scientific Nationalism in Modern Japan (Stanford, CA: Stanford University Press, 2009); Tessa Morris-Suzuki, The Technological Transformation of Japan: From the Seventeenth to the Twenty-First Century (Cambridge: Cambridge University Press, 1994).

27. Washburn, Translating Mount Fuji: Modern Japanese Fiction and the Ethics of Identity, pp. 9, 13.

28. Yumiko Iida, "Fleeing the West, Making Asia Home: Transpositions of Otherness in Japanese Pan-Asianism, 1905–1930," Alternatives 22 (1997): 409–432.

29. Washburn, Translating Mount Fuji, pp. 7–8.

30. Ibid., p. 141.

31. Harootunian, Overcome by Modernity, p. 35. The antagonism against the West was more complex during the Second World War, as Japan still maintained positive relations with Italy and Germany. While the Japanese opposed the West, it was specifically the American and British that "the West" actually denoted.

32. For instance, use of linear perspective in Edo-period woodblock prints. See Timon Screech, "Meaning of Western Perspective in Edo Period Culture," Archives of Asian Art 47 (1994): 58–69.

33. Kitazawa Noriaki, Me no shinden: "bijutsu" juyōshi nōto [Shrine of Eyes: "Art" Reception History] (Tokyo: Bijutsu Shuppansha, 1989); Satō Dōshin, "Nihon bijutsu" tanjō: Kindai Nihon no "kotoba" to senryaku [The Birth of "Japanese Art": Modern Japan's "Words" and Strategies] (Tokyo: Kōdansha, 1996).

34. Weston, Japanese Painting and National Identity: Okakura Tenshin and His Circle.

35. Yamanashi, Egakareta rekishi: Nihon kindai to "rekishiga" no jijō.

36. Ajioka Chiaki and John Clark, "The New Mainstream," Modern Boy, Modern Girl: Modernity in Japanese Art, 1910–1935, p. 67.

37. Translated and quoted in Thomas Rimer and Shūji Takashina, Paris in Japan: The Japanese Encounter with European Painting (St. Louis: Washington University Press, 1987), p. 60.

38. Erin E. Kelley, "Confronting Modernity: Shirakaba and the Japanese Avant-Garde" (PhD diss., University of Pennsylvania, 2012).

39. For a study on Bakusen and his group, see Szostak, Painting Circles.

40. Weisenfeld, MAVO.

41. George Tiberiu Sipos, "The Literature of Political Conversion (Tenkō) of Japan" (PhD diss., University of Chicago, 2013), p. 30.

42. George M. Beckmann, Japanese Communist Party, 1922–1945 (Stanford, CA: Stanford University Press, 1969); Miriam Silverberg, Changing Song: The Marxist Manifestos of Nakano Shigeharu (Princeton, NJ: Princeton University Press, 1990); Samuel Perry, Recasting Red Culture in

Proletarian Japan: Childhood, Korea, and the Historical Avant-Garde (Honolulu: University of Hawai'i Press, 2014).

43. *Shōwa no bijutsu* [Art of the Showa Period], exh. cat. (Niigata, Japan: Niigata Prefectural Museum of Modern Art, 2005); Okamoto Tōki and Matsuyama Fumio, *Nihon puroretaria bijutsushi* [The History of Japanese Proletarian Art] (Tokyo: Zōkeisha, 1967); Christopher Gerteis, "Political Protest in Interwar Japan-1: Posters and Handbills from the Ohara Collection (1920s–1930s)," *Visualizing Cultures: Image-Driven Scholarship.* http://ocw.mit.edu/ans7870/21f/21f.027/protest _interwar_japan/index.html (accessed on June 25, 2017); Heather Bowen-Struyk, "Proletarian Arts in East Asia," *Asia-Pacific Journal,* April 16, 2007, http://www.japanfocus.org/-Heather-Bowen-Struyk/2409 (accessed on June 25, 2017).

44. There was a great deal of interaction between literature and visual arts in the early twentieth century, which Murayama represents. For more on this, see *Shōwa Modan: Kaiga to bungaku 1926–1936* [Showa Modern: Paintings and Literature 1926–1936] (Hyogo: Hyogo Prefectural Museum, 2013).

45. Hanneman, *Japan Faces the World: 1925–1952*, p. 57. Many Asians were subjected to atrocities at the hands of the Japanese. These included the Nanjing Massacre in 1937, systematized sex slavery, biological experimentation, and forced labor.

46. The Peace Preservation Law came into effect in 1925. Ienaga Saburō, *The Pacific War, 1931–1945* (New York: Pantheon, 1978), p. 113.

47. Sipos, "The Literature of Political Conversion (Tenkō) of Japan," p. 14.

48. Ibid., p. 6.

49. Ibid., p. 3.

50. Ibid., p. 9.

51. For more on Murayama's *tenkō* literature, see Yukiko Shigeto, "The Politics of Writing: Tenkō and the Crisis of Representation" (PhD diss., University of Washington, 2009), p. 67. For more on *tenkō* literature in general, see Jennifer Cullen, "A Comparative Study of Tenkō: Sata Ineko and Miyamoto Yuriko," *Journal of Japanese Studies* 36, no. 1 (Winter 2010): 65–96; Yukiko Shigeto, "Tenkō and Writing: The Case of Nakano Shigeharu," *positions* 22, no. 2 (Spring 2014): 517–540.

52. According to Young, in the first month after the Manchurian Incident, "1,655,410 people (out of a population of 65,000,000) attended 1,866 events held nationwide." Young, *Japan's Total Empire*, p. 136.

53. In the National Spiritual Mobilization Movement (Kokumin seishin sōdōin undō) in 1937, nationalist organizations rallied the nation, promoting war with (very creative) catchphrases such as "extravagance is the enemy" (*zeitaku wa teki da*) and "covet nothing until we win" (*hoshigarimasen katsu made wa*), and prohibiting such things as permed hair, dance halls, Hollywood movies, and Western loan words.

54. Shillony, *Politics and Culture in Wartime Japan*, p. 93.

55. Gennifer Weisenfeld, "Touring 'Japan-as-Museum': *NIPPON* and Other Japanese Imperialist Travelogues," *positions* 8, no. 3 (Winter 2000): 747–793.

56. Kaneko, "Art in the Service of the State," pp. 135–137.

57. Ruoff, *Imperial Japan at Its Zenith*, p. 13.

58. For more on Matsumoto, see Sandler, "The Living Artist: Matsumoto Shunsuke's Reply to the State"; Winther-Tamaki, "Embodiment/Disembodiment: Japanese Painting during the Fifteen-Year War"; Kozawa, *Avan garudo no sensō taiken*; Kaneko, *Mirroring the Japanese Empire*.

59. Kozawa, *Avan garudo no sensō taiken*, p. 75.

60. Surrealists had also been labeled as "unhealthy" and authorities had questioned their link to "dangerous" thoughts about communism. Clark, "Artistic Subjectivity in the Taisho and Early Showa Avant-Garde," p. 48.

61. Kozawa, *Avan garudo no sensō taiken*, p. 80.

62. For more on drafted art students, see Kuboshima, *Mugonkan nōto*.

63. Kawata, "Sensō-ga towa nanika"; Kawata and Tan'o, *Imēji no nakano sensō: Nisshin, nichiro sensō kara rēsen made*; Hariu Ichirō et al., *Sensō to bijutsu 1937–1945*.

64. Hariu et al., *Sensō to bijutsu*, p. 283.

65. It was generally agreed that Japanese-style paintings were not suitable for realism and depicting the war, but some Japanese-style painters, including Kawabata Ryūshi, Hashimoto Kansetsu, and Dōmoto Inshō, painted contemporary battles and soldiers as well.

66. Akiyama Kunio, "Honnendo kirokuga ni tsuite" [On This Year's Record Paintings], *Bijutsu*, May 1944, p. 2.

67. For more on this specific painting, see Winther-Tamaki, "Embodiment/Disembodiment: Japanese Painting during the Fifteen-Year War"; Aya Louisa McDonald, "Fujita Tsuguharu: An Artist of the Holy War Revisited," *Art and War in Japan and Its Empire*.

68. "Militarism," *The Oxford Essential Dictionary of the U.S. Military* (London: Oxford University Press, 2001).

69. Hariu et al., *Sensō to bijutsu*, p. 285.

70. Furuta, "Taikan shōron: Umi yama ni chinande," p. 12; "Taikan dono ni hōkoku" [Mr. Yokoyama Serving the State], *Asahi shimbun*, April 13, 1941.

71. Hariu et al., *Sensō to bijutsu*, p. 285.

72. "Bijutsu no gosan" [Lunch over Art], *Asahi shimbun*, September 28, 1938.

73. "Shisetsu ni Inoue Kaoru" [Inoue Kaoru as Ambassador], *Asahi shimbun*, November 12, 1938.

74. Yoshifuku Teizō, "Jikyoku to Shōen no geijutsu" [The War and Shōen's Art], *Kokuga*, April 1942, p. 17.

CHAPTER TWO: YOKOYAMA TAIKAN'S PAINTINGS OF MOUNT FUJI

1. Tansman, *The Aesthetics of Japanese Fascism*, p. 3.

2. Ibid.

3. Ibid., p. 18.

4. In contrast to the lack of scholarship on him and his art in English-speaking countries. At the moment, there is no monograph, solo exhibition, or even PhD dissertation that focuses solely on this artist. For scholarship on the artist in Japanese, see Furuta, "Taikan shōron: Umi yama ni chinande"; Kitazawa, "Modanizumu to sensō-ga: Yokoyama Taikan to iu mondai"; Kawata, "Gūi ni kaete" [Instead of Allegory]"; Shibazaki, *Efude no nashonarizumu*.

5. Weston, *Japanese Painting and National Identity*, pp. 1, 3.

6. Ellen Conant, *Nihonga: Transcending the Past: Japanese-Style Painting, 1868–1968*, p. 27.

7. Furuta, "Taikan shōron: Umi yama ni chinande," p. 12; "Taikan dono ni hōkoku" [Mr. Yokoyama Serving the State], *Asahi shimbun*, April 13, 1941.

8. Yokoyama Taikan, "Nihon bijutsu shintaisei no teishō" [Proposal of the New Order in Japanese Art], *Bijutsu to shumi*, January 1941; *Asahi shimbun*, January 5, 1941; *Bi no kuni*, February 1941.

9. Gordon, *Labor and Imperial Democracy in Prewar Japan*, p. 325.

10. "Kokubō kokka to bijutsu: Gaka wa nani o subekika" [National Defense and Art: What Should Artists Do?], *Mizue*, January 1941, p. 132.

11. Suzuki Kurazō is reputed to have been the most infamous military officer regarding Japan's war-time press control. He evidently threatened uncooperative publishers by saying that the state would not distribute their papers. For his biography and influence on wartime censorship, see Satō Takumi, *Genron tōsei: Jōhōkan Suzuki Kurazō to kyōiku no kokubōkokka* [Press Control: Information Officer Suzuki Kurazō and the Teaching of National Defense] (Tokyo: Chūō kōron shinsha, 2004).

12. "Furansu bijutsu wa doko e iku," p. 221.

13. "Kokubō kokka to bijutsu: gaka wa nani o subekika," p. 131.

14. Uemura Takachiyo, "Nachisu geijutsu seisaku no zenyō" [Nazi Art in its Entirety], *Atorie*, October 1937. Eugène Wernert's original text was *L'Art dans le III Reich: Une tentative d'esthétique dirigée* (Paris: Paul Harmann, 1936). In addition to statements about Nazi art, a number of photographs of German paintings, sculptures, and architecture were published in the art magazine *Bijutsu* in August 1944, showing the readers what they actually looked like.

15. Uemura, "Nachisu geijutsu seisaku no zenyō," p. 2.

16. Ibid., pp. 9–14.

17. "Kokubō kokka to bijutsu: gaka wa nani o subekika," p. 133.

18. Ibid., p. 129.

19. "Furansu bijutsu wa dokoe iku" [Where Will French Art Go?], *Mizue,* August 1940, pp. 220–221.

20. Ibid., p. 222.

21. Yokoyama, "Nihon bijutsu shintaisei no teishō," *Asahi shinbun,* January 5, 1941.

22. J. Thomas Rimer, "'Teiten' and After, 1919–1935," in Conant, *Nihonga,* p. 44.

23. Sandler, "The Living Artist: Matsumoto Shunsuke's Reply to the State," p. 75; Michael Lucken, "Total Unity in the Mirror of Art," trans. Francesca Simkin, *Art and War in Japan and Its Empire,* p. 84; Thomas J. Rimer, "Encountering Blank Spaces: A Decade of War, 1935–1945," *Transcending the Past,* pp. 57–58.

24. *Kokuga,* June 1943. Reprinted in *Nihon bijutsuin hyakunenshi,* vol. 7 [One-Hundred-Year History of Nihon Bijutsu in] (Tokyo: Nihon bijutsuin, 1998), p. 849.

25. Ōkuma, "Kawaru Fuji, Kawaranu Fuji," p. 114.

26. For more on the history of Mount Fuji in Japanese literature and art, see Haruo Shirane, *Early Modern Japanese Literature: An Anthology, 1600–1900* (New York: Columbia University Press, 2013), p. 99; Haruo Shirane, *Japan and the Culture of the Four Seasons: Nature, Literature, and the Arts* (New York: Columbia University Press, 2012), p. 26; Nakamachi Keiko, "Ukiyo-e Memories of Ise Monogatari," trans. Henry Smith and Miriam Wattles, *Impressions* 22 (2000): 61.

27. Collcutt, "Mt. Fuji as the Realm of Miroku," p. 251. A number of books have been published in Japanese on the worship of Mount Fuji. See, for example, Inobe Shigeo, *Fuji no shinkō* [Devotion to Mt. Fuji] (Tokyo: Meichō shuppan, 1983). See also H. Byron Earhart, "Mount Fuji and Shugendo," *Japanese Journal of Religious Studies* 16, no. 2–3 (1989): 205–226.

28. Mount Fuji was enshrined by numerous Asama and Sengen shrines built around the mountain, and was thought of as a physical manifestation of the female deity Konohana Sakuya Hime, the deity of Fuji and all volcanic mountains. Konohana, who appears in Japan's ancient mythological texts, *The Records of Ancient Matters* (*Kojiki*) and *The Chronicle of Japan* (*Nihon shoki*), is the wife of Ningi, who is the grandson of the most important deity in Shinto, the sun goddess Amaterasu.

29. Collcutt, "Mt. Fuji as the Realm of Miroku," p. 252. In this context, the Shinto form of worship came to be closely entangled with Buddhist beliefs and practices, which was supported by the *honji suijaku* theory that posits that Amaterasu is a Japanese manifestation of the Buddha. The syncretic belief that combines both Shinto and Buddhism later gave birth to another religious group, Shugendō, a group of mountain ascetics called *yamabushi*. They climbed the mountain in hopes of gaining spiritual refinement and magical powers, encountering sacred figures, and ultimately attaining enlightenment

30. Christine Guth Kanda and Kageyama Haruki, *Shinto Arts: Nature, Gods, and Man in Japan* (New York: Japan Society, 1976), p. 142.

31. Ibid., p. 22.

32. Collcutt, "Mt. Fuji as the Realm of Miroku," p. 257; Melinda Takeuchi, "Making Mountains: Mini-Fujis, Edo Popular Religion and Hiroshige's One Hundred Famous Views of Edo," *Impressions* 24 (2002): 24–47; Andrew Bernstein, "Whose Fuji? Religion, Region, and State in the Fight for a National Symbol," *Monumenta Nipponica* 63, no. 1 (Spring 2008): 51–99.

33. For more on Edo-period visual representations of Mount Fuji in woodblock prints, in addition to Takeuchi's "Making Mountains," see Chris Uhlenbeck and Merel Molenaar, *Mount Fuji: Sacred Mountain of Japan* (Leiden: Hotei Publishing, 2000). For the most recent scholarship on Hokusai's Mount Fuji, see Christine M. E. Guth, *Hokusai's Great Wave: Biography of a Global Icon* (Honolulu: University of Hawai'i Press, 2015).

34. Kawata, "Fujizu no kindai," p. 7. Another exhibition that critically investigated the Japanese "obsession" with the mountain is Kohara, *Fuji zenkei: Kindai Nihon to Fuji no yamai.*

35. Quoted by Kawata, "Fuji no kindai," p. 7. Originally in Shurīman, *Shurīman ryokōki: Shinkoku Nihon,* trans. Ishii Kazuko (Tokyo: Kōdansha, 1998) and Suenson, *Edo bakumatsu daizaiki,* trans. Nagashima Yōichi (Tokyo: Kōdansha, 2003).

36. "The Early Years of Japanese Photography," *The History of Japanese Photography*, Anne Wilkes Tucker et al. (New Haven, CT: Yale University Press, 2003); Allen Hockley, "Expectation and Authenticity in Meiji Tourist Photography," in *Challenging Past and Present: The Metamorphosis of Nineteenth-Century Japanese Art*, ed. Ellen P. Conant (Honolulu: University of Hawai'i Press, 2006). The Nagasaki University Library Collection, Metadata Database of Japanese Old Photographs in Bakumatsu-Meiji Period provides the largest collection of Yokohama photographs accessible to the public online at oldphoto.lb.nagasaki-u.ac.jp/jp/index.html (accessed August 11, 2014).

37. Kawata, "Fujizu no kindai," p. 7.

38. *Kokutai no hongi*, trans. Gauntlett, p. 59. The original document is available online in the National Diet Library's digital collection: http://dl.ndl.go.jp/info:ndljp/pid/1156186 (accessed March 19, 2015).

39. Yokoyama Taikan, "Fuji no tamashii" [The Spirit of Mt. Fuji], *Yomiuri shimbun*, February 15, 1942.

40. This translation of the poem is from *Kokutai no hongi*, p. 130.

41. *Four Japanese Painters* (Tokyo: Japan Photo Service, 1939), p. 7.

42. Winther-Tamaki, "Embodiment/Disembodiment," 162.

43. Akiyama Kenzō, "Fuji wo aogu kokoro: Nihon no rekishi to gaijin" [The Heart that Worships Mt. Fuji: The History of Japan and Foreigners], *Asahi shimbun*, November 30, 1940.

44. For more on the celebration, see Ruoff, *Imperial Japan at Its Zenith*.

45. Ibid., p. 17.

46. *Shōwa no bijutsu*, p. 190.

47. Suzuki Susumu, "Hōshuku bijutsu ten Nihon-ga sōhyō" [Review of the Celebration of the 2600th Anniversary of the Imperial Reign Exhibition], *Tōei*, December 1940, p. 23; *Yasuda Yukihiko ten: Botsugo 30 nen* (Ibaraki Prefectural Museum of Modern Art, 2009), p. 157.

48. Kanzaki Ken'ichi, "Kigen nisen roppyakunen hōshuku bijutsuten kōki daiichibu shōhyō," *Tōei* (December 1940), p. 35.

49. Taikan, "Fuji no tamashii."

50. "Nihon bijutsu no seishin" was first published in *Bi no kuni* in November 1938 and then in *Kaizō* in April 1939.

51. Quoted in Winther-Tamaki, "Embodiment/Disembodiment," p. 162. Originally in Kawaji Ryūkō, "Risō gaka Yokoyama Taikan" [Idealist Painter Yokoyama Taikan], *Nihon bijutsu*, July 1943, p. 8.

52. Quoted in Winther-Tamaki, "Embodiment/Disembodiment," p. 162. Originally in Tōyama Takashi, "Yokoyama Taikan gahaku no seishin" [The Spirit of Painter Yokoyama Taikan], *Nihon Bijutsu*, July 1943, p. 18.

53. *Four Japanese Painters*, p. 9.

54. Okakura Tenshin, "Nature in East Asiatic Painting," *Okakura Kakuzo: Collected English Writings* (Tokyo: Heibonsha, 1984 [1911]), p. 146.

55. Chatterjee, *The Nation and Its Fragments: Colonial and Postcolonial Histories*, p. 121.

56. Okakura, *The Ideal of the East*, p. 224.

57. *Four Japanese Painters*, p. 12.

58. Yokoyama Taikan, "Nihon bijutsu no seishin" [The Spirit of Japanese Art], *Kaizō*, June 1939. Reprinted in *Nihon bijutsuin hyakunenshi*, vol. 7, p. 838.

59. Taikan, "Fuji no tamashii."

60. This visual combination of soldiers and Mount Fuji was probably an invention of the Second World War. The Sino-Japanese and Russo-Japanese War prints frequently show soldiers with the sun, but almost never with the mountain. For the earlier war prints, see the MIT Visualizing Culture website, http://ocw.mit.edu/ans7870/21f/21f.027/throwing_off_asia_02/index.html (accessed December 5, 2014).

61. Earhart, *Certain Victory*, p. 210.

62. Itakura "Yokoyama Taikan no naka no chūgoku," pp. 152–157.

63. *Botsugo gogojūnen: Yokoyama Taikan aratanaru densetsu e*, p. 172.

64. Aida Yuen Wong, "A New Life for Literati Painting in the Twentieth Century: Eastern Art and Modernity, a Transcultural Narrative?" *Artibus Asiae* 60, no. 2 (2000): 297–326.

65. *Four Japanese Painters,* p. 9.
66. Ibid., p. 10.
67. "The Six Laws of Xie He," trans. and ed. William Reynolds Beal Acker, in *Asian Art: An Anthology,* ed. Rebecca Brown and Deborah S. Hutton (Malden, MA: Blackwell), p. 242. The Chinese word "qiyun" has been translated as "kiin" in Japanese.
68. Patricia Ebrey, "Shifting South: The Song Dynasty 907–1276," *The Cambridge Illustrated History of China* (Cambridge: Cambridge University Press, 1996), p. 140.
69. Yukio Lippit, "House Manners," *Painting of the Realm: The Kano House of Painters in Seventeenth-Century Japan* (Seattle: University of Washington Press, 2012).
70. *Fuji zenkei: Kindai Nihon to Fuji no yamai,* p. 37.
71. Kawata, "Fuji no kindai," p. 10.
72. The visual combination of Fuji and the sun does have precedents: a print by Kitao Shigemasa (1739–1820) portrays Saigyō-Hōshi admiring Mount Fuji and the sun from a distance. Another Fuji painting by Kanō Tan'yū from 1665, which is now at the Itabashi Art Museum, Tokyo, also shows Mount Fuji with the sun, though the sun is half concealed behind mountain-like shapes. However, the combination was never used as prominently in pre-modern Japanese art as in Taikan's works.
73. "Bijutsu no gosan" [Lunch over Art], *Asahi shimbun,* September 28, 1938.
74. Ibid.
75. "Shisetsu ni Inoue Kaoru" [Inoue Kaoru as Ambassador], *Asahi shimbun,* November 12, 1938.
76. The exhibition occupied twenty-four rooms at the German History Museum, and started on February 25, 1939. "Miryoku hatsu no Nihon kokuhin," *Asahi shimbun,* January 28, 1939.
77. Maruo Shōsaburō, "Bijutsu ai no nichi doku kōryū" [Japan-Germany Relationship through Art], *Tōei,* October 1940, p. 5.
78. Yasumatsu Miyuki, "1939 nen no berurin Nihon kobijutsu tenrankai to shimbun, zasshi hihyō: kokka ishiki to bijutsu no kankei wo sihyōnishite" [The 1939 Japanese Ancient Art Exhibition in Berlin and Its Reviews in Newspapers and Magazines: On Relations between Nationalist Consciousness and Art], *"Teikoku" to bijutsu: 1930 nendai Nihon no taigai bijutsu senryaku* ["Empire" and Art: Diplomatic Strategies of Art in 1930s Japan], ed. Omuka Toshiharu (Tokyo: Kokusho kankōkai, 2010), p. 151.
79. Yasumatsu, "1939 nen no berurin Nihon kobijutsu tenrankai," p. 153.
80. "Doitsu e bijutsu hōsō" [Radio Broadcast on Art to Germany], *Asahi shimbun,* April 22, 1939.
81. Taikan traveled to Rome in 1933 on the occasion of a Japanese art exhibition in the city under the regime of Mussolini.
82. *Four Japanese Painters.*

CHAPTER 3: YASUDA YUKIHIKO'S *CAMP AT KISEGAWA* AND MODERN AESTHETICS

1. Kanzaki Ken'ichi, "Kigen nisen roppyakunen hōshuku bijutsuten kōki daiichibu shōhyō" [The Review of the Celebration of the 2600th Anniversary of the Imperial Reign Exhibition], *Tōei,* December 1940, p. 35; Endō Motoo, "Rekishi-ga no gendaiteki igi" [The Contemporary Meanings of History Paintings], *Kokuga,* April 1943, p. 5.
2. *Yasuda yukihiko ten* (Nagoya: Aichi Prefectural Museum, 1993), p. 157.
3. Kikuya, "Shōwa zenki ni okeru inten to sono hasei dantai to no kankei," p. 350.
4. *Yasuda Yukihiko ten: Botsugo 30 nen,* pp. 66–67.
5. Herf, *Reactionary Modernism;* Antliff, "Fascism, Modernism, and Modernity"; Hewitt, "Fascist Modernism, Futurism, and 'Post-Modernity'"; Affron and Antliff, *Fascist Visions: Art and Ideology in France and Italy.*
6. *Yasuda yukihiko ten,* pp. 157–158. The only statement about the painting that the artist made was that he "wanted to show a contrast between Yoritomo, who is promised a bright future, and Yoshitsune, whose face evokes a hint of his tragic ending." Yasuda Yukihiko, "Jisaku no ben" [A Statement about My Work], *Asahi shimbun,* November 13, 1940.

7. Kanzaki, "Kigen nisen roppyakunen hōsyuku bijutsu ten kōki dai ichibu shōhyō," p. 29.

8. Miyeko Murase, "Japanese Screen Paintings of the Hōgen and Heiji Insurrections," *Artibus Asiae* 29 2/3 (1967): 193–228.

9. Haruo Shirane, "The Tales of the Heike" [*Heike monogatari*], *Traditional Japanese Literature: An Anthology, Beginnings to 1600* (New York: Columbia University Press, 2008), p. 707.

10. The other important painting that was produced by a Japanese-style painter about Yoshitsune during the war was Kawabata Ryūshi's *Genghis Khan* (1938), which represents the legend that the warrior later became Genghis Khan in central Asia. Ryūshi is an interesting artist who started out as a Western-style painter but switched to Japanese style later in his career. He was prominently active during the war, producing a wide range of subjects—a soldier in an airplane, a soldier praying in front of the Great Buddha in China, and Shinto water deities with bombs. In-depth analysis of his wartime works has yet to appear, however.

11. Benesch, "Bushido: The Creation of a Martial Ethic in Late Meiji Japan," p. 15.

12. Hanneman, *Japan Faces the World: 1925–1952*, p. 79.

13. Dower, *War without Mercy*, p. 264.

14. *Kokutai no hongi*, p. 98.

15. Dower, *War without Mercy*, p. 264.

16. Varley, *Warriors of Japan as Portrayed in the War Tales*, p. 126.

17. Ibid., p. 156.

18. Morris, *The Nobility of Failure: Tragic Heroes in the History of Japan*.

19. Hattori Yukio et al., *Kabuki jiten* [Kabuki Encyclopedia] (Tokyo: Heibonsha, 2000), pp. 130, 354, 400.

20. Suzuki, "Hōshuku bijutsu ten Nihonga sōhyō," pp. 25–26; Kanzaki, "Kigen nisen roppyakunen hōshuku bijutsuten kōki daiichibu shōzō," p. 35.

21. Originally in Kawasaki Katsu, "Hōshuku-ten ni yosu" [On the Celebration Exhibition], *Tōei*, December 1940. Quoted in Maeda, "Senjika ni okeru bijutsu to bijutsu hihyō: Yasuda Yukihiko's Kisegawa no jin wo chūshin ni," p. 80.

22. Okazaki Yoshie, "Gendai Nihonga to kokumin sei" [Contemporary Japanese-Style Painting and Its National Characteristics], *Kokuga*, May 1942, p. 2.

23. These Japanese aesthetics were considered "untranslatable" and seen as standing for qualities unique to the Japanese people. See Pincus, *Authenticating Culture*; Ueda, "Yūgen and Erhabene: Ōnishi Yoshinori's Attempt to Synthesize Japanese and Western Aesthetics."

24. Okazaki Yoshie, "Gendai Nihonga to kokumin sei," p. 3.

25. Ibid., p. 4.

26. Kinbara Seigo, "Gendai Nihonga ron" [Theory of Contemporary Japanese-Style Painting], *Kokuga*, May 1942, p. 9.

27. Penelope Mason, *History of Japanese Art* (New York: H. N. Abrams, 1993), p. 168.

28. Special Issue on Buke no shōzō [Portraits of Warriors], *Nihon no bijutsu*, June 1998, p. 17.

29. Miyeko Murase, "Court and Samurai in an Age of Transition," *Court and Samurai in an Age of Transition: Medieval Paintings and Blades from the Gotoh Museum, Tokyo* (New York: Japan Society, 1989), p. 15.

30. Ōta Aya, Special Issue on Mōko shūrai ekotoba [The Illustrated Account of the Mongol Invasion], *Nihon no bijutsu*, November 2000. For a comprehensive study of this scroll in English, see Thomas D. Conlan, *In Little Need of Divine Intervention: Takezaki Suenaga's Scroll of the Mongol Invasions of Japan* (Ithaca: Cornell University East Asia Program, 2001).

31. Ogawa Morihiro, *Art of the Samurai: Japanese Arms and Armor, 1156–1868* (New York: Metropolitan Museum of Art, 2009), p. 18.

32. Yamanashi, *Egakareta rekishi*.

33. Erin E. Kelley, "Confronting Modernity: Shirakaba and the Japanese Avant-Garde" (PhD diss., University of Pennsylvania, 2012).

34. Alicia Volk, *In Pursuit of Universalism: Yorozu Tetsugoro and Japanese Modern Art* (Berkeley: University of California Press, 2010).

35. For more on Tsuchida Bakusen, see Szostak, *Painting Circles.*
36. Trans. Szostak, *Painting Circles,* pp. 234–235.
37. Ibid., p. 234.
38. Ikeda, "Modern Girls and Militarism: Japanese-Style Machine-ist Paintings, 1935–1940."
39. Many of them were displayed in the recent North American exhibitions at the Honolulu Academy of Art (*Taisho Chic: Japanese Modernity, Nostalgia, and Deco,* 2002) and the Museum of Fine Arts, Boston (*Showa Sophistication: Japan in the 1930s,* 2009).
40. In my previous research, based on the Miyako shimbun of 1936, I decided to tentatively call these paintings "machine-ist" (*mekanizumu* or *kikaishugi*) paintings. "Nihon-ga nimo mekanizumu" [Machine Aesthetics, Also in Japanese-Style Painting], *Miyako shimbun,* September 10, 1936.
41. A similar development to machine-ist painting in crafts can be located in Art Deco. Brown, "Japan and 'Art Deco,'" *Deco Japan: Shaping Art and Culture, 1920–1945,* p. 11. The term "Art Deco" was coined retrospectively in the 1960s and refers to aesthetic sensibilities seen at the 1925 *Exposition Internationale des arts décoratifs et industriels modernes* held in Paris. Charlotte Benton and Tim Benton identify Art Deco as a cosmopolitan style of art developed between 1910 and 1939 that was closely connected to capitalist consumerism and that embraced the two-dimensional, simplified shapes of electronics and mechanics such as streamline and zigzag. Charlotte Benton and Tim Benton, "The Style of the Age," *Art Deco 1910–1939.*
42. Johnson, foreword to *Machine Art,* n.p.
43. Here it is useful to bring up the modern movement called *Shinkō yamato-e* (The New Yamato-e), which was headed by Matsuoka Eikyū (1881–1938) and began in 1921. As Nagashima Keiya points out, the New Yamato-e Movement artists, such as Iwata Masami (1893–1988), produced works that included extensive landscapes until the early 1930s, and it was only after Matsuoka's death in 1938 that Iwata's paintings began featuring prominent blank backgrounds. This clearly shows that interest in *yamato-e* did not necessarily lead to art in the *style* of *yamato-e;* the works in fact predominantly revisited its *subject matter.* Nagashima Keiya, "Taishō, shōwa senzenki ni okeru Iwata Masami no gafū henka ni tsuite" [On Iwata Masami's Artistic Trajectory in the Taisho, Showa, and Prewar Periods], *The Niigata Bandaijima Art Museum Research Bulletin* (March 2010): 17–25.
44. Originally in Fukuda Toyoshirō, "Shin Nihonga no dōkō ni tsuite" [The Direction of New Japanese-Style Paintings], *Tōei,* September 1937. Quoted in Shōji Jun'ichi, "Modanisuto no kikyō: Fukuda Toyoshirō no kaiga shisō to furusato" [The Modernist's Return Home: Fukuda Toyoshirō's Idea of Painting and Rural Home], *Fukuda Toyoshirō ten* [The Fukuda Toyoshirō Exhibition] (Akita: Akita Museum of Modern Art, 2004), p. 10.
45. Hasegawa Saburō, "Zenei bijutsu to tōyō no koten," *Mizue,* February 1937, pp. 146–152.
46. Between 1940 and 1942, Le Corbusier's student Charlotte Perriand was also in Japan, working for the Ministry of Trade and Industry.
47. Taut, *Nihonbi no saihakken,* pp. 14–15.
48. Kikuchi, *Japanese Modernization and Mingei Theory: Cultural Nationalism and Oriental Orientalism,* p. 99. Originally published in Taut, "Nihon deno watakushi no shigoto" [My Work in Japan], p. 4.
49. For Taut's role in Japan in the 1930s and his influence on Japanese architecture, see Jacqueline Eve Kestenbaum, "Modernism and Tradition in Japanese Architectural Ideology, 1931–1955" (PhD diss., Columbia University, 1996), p. 204.
50. At Ise Shrine, the main building is rebuilt every twenty years. For this reason, there are two identical sites next to each other. One is in use when the other is being rebuilt. William H. Coaldrake, "Ise Jingu," *Asian Art: An Anthology,* ed. Rebecca Brown and Deborah S. Hutton (Oxford: Blackwell, 2006).
51. McLeod, "'Architecture or Revolution': Taylorism, Technocracy and Social Change," 135.
52. Reynolds, *Maekawa Kunio and the Emergence of Japanese Modernist Architecture,* pp. 59–69.
53. Ibid., p. 97.
54. Weisenfeld, "Publicity and Propaganda in 1930s Japan: Modernism as Method," 13–28.
55. Ibid., p. 20.

56. Commodification of politics in fascism has in fact been the focus of some authors who work on Italian and German fascism. Falasca-Zamponi, *Fascist Spectacle*; Koepnick, "Fascist Aesthetics Revisited."

57. Numerous scholars—including Mark Antliff, Jeffery Schnapp, Emily Braun, Diane Y. Ghirardo, Ian Boyd Whyte, Terri J. Gordon, Winfried Nerdinger, and John Heskett—have shown how modern aesthetics in the field of architecture, design, painting, dance, and theater were appropriated by European fascism.

58. Braun, "Political Rhetoric and Poetic Irony: The Uses of Classicism in the Art of Fascist Italy," p. 347.

59. *Chaos and Classicism: Art in France, Italy, and Germany, 1918–1936.*

60. Kikuya, "Showa zenki ni okeru inten to sono hasei dantai to no kankei"; Ōkuma, "Kankaku to kōsei no hazama de: 1930 nendai no Nihonga modanizumu."

CHAPTER 4: UEMURA SHŌEN'S *BIJIN-GA*

1. As with Yokoyama Taikan and Yasuda Yukihiko, the two other Japanese-style painters examined in this book, there are a number of Japanese-language publications on Shōen, but little written about her in English. For previous studies of this artist, see Kusanagi Natsuko, *Uemura Shōen,* exh. cat. (Tokyo: Shinchō Nihon bijutsu bunko, 1996); *Uemura Shōen ten,* exh. cat. (Tokyo: Asahi Newspaper Company, 1999); *Bijinga no keifu ten: Uemura Shōen, Kaburaki Kiyokata, Itō Shinsui,* exh. cat. [The Genealogy of *Bijin-ga:* Uemura Shōen, Kaburaki Kiyokata, Itō Shinsui] (Kagoshima: Kagoshima City Museum, 1999); *Uemura Shōen ten,* exh. cat. (Tsu: Mie Prefectual Museum, 2004); *Uemura Shōen: Kindai to dentō,* exh. cat. [Uemura Shōen: Modernity and Tradition] (Fukushima: Fukushima Prefectural Museum, 2007); Katō Ruiko, *Uemura Shōen to sakuhin* [Uemura Shōen and Her Works] (Tokyo: Tokyo bijutsu, 2007); *Bi no daikyōen: Uemura Shōen, Kaburaki Kiyokata, Itō Shinsui,* exh. cat. [The Competition of Beauty: Uemura Shōen, Kaburaki Kiyokata, and Itō Shinsui] (Aichi: Meito Art Museum, 2008); *Uemura Shōen,* exh. cat. (Tokyo: National Museum of Modern Art, Tokyo, 2010).

 For English-language publications on the artist, see Yamada Nakako and Helen Merritt, "Uemura Shōen: Her Paintings of Beautiful Women," *Woman's Art Journal* 13, no. 2 (Autumn 1992–Winter 1993): 12–16; Morioka, "Changing Images of Women: Taisho Period Paintings by Uemura Shoen (1875–1949), Ito Shoha (1877–1968), and Kajiwara Hisako (1896–1988)"; Wakakuwa, "Three Women Artists of the Meiji Period (1868–1912): Reconsidering their Significance from a Feminist Perspective"; Michiyo Morioka and Paul Berry, *Modern Masters of Kyoto: Transformation of Japanese Painting Traditions, Nihonga from the Griffith and Patricia Way Collection* (Seattle: Seattle Art Museum, 2000).

2. Kimura Shigeo, "Nihon fujo zu kō" [Thinking about Images of Japanese Women], *Kokuga,* April 1942, pp. 7–11; Yoshifuku Teizō, "Jikyoku to Shōen no geijutsu" [Contemporary Politics and Shōen's Art], *Kokuga,* April 1942, p. 17.

3. Uemura Shōen, *Seibishō* (Tokyo: Kōdansha, 1977 [1943]), p. 52.

4. Morioka, "Changing Images of Women," p. 180.

5. *Kokuga,* April 1942; *Bi no kuni,* July 1942.

6. *Uemura Shōen,* exh. cat. (Tokyo: National Museum of Modern Art, Tokyo, 2010), pp. 199–202.

7. Yoshifuku Teizō, "Jikyoku to Shōen no geijutsu" [The War and Shōen's Art], *Kokuga,* April 1942, p. 17.

8. Uemura Shōen, "Seikaken zakki," *Seibishō,* p. 74. This is Morioka's translation. Morioka, "Changing Images of Women," p. 82.

9. Kitō Minako, "Shōen geijutsu ni yadoru hinkaku towa: Nōgaku sekai ni miru seishin sei wo tegakari ni" [On the Elegance in Shōen's Works: The Spiritual World of Noh as a Hint], *Uemura Shōen: Kindai to dentō.*

10. Haruo Shirane, *Traditional Japanese Literature: An Anthology, Beginnings to 1600* (New York: Columbia University Press, 2008), p. 917.

11. Ibid., p. 922.

12. Trans. J. Thomas Rimer and Yamazaki Masakazu, in Haruo Shirane, *Traditional Japanese Literature*, pp. 1039–1040.

13. Ibid., p. 1040.

14. Uemura Shōen, "Sōshi arai wo kaite" [Upon Painting Sōshi arai] (1937), *Seibishō sonogo* (Tokyo: Kyūryūdō, 1985), p. 216.

15. Uemura Shōen, "Muhyōjō no hyōjō (1937)" [Expression of Non-Expression], *Seibishō sonogo*, p. 166.

16. The idea that *noh* is Japan's "national" theater emerged in the Meiji period, supported by the government as well as by the Imperial Household Ministry (*kunaishō*). For nationalization of *noh*, see Eric C. Rath, "Rituals," *The Ethos of Noh: Actors and Their Art* (Cambridge, MA: Harvard University Asia Center, 2004).

17. Tanizaki Jun'ichirō, *In Praise of Shadows*, trans. Thomas J. Harper and Edward G. Seidensticker (New Haven, CT: Leete's Island Books, 1977 [1933]), p. 26.

18. Ibid., p. 33.

19. Another intellectual who is known for his theorization of *yūgen* is Nose Asaji. Nose, *Yūgen ron*.

20. Ueda, "Yūgen and Erhabene: Ōnishi Yoshinori's Attempt to Synthesize Japanese and Western Aesthetics," p. 289.

21. Originally in Ōnishi Yoshinori, *Yūgen to Aware*, pp. 99–100. Quoted in Ueda, "Yūgen and Erhabene," p. 291.

22. Ōnishi "Yūgen ron," pp. 547–550; Makoto Ueda, "Yūgen and Erhabene," p. 291. For more on Ōnishi, see Masao Yamamoto, "The Aesthetic Thought of Ōnishi Yoshinori"; Ken'ichi Sasaki, "Style in Japanese Aesthetics: Ōnishi Yoshinori," in *A History of Modern Japanese Aesthetics*, ed. F. Marra (Honolulu: University of Hawai'i Press, 2001); Michele Marra, "Ōnishi Yoshinori and the Category of the Aesthetic," *Modern Japanese Aesthetics: A Reader* (Honolulu: University of Hawai'i Press, 1999).

23. Hasegawa Nyozekan, "Nōgaku to Nihonteki seikatsu" [Noh and Japanese Life], *Nōgaku zenshū* [The Noh Collection], ed. Nogami Toyoichirō, vol. 1 (Tokyo: Sōgensha, 1943), pp. 328, 340–341.

24. Hasegawa, "Nōgaku to Nihonteki seikatsu," p. 343.

25. Importantly, *Bungakukai* published conversations that took place in the "Overcoming Modernity" symposium in the next issue.

26. Kamei Katsuichirō, "Gendai seishin ni kansuru oboegaki" [Notes on Contemporary Spirits], *Bungakukai*, September 1942. Reprinted in Taiekchi Yoshimi, ed., *Kindai no chōkoku* [Overcoming Modernity] (Tokyo: Fuzambō, 1979), p. 9.

27. Kamei, "Gendai seishin ni kansuru oboegaki," p. 9. Harootunian, *Overcome by Modernity*, p. 73.

28. Davis, *Picturing Japaneseness*, p. 2.

29. Ibid., pp. 136, 176–177.

30. For more on the artist, see Robert Schaap and J. Thomas Rimer, *The Beauty of Silence: Japanese Nō and Nature Prints by Tsukioka Kōgyo (1869–1927)* (Leiden: Brill, 2010).

31. Chatterjee, *The Nation and Its Fragments*.

32. Wakakuwa Midori, *Kōgō no shōzō: Shōken kōtaigō no hyōshō to jyosei no kokuminka* [Portraits of the Empress: Representations of Shōken Empress and Mobilization of Women] (Tokyo: Chikuma shobō, 2001).

33. Katō Ruiko, "Bijin-ga," in *Nihonga: Transcending the Past: Japanese-Style Painting, 1868–1968,* pp. 108–109.

34. Carol Gluck, "The Invention of Edo," in *Mirror of Modernity: Invented Traditions of Modern Japan,* ed. Stephen Valstos (Berkeley: University of California Press, 1998), p. 271.

35. Hiromi Nobuhiko, "Uemura Shōen kenkyū no ichidan shō / A Study on Uemura Shoen," *Idemitsu Museum of Art Journal of Art Historical Research* 14 (2008): 33–50.

36. Kuki Shūzō, *"Iki" no kōzō* (Tokyo: Iwanami shoten, 1930).

37. Hiroshi Nara, *The Structure of Detachment: The Aesthetic Vision of Kuki Shuzo: With a Translation of Iki no kozo* (Honolulu: University of Hawai'i Press, 2004), pp. 18–34.

38. Ibid., pp. 34–40.

39. Ibid., pp. 16–17.

40. Pincus, *Authenticating Culture in Imperial Japan*, p. 88. See also Joshua Mostow, "Utagawa Shunga, Kuki's 'Chic,' and the Construction of a National Erotics in Japan," in *Performing "Nation": Gender Politics in Literature, Theater, and the Visual Arts of China and Japan, 1880–1940*, ed. Doris Croissant, Catherine Vance Yeh, and Joshua S. Mostow (Leiden: Brill, 2008).

41. Okazaki Yoshie, "Gendai Nihonga to kokumin sei" [Contemporary Japanese-Style Painting and Its National Characteristics], *Kokuga*, May 1942, p. 3.

42. John Szostak, "'Fair Is Foul, and Foul Is Fair': Kyoto Nihonga Anti-Bijin Portraiture and the Psychology of the Grotesque," in *Rethinking Japanese Modernism*, ed. Roy Starrs (Leiden: Global Oriental, 2012), p. 364.

43. Ibid., p. 372.

44. Originally in Kajiwara Hisako, "Omoide no arubamu," *Bijutsu*, 1974. Quoted in Szostak, "'Fair Is Foul, and Foul Is Fair,'" p. 375.

45. *Kainoshō Tadaoto to Taishō ki no gaka tachi* [Kainoshō Tadaoto and Other Artists of the Taishō Period] (Chiba: Chiba City Museum, 1999), 11. Doris Croissant, "From Madonna to Femme Fatale: Gender Play in Japanese National Painting," *Performing "Nation": Gender Politics in Literature, Theater, and the Visual Arts of China and Japan, 1880–1940,* ed. Doris Croissant, Catherine Vance Yeh, and Joshua S. Mostow (Leiden: Brill, 2008), pp. 304–305.

46. Elizabeth de Sabato Winton, *The Women of the Pleasure Quarter: Japanese Paintings and Prints of the Floating World* (New York: Hudson Hill, 1996); Timon Screech, *Sex and the Floating World: Erotic Images in Japan, 1700–1820* (Honolulu: University of Hawai'i Press, 1999).

47. Wakakuwa, "Three Women Artists of the Meiji Period," p. 71.

48. Silverberg, *Erotic Grotesque Nonsense*, p. 5; "The Café Waitress Serving Modern Japan."

49. Kendall H. Brown, "Flowers of Taisho: Images of Women in Japanese Society and Art: 1915–1935," *Taisho Chic: Japanese Modernity, Nostalgia, and Deco*, p. 19; see also Silverberg, "The Modern Girl as Militant."

50. Uemura Shōen, "Teiten no bijin-ga" [*Bijin-ga* at Teiten] (1929), in *Seibishō sono go* (Tokyo: Kyūryūdō, 1985), pp. 33–34; Uemura Shōen, "Mayu no ki" [Notes on Eyebrows]; "Mage" [Hair] (n.d.), *Seibishō*, pp. 36, 42.

51. Thomas R. H. Havens, *Valley of Darkness: The Japanese People and World War Two* (New York: Norton, 1978), pp. 18, 51; Shillony, *Politics and Culture in Wartime Japan*, p. 148.

52. Conant, *Nihonga: Transcending the Past*, p. 328. Emphasis added.

53. The National Defense Women's Association was established in 1932, right after the Manchurian Incident, and boasted 9 million members at its height; the Greater Japan Women's Association, established in 1942, later subsumed the National Defense Women's Association. Kanō, *Onnatachi no jūgo*; Okano, *Onnatachi no sensō sekinin*.

54. Havens, *Valley of Darkness*, p. 15.

55. Ibid., p. 49.

56. Ibid., p. 50. These conditions also affected artistic production: sculpture, which was ordinarily made of and required bronze, steel and plaster, came to be made of clay and paper. Hirase Reita, "War and Bronze Sculpture," in *Art and War in Japan and Its Empire, 1931–1960*, ed. Ikeda, Tiampo, and McDonald, pp. 232–234. In *mingei*, wood had to be used instead of leather or metal. Kikuchi, *Japanese Modernisation and Mingei Theory*, p. 115.

57. Morris, *The Nobility of Failure: Tragic Heroes in the History of Japan*, p. 134.

58. Uemura Shōen, *Seibishō shūi* (Tokyo: Kōdansha, 1976), p. 135. The text is not dated, but may have been written in the early 1940s.

59. Wakakuwa, *Sensō ga tsukuru josei zō*, p. 35.

60. Miyake Yoshiko, "Doubling Expectations: Motherhood and Women's Factory Work under State Management in the 1930s and 1940s," in *Recreating Japanese Women, 1600–1945*, ed. Gail Lee Gernstain (Berkeley: University of California Press, 1991).

61. Vera Mackie and Miyume Tanji, "Militarised Sexualities in East Asia," *The Routledge Handbook of Sexuality Studies in East Asia* (Oxford: Routledge, 2014), p. 63.

62. Wakakuwa, *Sensō ga tsukuru josei zō*, p. 197.

63. Uemura Shōen, "Kiri no kanata" (1932), *Seibishō sonogo*.

64. Similarly, according to Susan Sontag, the 1970s rehabilitation of the filmmaker Leni Riefenstahl, who worked with the Nazi regime, stemmed from the fact that the artist was a woman. Susan Sontag, "Fascinating Fascism."

65. Miyao Tomiko, *Jo no mai* (Tokyo: Chūō Kōron sha, 1983).

66. Wakakuwa, "Three Women Artists," p. 62.

67. Ibid., p. 70.

68. Ibid.

69. Ibid., p. 71.

70. Ibid.

71. Shiokawa Kyōko, "Uemura Shōen no shōgai to geijutsu," p. 103.

72. Morioka, "Changing Images of Women," p. 152.

73. Ibid., p. 77.

74. Wakakuwa, *Sensō ga tsukuru josei zō.*

75. Kira, *Sensō to josei gaka: Mōhitotsu no kindai "bijutsu."* For a landmark exhibition on this topic, see Kokatsu, *Hashiru onnatachi: Josei gaka no senzen, sengo 1930–1950.*

76. For Katsura's postwar activity, see Alicia Volk, "Katsura Yuki and the Japanese Avant-Garde," *Woman's Art Journal* 24, no. 2 (Autumn 2003–Winter 2004): 3–9.

77. Kira, *Sensō to josei gaka,* p. 180.

78. Ibid., p. 181.

79. Garon Sheldon, "Integrating Women into Public Life: Women's Groups and the State," p. 141.

80. Kanō, *Onnatachi no jūgo;* Okano et al., *Onnatachi no sensō sekinin.*

81. Takashi Fujitani, *Race for Empire: Koreans as Japanese and Japanese as Americans during World War II* (Berkeley: University of California Press, 2011), p. 28.

CHAPTER 5: FUJITA TSUGUHARU AND *EVENTS IN AKITA* (1937)

1. Tohoku is the northeast region of Japan that includes six prefectures: Aomori, Akita, Yamagata, Miyagi, Fukushima, and Iwate.

2. *Seitan hyaku nijūnen Tsuguharu ten.*

3. Masaaki Ozaki, "On Tsuguharu Léonard Foujita," trans. Kikuko Ogawa, *Seitan hyaku nijūnen Fujita Tsuguharu ten,* p. 188.

4. After the 2006 retrospective, Fujita was prominently featured in exhibitions by other museums in Japan. These included *Ihōjin (entranju) tachi no pari, 1900–2005/Paris du monde entier: Artistes étrangers à Paris 1900–2005* in 2007, held by the National Art Center, Tokyo, which celebrated its opening in that year and exhibited Fujita's works along with paintings by Picasso, Modigliani, Pascin, and Soutine, among others. In July 2008, the Hokkaido Museum of Modern Art held the Léonard Fujita Exhibition. This exhibition, organized in a large-scale collaboration with French museums and curators, focused on newly discovered mural paintings Fujita produced in the 1920s in France as well as his postwar works, especially decorations of the Fujita chapel. The exhibition produced an impressive bilingual exhibition catalogue in Japanese and French. In 2013, *Reonāru Fujita: Pōra korekushon wo chūshin ni/Léonard Foujita from the Collection of the Pola Museum of Art* was held at the Bunkamura Museum in Tokyo and focused on the artist as "craftsman," creating detail-oriented works not only on canvas but also on panels, glass, ceramic, and other media. In 2013, the Akita Museum of Art, funded by the Masakichi Hirano Art Foundation, held *Hekiga Akita no gyōji kara no messēji: Fujita Tsuguharu no 1930 nen dai,* to mark the museum's reopening that year. These exhibitions have been complemented by numerous exhibition catalogues and books targeted to general audiences. It is not surprising, then, that a film, *Foujita* (2015), was also produced, directed by Oguri Kōhei and featuring Joe Odagiri as Fujita. The production was made in collaboration with France. For journal articles and book chapters on Fujita in English, see Winther-Tamaki, "Embodiment/Disembodiment in Japanese Painting during the Fifteen Year War"; Mark H. Sandler, "A Painter of the 'Holy War': Fujita Tsuguji and the Japanese Military," in *War, Occupation, and Creativity: Japan and East Asia, 1920–1960,* ed. Marlene J. Mayo and

J. Thomas Rimer (Honolulu: University of Hawai'i Press, 2001); McDonald, "Fujita Tsuguharu: An Artist of the Holy War Revisited"; Aya Louisa McDonald, "Art, War and Truth: Nomonhan 1939," *Journal of War and Culture Studies* 8, no. 2 (2015): 143–157; Ikeda, "Fujita Tsuguharu Retrospective 2006: Resurrection of a Former Official War Painter"; Winther-Tamaki, *Maximum Embodiment*; Kaneko, *Mirroring the Japanese Empire*.

5. Moriya Miho, "Nihonkan hekiga ōjin Nihon e tōrai no zu ni itaru taisaku seisaku no keiini tsuite" [Processes behind Production of Large-Scale Paintings that Eventually Led the Artist to The Arrival of Occidentals in Japan at the Japan Pavilion], *Reonāru Fujita/Léonard Foujita,* exh. cat. (Sapporo: Hokkaido Museum of Modern Art, 2008), p. 90.

6. Fujita Tsuguharu "Kokusai eiga satsuei to moderu Akita" [World Cinema Shooting and Models in Akita], *Akita sakigake shimpō,* January 1, 1937.

7. Fujita, *Bura ippon Pari no yokogao,* p. 82.

8. Ishio Noriko "Subarashiki nyūhakushoku no ji ni tsuite" [On the Groundwork of "Great Milk White"], *Hekiga "Akita no gyōji" kara no messēji: Fujita Tsuguharu no 1930 nendai,* p. 41.

9. Ozaki, "On Tsuguharu Léonard Foujita," p. 188.

10. *Hekiga "Akita no gyōji" kara no messēji,* p. 23. Hayashi Yōko, "Fujita Tsuguharu no 1929 nen: Pari kara Nihon e no henkanten" [Fujita Tsuguharu's 1929: Transitional Period from Paris to Japan], *Kajima bijutsu zaidan nenpō* 16 (1998): 24–34.

11. This kind of painting became especially popular during the Momoyama period (1573–1615), when samurai began building more castles, as the paintings were integrated into the interior decoration, as walls, screens, or sliding doors. Kanō school artists are renowned for dominating this genre of painting.

12. Fujita Tsuguharu, "Mekishiko wo kaeri mite" [Reflecting on Mexico], written in April 1934 and published in *Zuihitsu shū: Chi wo oyogu* [Collection of Essays: Swimming on the Ground] (Tokyo: Shomotsu tenbōsha, 1942). Republished by Heibonsha Library in 2014.

13. Gaimushō ga "kantoku," kokusai eiga kyōkai no jinyō wo kyōka: zokuzoku kokusaku mono wo fūgiri." [Films Directed by the Ministry of Foreign Affairs and Enhancement of International Film Association: More and More National Policy Films Being Released], *Asahi shimbun,* August 27, 1936; "Gendai no Nihon wo seikai no sukurīn e" [Bringing Contemporary Japan to World Screens], *Akita sakigake shimpō,* March 12, 1936.

14. The five individual titles were "Japanese Children" (*Kodomo Nihon*), "Japanese Women" (*Fujin Nihon*), "Japanese Entertainment" (*Goraku Nihon*), "Urban Japan" (*Tokai Nihon*), and "Countryside Japan" (*Den'en Nihon*). The other five (titled "Advancing Japan," or *Yakushin Nippon*) were directed by Suzuki Shigeyoshi (1900–1976) and focused on scenes of modern industry, national defense, and education. Hosaka Fujio, "Hatashite kokujyoku ka: Fujita Tsuguharu shi no eiga Fūzoku Nippon" [Is This National Shame? Mr. Fujita Tsuguharu's Film *Picturesque Nippon*], *Atorie,* May 1937, p. 64.

15. Fujita, "Kokusai eiga satsuei to moderu akita."

16. Ibid.

17. Karen "Misu Nippon" chigo mage uiuishii Akita musume futari eigani natte yōkō [Two Akita Girls, Lovely and Innocent "Miss Nippon" with Kids' Hairstyles, Going to the West in Movie], *Asahi shimbun,* March 27, 1936.

18. Yamamoto Kanae, "Nihon nōmin bijutsu no kengyō ni nozomite hitokoto" [A Word about Establishing Farmers' Art in Japan], *Yomiuri shimbun,* January 11, 1920. For more on earlier discourses on Japan's countryside, see Mochida Keizō, *Kindai Nihon no chishikijin to nōmin* [Intelligentsia and Farmers in Modern Japan] (Tokyo: Ienohikari kyōkai), 1997; Itagaki Kuniko, *Shōwa senzen senchūki no nōson seikatsu: Zasshi Ie no hikari ni miru* [Rural Lives in Prewar and Wartime Japan Seen in the Magazine *Ie no hikari*] (Tokyo: Sanrei shobō, 1992).

19. Kikuchi, *Japanese Modernisation and Mingei Theory,* p. 110.

20. Brandt, *Kingdom of Beauty,* pp. 137–146. Brandt calls him Matsuoka Shunzō; however, according to my research, the correct reading of his name is Matsuoka Toshizō.

21. Kikuchi, *Japanese Modernisation and Mingei Theory,* p. 109.

22. Yanagi, originally in "Mingei to Tohōku" [Mingei and Tohoku], *Kōgei* 108 (January 1942): 10. Quoted by Brandt, *Kingdom of Beauty,* p. 142.

23. Originally in Yamaguchi Hiromichi, "Tōhoku mingeiten no shushi" [The Significance of the Tohoku Mingei Exhibit], *Gekkan mingei* 2, no. 8 (August 1940): 2–4. Quoted by Brandt, *Kingdom of Beauty,* p. 142.

24. Brandt, *Kingdom of Beauty,* p. 143. For more on this discourse, or what Thomas Havens calls "Agrarian Nationalism" in the 1930s, see Havens, *Farm and Nation in Modern Japan: Agrarian Nationalism, 1870–1950* (Princeton, NJ: Princeton University Press, 1974).

25. Ortabasi, *The Undiscovered Country,* p. 11. For recent critical English-language studies on Yanagita's activity in the prewar and wartime era, see Marilyn Ivy, "Ghastly Insufficiencies: Tōno Monogatari and the Origins of Nativist Ethnology," *Discourses of the Vanishing: Modernity, Phantasm, Japan;* Harootunian, *Overcome by Modernity;* Kevin M. Doak, "Building National Identity through Ethnicity: Ethnology in Wartime Japan and After," *Journal of Japanese Studies* 27, no. 1 (Winter 2001): 1–39.

26. Ortabasi, *The Undiscovered Country,* p. 15.

27. Ibid., p. 107.

28. Miki Shigeru took the photographs during the production of his film *Living with Soil* (*Tsuchi ni ikiru*), a film about farmers in Akita released in 1941. Yanagita Kunio, *Yukiguni no fūzoku* [The Customs of Snow Country] (Tokyo: Daiichi hōki shuppan, 1977 [1943]), p. 286. For a recent study on Miyazawa Kenji and his activity in "the periphery," see Hoyt Long, *On Uneven Ground: Miyazawa Kenji and the Making of Place in Modern Japan* (Stanford, CA: Stanford University Press, 2012).

29. Yanagita, *Yukiguni no fūzoku,* p. 17.

30. Ibid. Emphasis added.

31. For more on Katsuhira Tokushi, see *Hanga Akita no shiki: Katsuhira Tokushi sakuhin shū* [Woodblock Prints, Four Seasons in Akita: Collection of Katsuhira Tokushi's Works] (Akita: Akita bunka shuppan, 2001).

32. Akita City Akarenga Kyōdokan Katsuhira Tokushi Memorial Museum website, http://www.city .akita.akita.jp/city/ed/ak/katu_nen.htm (accessed January 19, 2015).

33. *Hanga Akita no shiki: Katsuhira Tokushi sakuhin shū,* p. 82.

34. Yanagita, *Yukiguni no fūzoku,* p. 286.

35. Bruno Taut, *Nihon: Tauto no nikki,* in *Tauto ga totta Nippon/Bruno Taut: A Photo Diary in Japan,* ed. Sakai Michio and Sawa Ryōko (Tokyo: Musashino bijutsu daigaku shuppankyoku, 2007), pp. 89–90.

36. Weisenfeld, "Touring 'Japan-as-Museum.'"

37. The Snowfall Institute, mentioned above, did indeed include Niigata in the area of their activity.

38. Reynolds, "Hiroshi Hamaya's Snow Country: A Return to 'Japan,'" pp. 17–29. Also see Joseph Capezutto, "Persistence of Vision: Hamaya Hiroshi's Yukiguni and Kuwabara Kineo's Tōkyō Shōwa 11-nen in the Transwar Era," MA thesis (California State University, Long Beach, 2012).

39. Reynolds, "Hiroshi Hamaya's Snow Country," p. 24.

40. Ibid., p. 28.

41. Tansman, *The Aesthetics of Japanese Fascism,* p. 106.

42. Mitani was a female Japanese-style painter, like Uemura Shōen (see previous chapter). Indeed, the two women were close and traveled to Manchuria together. It is not known precisely which geographical location Mitani was interested in portraying, but she did depict a snowy landscape in *Yuki* [Snow] in 1939. For more on her work, see *Mitani Toshiko ten: hitosuji no michi* [The Mitani Toshiko Exhibition: The Line of a Path], exh. cat. (Hyogo Prefectural Museum of Modern Art, 1992).

43. Tanaka, *Japan's Orient.*

44. Ka F. Wong, "Visual Methods in Early Japanese Anthropology: Torii Ryuzo in Taiwan," *Photography, Anthropology and History: Expanding the Frame,* ed. Christopher Morton and Elizabeth Edwards (Farnham, Surrey: Ashgate, 2009).

45. Yen Chuan-Ying, "The Demise of Oriental-Style Painting in Taiwan," *Refracted Modernity: Visual Culture and Identity in Colonial Taiwan* (Honolulu: University of Hawai'i Press, 2007); Kim Hye-sin, "Chōsenshoku no bijutsu," *Kankoku kindai bijutsu kenkyū: Shokuminchiki*

chōsenbijutsutenrankai ni miru ibunkashihai to bunka hyōshō [Studies of Korean Modern Art: Cultural Control and Cultural Representation in Colonial "Korean Art Exhibitions"] (Tokyo: Brücke, 2005); Hong Kal, "Modeling the West, Returning to Asia: Shifting Politics of Representation in Japanese Colonial Expositions in Korea," *Comparative Studies in Society and History* 47, no. 3 (July 2005): 507–531.

46. Satō Shōsuke, "Tōhoku no shinkō" [Development of Tohoku], *Iwate nippō*, November 6, 1915. Translated and quoted by Long, *On Uneven Ground*, p. 93.

47. Satō Yukihiro points out that it was during Fujita's stay in South America in the early 1930s that the artist became intensely interested in distinct cultures unique to different races. Satō Yukihiro, "Hyōshō no henkan: Fujita Tsuguharu 1930 nendai no hekiga" [Transformation of Representations: Mural Paintings by Fujita Tsuguharu in the 1930s], *Hekiga "Akita no gyōji" kara no messēji: Fujita Tsuguharu no 1930 nendai*, p. 9.

48. "Gurotesuku na funsō de gahitsu: Taiheiyō jinshushū kanseie" [Painting in Grotesque Outfit: Asia-Pacific Races to Be Completed], *Asahi shimbun*, January 26, 1935. The newspaper uses the term "jinshu" (race), not "minzoku" (ethnicity) here.

49. "Fujita gahaku no eiga kokujyoku de wa nai" [Painter Fujita's Film Not National Shame], *Asahi shimbun*, April 20, 1937; "Eiga 'gendai Nihon' kōkai kentō shishakai" [Film "Contemporary Japan" Test Screening to Consider Public Release], *Asahi shimbun*, April 30, 1937.

50. Hosaka Fujio, "Hatashite kokujoku ka: Fujita Tsuguharu shi no eiga Fūzoku Nippon," May 1937, pp. 63–65.

51. Kikuchi, *Japanese Modernisation and Mingei Theory*, pp. 100–109.

52. Ibid., p. 107.

53. Originally in "Perian joshu sōsakuhinten ni tsuite kiku" [Hearing from Perriand about Her Exhibition], *Kōgei Nyūsu* 10, no. 5 (1941): 187–193. Translated by and quoted in Kikuchi, p. 107.

54. Kojima Zenzaburō, "Shin Nihonshugi ni tsuite" [On New Japanism], *Atorie* (May 1935). Volk, *In Pursuit of Universalism: Yorozu Tetsugoro and Japanese Modern Art*, p. 212.

55. Kaneko, "Under the Banner of the New Order: Uchida Iwao's Responses to the Asia-Pacific War and Japan's Defeat," *Art and War in Japan and Its Empire, 1931–1960*, pp. 201–203; for the case of Yorozu Tetsugorō, see Volk, *In Pursuit of Universalism*, p. 212.

CONCLUSION

1. For instance, Weisenfeld, *MAVO*; Volk, *In Pursuit of Universalism: Yorozu Tetsugoro and Japanese Modern Art*; Ming Tiampo, *Gutai: Decentering Modernism* (Chicago: University of Chicago Press, 2010).

2. For discussion of Riefenstahl's Nazi period films and fascist aesthetics, see Susan Sontag, "Fascinating Fascism."

SELECTED BIBLIOGRAPHY

NEWSPAPERS, SERIALS, AND WEBSITES

Asahi shimbun
Atorie
Bi no kuni
Bijutsu
Bijutsu to shumi
Bungakukai
Gekkan mingei

Japan Focus
The Japan Times
Kaizō
Kōgei
Kōgei Nyūsu
Kokuga
Mizue

Nihon bijutsu
Tōei
Visualizing Cultures: Image-
 Driven Scholarship
Yomiuri shimbun

Adam, Peter. *Art of the Third Reich*. New York: H. N. Abrams, 1992.

Affron, Matthew, and Mark Antliff, eds. *Fascist Visions: Art and Ideology in France and Italy*. Princeton, NJ: Princeton University Press, 1997.

Ajioka, Chiaki, and Jackie Menzies, eds. "The New Mainstream." *Modern Boy, Modern Girl: Modernity in Japanese Art, 1910–1935*. Sydney: Art Gallery of New South Wales, 1998.

Althusser, Louis Althusser. "Ideology and Ideological State Apparatuses (Notes towards an Investigation)." *Lenin and Philosophy and Other Essays*, translated by Ben Brewster. London: New Left Books, 1971.

Antliff, Mark. *Avant-Garde Fascism: The Mobilization of Myth, Art, and Culture in France, 1909–1939*. Durham, NC: Duke University Press, 2007.

———. "Fascism, Modernism, and Modernity." *Art Bulletin* 84, no. 1 (March 2002): 148–169.

Benesch, Oleg. "Bushido: The Creation of a Martial Ethic in Late Meiji Japan." PhD diss., Vancouver: University of British Columbia, 2011.

Benjamin, Walter. "The Work of Art in the Age of Mechanical Reproduction" (1936). In *Illuminations: Essays and Reflections*, edited by Hannah Arendt and translated by Harry Zohn. New York: Schocken Books, 1968.

Benton, Charlotte, and Tim Benton. *Art Deco 1910–1939*. Boston: Bulfinch Press, 2003.

Brandon, Laura. *Art and War*. London: I. B. Tauris, 2006.

Brandt, Kim. *Kingdom of Beauty: Mingei and the Politics of Folk Art in Imperial Japan*. Durham, NC: Duke University Press, 2007.

Braun, Emily. *Mario Sironi and Italian Modernism: Art and Politics under Fascism*. Cambridge: Cambridge University Press, 2000.

———. "Political Rhetoric and Poetic Irony: The Uses of Classicism in the Art of Fascist Italy." In *On Classic Ground: Picasso, Léger, de Chirico and the New Classicism 1910–1930,* edited by Elizabeth Cowling and Jennifer Mundy. London: Tate Gallery, 1990.

Brown, Kendall H. *Deco Japan: Shaping Art and Culture, 1920–1945*. Seattle: University of Washington Press, 2013.

———. "Out of the Dark Valley: Japanese Woodblock Prints and War, 1937–1945." *Impressions* 23 (2001): 65–85.

———. *Taisho Chic: Japanese Modernity, Nostalgia, and Deco*. Honolulu: Honolulu Academy of Arts, 2002.

Buck-Morss, Susan. "Aesthetics and Anaesthetics: Walter Benjamin's Artwork Essay Reconsidered," *October* 62 (Autumn 1992): 3–41.

Chaos and Classicism: Art in France, Italy, and Germany, 1918–1936. New York: Guggenheim Museum, 2010.

Chatterjee, Partha. *The Nation and Its Fragments: Colonial and Postcolonial Histories*. Princeton, NJ: Princeton University Press, 1993.

Clair, Jean, et al. *The 1930s: The Making of "The New Man."* Ottawa: National Gallery of Canada, 2008.

Clark, John. "Artistic Subjectivity in the Taisho and Early Showa Avant-Garde." In *Japanese Art after 1945: Scream against the Sky*, edited by Alexandra Munroe. New York: Harry N. Abrams, 1994.

———. "Okakura Tenshin and Aesthetic Nationalism." In *Since Meiji: Perspectives on the Japanese Visual Arts, 1868–2000*, edited by Thomas J. Rimer. Honolulu: University of Hawai'i Press, 2012.

Colcutt, Martin. "Mt. Fuji as the Realm of Miroku." In *Maitreya, the Future Buddha*, edited by Alan Sponberg and Helen Hardacre. (Cambridge: Cambridge University Press, 1988).

Conant, Ellen, ed. *Nihonga: Transcending the Past: Japanese-Style Painting, 1868–1968*. St. Louis: St. Louis Art Museum 1995.

Davis, Darrell William. *Picturing Japaneseness: Monumental Style, National Identity, Japanese Film*. New York: Columbia University Press, 1995.

Dawn, Ades, et al. *Art and Power*. London: Hayward Gallery, 1995.

Doak, Kevin Michael. *Dreams of Difference: The Japan Romantic School and the Crisis of Modernity*. Berkeley: University of California Press, 1994.

Dower, John. *War without Mercy: Race and Power in the Pacific War*. New York: Pantheon Books, 1986.

Earhart, David C. *Certain Victory*. New York: M. E. Sharpe, 2009.

Falasca-Zamponi, Simonetta. *Fascist Spectacle*. Berkeley: University of California Press, 1997.

Foss, Brian. *War Paint: Art, War, State and Identity in Britain 1939–1945*. New Haven, CT: Yale University Press, 2007.

Foster, Hal. "Armor Fou." *October* 56 (Spring 1991): 64–97.

Four Japanese Painters. Tokyo: Japan Photo Service, 1939.

Fujita Tsuguharu. *Bura ippon Pari no yokogao*. Edited by Kondō Fumito. Tokyo: Kōdansha, 2005.

———. *Zuihitsu shū: Chi wo oyogu* [Collection of Essays: Swimming on Ground]. Tokyo: Shomotsu tenbōsha, 1942.

Furuta Ryō. "Taikan shōron: Umi yama ni chinande" [Essay on Taikan: About Sea and Mountain]. *Yokoyama Taikan "Umi yama jūdai" ten* [The Exhibition of Yokoyama Taikan's Ten Works on Sea and Mountain]. Tokyo: University Art Museum, Tokyo University of the Arts, 2004.

Ghirado, Diane Y. "Italian Architects and Fascist Politics: An Evaluation of the Rationalist Role in Regime Building." *Journal of the Society of Architectural Historians* 39, no. 2 (May 1980): 109–127.

Gluck, Carol. "The Invention of Edo." In *Mirror of Modernity: Invented Traditions of Modern Japan*, edited by Stephen Valstos. Berkeley: University of California Press, 1998.

Golomstock, Igor. *Totalitarian Art: In the Soviet Union, the Third Reich, Fascist Italy, and the People's Republic of China*. London: Collins Harvill, 1990.

Gordon, Andrew. *Labor and Imperial Democracy in Prewar Japan*. Berkeley: University of California Press, 1992.

Gordon, Terri J. "Fascism and the Female Form: Performance Art in the Third Reich." In *Sexuality and German Fascism*, edited by Dagmar Herzog. New York: Berghahn Books, 2005.

Griffin, Roger. *Fascism*. Oxford: Oxford University Press, 1995.

———. *A Fascist Century: Essays by Roger Griffin*, edited by Matthew Feldman. New York: Palgrave Macmillan, 2008.

———. *The Nature of Fascism*. London: Routledge, 2013.

Hanga Akita no shiki: Katsuhira Tokushi sakuhin shū [Woodblock Prints Four Seasons in Akita: Collection of Katsuhira Tokushi's Works]. Akita: Akita bunka shuppan, 2001.

Hanneman, Mary L. *Japan Faces the World: 1925–1952*. Harlow, UK: Pearson Education, 2001.

Hariu Ichirō et al. *Sensō to bijutsu 1937–1945/Art in Wartime Japan 1937–1945*. Tokyo: Kokusho kankōkai, 2007.

Harootunian, Harry. *Overcome by Modernity: History, Culture, and Community in Interwar Japan*. Princeton, NJ: Princeton University Press, 2001.

Hasegawa Nyozekan. "Nōgaku to Nihonteki seikatsu" [Noh and Japanese Life]. In *Nōgaku zenshū* [The Noh Collection], edited by Nogami Toyoichirō. vol. 1. Tokyo: Sōgensha, 1943.

Hayashi Yōko. "Fujita Tsuguharu no 1929 nen: Pari kara Nihon e no henkanten" [Fujita Tsuguharu's 1929: Transitional Period from Paris to Japan]. *Kajima bijutsu zaidan nenpō* 16 (1998): 24–34.

Herf, Jeffrey. *Reactionary Modernism*. Cambridge: Cambridge University Press, 1984.

Heskett, John. "Modernism and Archaism in Design in the Third Reich." In *The Nazification of Art*, edited by Brandon Taylor and Wilfried van der Will. Winchester, NH: Winchester Press, 1990.

Hewitt, Andrew. "Fascist Modernism, Futurism, and 'Post-Modernity'" In *Fascism, Aesthetics, and Culture*, edited by Richard J. Golsan. Hanover, NH: University Press of New England, 1992.

Hiromi Nobuhiko. "Uemura Shōen kenkyū no ichidan shō/A Study on Uemura Shōen." *Idemitsu Museum of Art Journal of Art Historical Research* 14 (2008): 33–50.

Ikeda, Asato. "Envisioning Fascist Space, Time, and Body: Japanese Painting during the Fifteen-Year War (1931–1945)." PhD diss., University of British Columbia, Vancouver, 2012.

———. "Fujita Tsuguharu Retrospective 2006: Resurrection of a Former Official War Painter." *Review of Japanese Culture and Society* 21 (December 2009): 97–115.

———. "The Japanese Art of Fascist Modernism: Yasuda Yukihiko's The Arrival of Yoshitsune/Camp at Kisegawa (1940–41)." *Modernism/modernity Print Plus* 1.2. https://modernismmodernity.org/articles/japanese-art-fascist-modernism.

———. "Japan's Haunting War Art: Contested War Memories and Art Museums." *disClosure* 18 (2009): 5–32.

———. "Modern Girls and Militarism: Japanese-Style Machine-ist Paintings, 1935–1940." In *Art and War in Japan and Its Empire, 1931–1960*, edited by Asato Ikeda, Ming Tiampo, and Aya Louisa McDonald. Leiden: Brill, 2012.

———. "Twentieth Century Japanese Art and the Wartime State: Reassessing the Art of Ogawara Shū and Fujita Tsuguharu." *Asia-Pacific Journal* 43 (October 25, 2010): 2–10.

Ikeda, Asato, Ming Tiampo, and Aya Louisa McDonald, ed. *Art and War in Japan and Its Empire: 1931–1960*. Leiden: Brill, 2012.

Ikeda, Shinobu. "The Allure of Women Clothed in Chinese Dress." In *Performing "Nation": Gender Politics in Literature, Theater, and the Visual Arts of China and Japan, 1880–1940*, edited by Doris Croissant, Catherine Vance Yeh, and Joshua S. Mostow. Leiden: Brill, 2008.

Itakura Masaaki. "Yokoyama Taikan no naka no chūgoku" [China in Yokoyama Taikan]. In *Botsugo gojūnen: Yokoyama Taikan aratanaru densetsu e*. Tokyo: National Art Center, 2008.

Ivy, Marilyn. *Discourses of the Vanishing: Modernity, Phantasm, Japan*. Chicago: University of Chicago Press, 1995.

Johnson, Philip. Foreword to *Machine Art*. New York: Museum of Modern Art, New York, 1934.

Kainoshō Tadaoto to Taishō ki no gaka tachi [Kainoshō Tadaoto and Other Artists of the Taishō Period]. Chiba: Chiba City Museum, 1999.

Kaneko, Maki. "Art in the Service of the State: Artistic Production in Japan during the Asia-Pacific War." PhD diss., University of East Anglia, 2006.

———. *Mirroring the Japanese Empire: The Male Figures in Yoga Painting, 1930–1950*. Leiden: Brill, 2014.

———. "Under the Banner of the New Order: Uchida Iwao's Responses to the Asia-Pacific War and Japan's Defeat." In *Art and War in Japan and Its Empire, 1931–1960*, edited by Asato Ikeda, Ming Tiampo, and Aya Louisa McDonald. Leiden: Brill, 2012.

Kanō Mikiyo. *Onnatachi no jūgo* [Women on the Home Front]. Tokyo: Inpakuto shuppankai, 1995.

Kaplan, Alice Yaeger. *Reproductions of Banality: Fascism, Literature, and French Intellectual Life*. Minneapolis: University of Minnesota Press, 1986.

Katō Ruiko. "Bijin-ga." In *Nihonga: Transcending the Past: Japanese-Style Painting, 1868–1968*, edited by Ellen Conant. St. Louis: St. Louis Art Museum, 1995.

———. *Uemura Shōen to sakuhin* [Uemura Shōen and Her Works]. Tokyo: Tokyo bijutsu, 2007.

Kawata Akihisa. "Fujizu no kindai." *Fujisan: Kindai ni tenkai shita Nihonno shinboru*. Kōfu: Yamanashi Prefectural Museum of Art, 2008.

———. *Gaka to sensō: Nihon bijutsushi no kūhaku* [Artist and War: A Gap in Japanese Art History]. Tokyo: Heibonsha, 2014.

———. "Gūi ni kaete" [Instead of Allegory]. In *Sensō to hyōshō: bijutsu nijyusseiki igo/Symposium War and Representation: Art after 20th Century Report*, edited by Nagata Kenichi. Tokyo: Bigaku Shuppan, 2006.

———. "Sensō-ga towa nanika" [What Is *Sensō-ga*?]. *Geijutsu Shinchō*. August 1995.

———. "Sorera wo dō sureba iinoka" [What Do We Do with Them?]. *Kindai gasetsu* 8 (1999): 1–41.

Kawata Akihisa and Tan'o Yasunori. *Imēji no nakano sensō*: Nisshin, nichiro sensō kara reisen made [War in Images: From the Sino-Japanese War to the Cold War]. Tokyo: Iwanami, 1996.

Kawata Kazuko. *Senjika no bungaku to Nihonteki na mono: Yokomitsu Riichi to Yasuda Yojūrō* [Wartime Literature and Things Japanese: Yokomitsu Riichi and Yasuda Yojūrō]. Fukuoka: Hanashoin, 2009.

Kikuchi Yuko. *Japanese Modernization and Mingei Theory: Cultural Nationalism and Oriental Orientalism*. London: Routledge, 2004.

Kikuya Yoshio. "Shōwa zenki ni okeru inten to sono hasei dantai to no kankei" [The Relationship between Inten and Other Art Groups in the Early Showa Period]. In *Nihon bijutsuin hyakunenshi* [A Hundred-Year History of the Japan Art Institute]. Tokyo: Nihon bijutsuin, 1998.

Kim Hye-sin. *Kankoku kindai bijutsu kenkyū: Shokuminchiki chōsenbijutsutenrankai ni miru ibunkashihai to bunka hyōshō* [Studies of Korean Modern Art: Cultural Control and Cultural Representation in Colonial "Korean Art Exhibitions"]. Tokyo: Brücke, 2005.

Kira Tomoko. *Sensō to josei gaka* [War and Female Artists]. Tokyo: Brücke, 2013.

Kitazawa Noriaki. "Modanizumu to sensō-ga: Yokoyama Taikan to iu mondai" [Modernism and War Paintings: The Problem of Yokoyama Taikan]. *Nikkan bijutsu*. December 1994.

Koepnick, Lutz. "Fascist Aesthetics Revisited." *Modernism/modernity* 6, no. 1 (January 1999): 51–73.

Kohara Masashi. *Fuji zenkei: Kindai Nihon to Fuji no yamai/Visions of Fuji: An Incurable Malady of Modern Japan*. Shizuoka: Izu Photo Museum, 2011.

Kokatsu Reiko. *Hashiru onnatachi: Josei gaka no senzen, sengo 1930–1950/Japanese Women Artists before and after World War II, 1930s–1950s*. Utsunomiya: Tochigi Prefectural Museum 2001.

Kokutai no hongi/Cardinal Principles of the National Entity of Japan, translated by John Owen Gauntlett. Cambridge, MA: Harvard University Press, 1949 [1937].

Kōsaka Jirō et al. *Gaka tachi no "sensō"* [Painter's "War"]. Tokyo: Tonbo no hon, 2010.

Kozawa Setsuko. *Avan garudo no sensō taiken* [Wartime Experiences of Avant-Garde Artists]. Tokyo: Aoki Shoten, 2004.

Kuboshima Sei'ichirō. *Mugonkan nōto* [The Silence Museum Notebook]. Tokyo: Shūeisha, 2005.

Kuki Shūzō. *"Iki" no kōzō*. Tokyo: Iwanami shoten, 1930.

Kunst und Propaganda: Im Streit der Nationen 1930–1945/Art and Propaganda: Clash of the Nations 1930–1945. Berlin: German Historical Museum, 2007.

Kusanagi Natsuko, *Uemura Shōen*, exhibition cat. Tokyo: Shinchō Nihon bijutsu bunko, 1996.

Maeda Kō. "Senjika ni okeru bijutsu to bijutsu hihyō: Yasuda Yukihiko's Kisegawa no jin wo chūshin ni" [Art and Art Criticism during the War: With Focus on Yasuda Yukihiko's Camp at Kisegawa]. *Bijutsu Forum* 21 (2006): 79–85.

Marra, Michele. "Ōnishi Yoshinori and the Category of the Aesthetic." In *Modern Japanese Aesthetics: A Reader*. Honolulu: University of Hawai'i Press, 1999.

McDonald, Aya Louisa. "Fujita Tsuguharu: An Artist of the Holy War Revisited." In *Art and War in Japan and Its Empire: 1931–1960*, edited by Asato Ikeda, Ming Tiampo, and Aya Louisa McDonald. Leiden: Brill, 2012.

McLeod, Mary. "'Architecture or Revolution': Taylorism, Technocracy and Social Change." *Art Journal* 43, no. 2 (1987): 132–147.

Michio Takeyama. *Shōwa seishin shi* [The Spiritual History of Shōwa]. Tokyo: Shinchōsha, 1956.

Mizoguchi Ikuo et al. *Enogu to sensō* [Paints and War]. Tokyo: Kokusho kankōkai, 2011.

Morioka, Michiyo. "Changing Images of Women: Taisho Period Paintings by Uemura Shoen (1875–1949), Ito Shoha (1877–1968), and Kajiwara Hisako (1896–1988)." PhD diss., University of Washington, Seattle, 1990.

Morioka, Michiyo, and Paul Berry, *Modern Masters of Kyoto: Transformation of Japanese Painting Traditions, Nihonga from Griffith and Patricia Way Collection*. Seattle: Seattle Art Museum, 2000.

Morita Naruo. *Sensō to geijutsu: Jūgun sakka gaka tachi no senchū to sengo* [War and Art]. Tokyo: Sankei Newspaper, 2007.

Moriya Miho. "Nihonkan hekiga ōjin Nihon e tōrai no zu ni itaru taisaku seisaku no keii ni tsuite" [Processes behind Production of Large-Scale Paintings that Eventually Led the Artist to *The Arrival of Occidentals in Japan* at Japan Pavilion]. In *Reonāru Fujita/Léonard Foujita*. Sapporo: Hokkaido Museum of Modern Art, 2008.

Morris, Ivan. *The Nobility of Failure: Tragic Heroes in the History of Japan*. New York: Holt, Rinehart and Winston, 1975.

Nara, Hiroshi. *The Structure of Detachment: The Aesthetic Vision of Kuki Shuzo: With a Translation of Iki no kozo*. Honolulu: University of Hawai'i Press, 2004.

Nerdinger, Winfried. "A Hierarchy of Styles: National Socialist Architecture between Neoclassicism and Regionalism." In *Art and Power: Europe under the Dictators, 1930–45*. London: Hayward Gallery, 1995.

Nihon bijutsuin hyakunenshi [One-Hundred-Year History of Nihon Bijutsuin]. vol. 7. Tokyo: Nihon bijutsuin, 1998.

Nomiyama Gyōji et al. *Sensōga unda e, ubatta e* [Paintings that War Produced, that War Robbed]. Tokyo: Tonbo no hon, 2010.

Nose, Asaji. *Yūgen ron* [On Yūgen]. Tokyo: Kaede shobō, 1944.

Ohnuki-Tierney, Emiko. *Kamikaze, Cherry Blossoms, and Nationalisms*. Chicago: University of Chicago Press, 2002.

Okakura, Tenshin. "Nature in East Asiatic Painting." In *Okakura Kakuzo: Collected English Writings*. Tokyo: Heibonsha, 1984 [1911].

Okamoto Tōki and Matsuyama Fumio. *Nihon puroretaria bijutsushi* [History of Japanese Proletarian Art]. Tokyo: Zōkeisha, 1967.

Okano, Yukie, et al. *Onnatachi no sensō sekinin* [War Responsibility of Women]. Tokyo: Tokyodō shuppan, 2004.

Ōkuma Toshiyuki. "Kankaku to kōsei no hazama de: 1930 nendai no Nihonga modanizumu" [Caught between Senses and Structure: Japanese-Style Paintings of the 1930s]. *Nihon bijutsuin hyakunenshi*, vol. 6. Tokyo: Nihon Bijutsuin, 1996.

———. "Kawaru Fuji, Kawaranu Fuji" [Fuji that Changes, Fuji that Does Not Change]. In *Bessatsu Taiyō: Kihaku no hito Yokoyama Taikan*. Tokyo: Heibonsha, 2006.

Ōnishi Yoshinori. *Yūgen to aware* [Yūgen and aware]. Tokyo: Iwanami shoten, 1939.

Ortabasi, Melek. *The Undiscovered Country: Text, Translation, and Modernity in the Work of Yanagita Kunio*. Cambridge, MA: Harvard University Asia Center, 2014.

Pincus, Leslie. *Authenticating Culture in Imperial Japan: Kuki Shūzō and the Rise of National Aesthetics*. Berkeley: University of California Press, 1996.

Reynolds, Jonathan. "Hiroshi Hamaya's Snow Country: A Return to 'Japan.'" *Japan's Modern Divide: The Photographs of Hiroshi Hamaya and Kansuke Yamamoto*. Los Angeles: J. Paul Getty Museum, 2013.

———. *Maekawa Kunio and the Emergence of Japanese Modernist Architecture*. Berkeley: University of California Press, 2001.

Rimer, Thomas J. "Encountering Blank Spaces: A Decade of War, 1935–1945." In *Nihonga: Transcending the Past: Japanese-Style Painting, 1868–1968*, edited by Ellen Conant. St. Louis: St. Louis Art Museum, 1995.

Ruoff, Kenneth J. *Imperial Japan at Its Zenith: The Wartime Celebration of the Empire's 2,600th Anniversary*. Ithaca, NY: Cornell University Press, 2010.

Sandler, Mark H. "The Living Artist: Matsumoto Shunsuke's Reply to the State." *Art Journal* 55, no. 3 (Autumn 1996): 74–82.

Satō Takumi. *Genron tōsei: Jyōhōkan Suzuki Kurazō to kyōiku no kokubōkokka* [Press Control: Information Officer Suzuki Kurazō and Education of National Defense]. Tokyo: Chūō kōron shinsha, 2004.

Sawaragi, Noi. *Bakushinchi no geijutsu/The Art of Ground Zero 1999–2001*. Tokyo: Shōbunsha, 2002.

Schnapp, Jeffrey. "18 BL: Fascist Mass Spectacle." *Representations* 43 (Summer 1993): 89–125.

———. "Epic Demonstrations: Fascist Modernity and the 1932 Exhibition of the Fascist Revolution." In *Fascism, Aesthetics, and Culture,* edited by Richard J. Golsan. Hanover, NH: University Press of New England, 1992.

Seitan hyaku nijūnen Tsuguharu ten/Leonard Foujita. Tokyo: National Museum of Modern Art Tokyo, 2006.

Sheldon, Garon. "Integrating Women into Public Life: Women's Groups and the State." In *Molding Japanese Minds*. Princeton, NJ: Princeton University Press, 1998.

Shepherdson-Scott, Kari. "Fuchikami Hakuyō's Evening Sun: Manchuria, Memory, and the Aesthetic Abstraction of War." *Art and War in Japan and Its Empire*. Leiden: Brill, 2012.

Shibazaki Shinzō. *Efude no nashonarizumu* [Nationalism of the Brush]. Tokyo: Genki shobō, 2011.

Shillony, Ben-Ami. *Politics and Culture in Wartime Japan*. Oxford: Oxford University Press, 1981.

Shiokawa Kyōko. "Uemura Shōen no shōgai to geijutsu" [The Life and Works of Uemura Shōen]. *Uemura Shōen*. Tokyo: Gakken, 1993.

Shōji Jun'ichi. "Modanisuto no kikyō: Fukuda Toyoshirō no kaiga shisō to furusato" [Modernist's Return Home: Fukuda Toyoshirō's Idea of Painting and Rural Home]. *Fukuda Toyoshirō ten* [The Fukuda Toyoshirō Exhibition]. Akita: Akita Museum of Modern Art, 2004.

Shōwa Modan: Kaiga to bungaku 1926–1936 [Showa Modern: Paintings and Literature 1926–1936]. Hyogo: Hyogo Prefectural Museum, 2013.

Shōwa no bijutsu [Art of the Showa Period]. Niigata: Niigata Prefectural Museum of Modern Art, 2005.

Silverberg, Miriam. "The Café Waitress Serving Modern Japan." *Mirror of Modernity: Invented Traditions of Modern Japan,* edited by Stephen Vlastos. Berkeley: University of California Press, 1998.

———. *Erotic Grotesque Nonsense: The Mass Culture of Japanese Modern Times*. Berkeley: University of California Press, 2006.

———. "The Modern Girl as Militant." In *Recreating Japanese Women, 1600–1945,* edited by Gail Lee Gernstain. Berkeley: University of California Press, 1991.

Sontag, Susan. "Fascinating Fascism." *New York Review of Books* 22, no. 1 (February 6, 1975): 23–30.

Szostak, John. "'Fair Is Foul, and Foul Is Fair': Kyoto Nihonga Anti-Bijin Portraiture and the Psychology of the Grotesque." In *Rethinking Japanese Modernism,* edited by Roy Starrs. Leiden: Global Oriental, 2012.

———. *Painting Circles: Tsuchida Bakusen and Nihonga Collectives in Early Twentieth Century Japan*. Leiden: Brill, 2013.

Tanaka Hisao. *Nihon no sensōga: Sono keifu to tokushitsu* [Japanese War Art: Its Genealogy and Characteristics]. Tokyo: Perikan sha, 1985.

Tanaka, Stefan. *Japan's Orient: Rendering Pasts into History*. Berkeley: University of California Press, 1995.

Tanin, O., and E. Yohan, *Militarism and Fascism in Japan*. New York: International Publishers, 1934.

Tanizaki, Jun'ichiro. *In Praise of Shadows,* translated by Thomas J. Harper and Edward G. Seidensticker. New Haven, CT: Leete's Island Books, 1977 [1933].

Tansman, Alan. *The Aesthetics of Japanese Fascism*. Berkeley: University of California Press, 2009.

———., ed. *The Cultures of Japanese Fascism*. Durham, NC: Duke University Press, 2009.

Taut, Bruno. "Nihon deno watakushi no shigoto" [My Work in Japan]. *Burūno Tauto no Kōgei to Kaiga* [Crafts and Paintings by Bruno Taut]. Maebashi: Jōmō shinbunsha, 1992.

———. *Nihon: Tauto no nikki* [Japan: The Diary of Taut], translated by Shinoda Hideo. Tokyo: Iwanami shoten, 1975.

———. *Nihonbi no saihakken* [The Rediscovery of Japanese Beauty], translated by Shinoda Hideo. Tokyo: Iwanami shoten, 1939.

Tipton, Elise K., and John Clark. *Being Modern in Japan: Culture and Society from the 1910s to the 1930s.* Honolulu: University of Hawai'i Press, 2000.

Tsukasa, Osamu. *Sensō to bijutsu* [War and Art]. Tokyo: Iwanami shoten, 1992.

Tsuruya, Mayu. "Sensō Sakusen Kirokuga [War Campaign Documentary Art Painting]: Japan's National Imagery of the 'Holy War' 1937–1945." PhD diss., University of Pittsburgh, 2005.

Ueda, Makoto. "Yūgen and Erhabene: Ōnishi Yoshinori's Attempt to Synthesize Japanese and Western Aesthetics." In *Culture and Identity: Japanese Intellectuals during the Interwar Years,* edited by J. Thomas Rimer. Princeton, NJ: Princeton University Press, 1990.

Uemura Shōen. *Seibishō* (Tokyo: Kōdansha, 1977 [1943]).

Uemura Shōen. *Seibishō sonogo* (Tokyo: Kyūryūdō, 1985).

Uemura Shōen. Tokyo: National Museum of Modern Art, Tokyo, 2010.

Varley, Paul. *Warriors of Japan: As Portrayed in the War Tales.* Honolulu: University of Hawai'i Press, 1994.

Volk, Alicia. *In Pursuit of Universalism: Yorozu Tetsugoro and Japanese Modern Art.* Berkeley: University of California Press, 2010.

Wakakuwa, Midori. *Sensō ga tsukuru josei zō* [Female Imagery That War Creates]. Tokyo: Chikuma gakugei bunko, 2000.

———. "Three Women Artists of the Meiji Period (1868–1912): Reconsidering Their Significance from a Feminist Perspective," translated by Naoko Aoki. In *Japanese Women: New Feminist Perspectives on the Past, Present, and Future,* edited by Kumiko Fujimura-Fanselow and Atsuko Kameda. New York: Feminist Press, 1994.

Washburn, Dennis. *Translating Mount Fuji: Modern Japanese Fiction and the Ethics of Identity.* New York: Columbia University Press, 2006.

Wattles, Miriam. "The 1909 Ryūtō and the Aesthetics of Affectivity." *Art Journal* 55, no. 3 (Autumn 1996): 48–56.

Weisenfeld, Gennifer. *MAVO: Japanese Artists and the Avant-Garde, 1905–1931.* Berkeley: University of California Press, 2002.

———. "Publicity and Propaganda in 1930s Japan: Modernism as Method." *Design Issue* 25, no. 4 (Autumn 2009): 13–28.

———. "Touring 'Japan-As-Museum': *NIPPON* and Other Japanese Imperialist Travelogues." *positions* 8, no. 3 (Winter 2000): 747–793.

Weston, Victoria. *Japanese Painting and National Identity: Okakura Tenshin and His Circle.* Ann Arbor: University of Michigan Press, 2004.

Whyte, Ian Boyd. "National Socialism and Modernism." In *Art and Power: Europe under the Dictators, 1930–45.* London: Hayward Gallery, 1995.

Wilson, Sandra. "Rethinking Nation and Nationalism in Japan." In *Nation and Nationalism in Japan,* edited by Sandra Wilson. London: Routledge, 2002.

Winther-Tamaki, Bert. "Embodiment/Disembodiment: Japanese Painting during the Fifteen-Year War." *Monumenta Nipponica* 52, no. 2 (Summer 1997): 145–180.

———. *Maximum Embodiment: Yoga, the Western Painting of Japan, 1912–1955.* Honolulu: University of Hawai'i Press, 2012.

Wong, Aida Yuen. "A New Life for Literati Painting in the Twentieth Century: Eastern Art and Modernity, a Transcultural Narrative?" *Artibus Asiae* 60, no. 2 (2000): 297–326.

———. "Art of Non-Resistance: Elitism, Fascist Aesthetics, and the Taiwanese Painter Lin Chih-chu." *Art and War in Japan and Its Empire: 1930–1960,* edited by Asato Ikeda, Ming Tiampo, and Aya Louisa McDonald. Leiden: Brill, 2012.

Yamamoto, Masao. "The Aesthetic Thought of Ōnishi Yoshinori." In *A History of Modern Japanese Aesthetics,* translated and edited by Michael F. Marra. Honolulu: University of Hawai'i Press, 2001.

Yamanashi, Toshio. *Egakareta rekishi: Nihon kindai to "rekishiga" no jijō* [Painted History: Japan's Modernity and the Magnetic Field of "History Paintings"]. Tokyo: Brüke, 2005.

Yamanouchi, Yasushi, J. Victor Koschmann, and Ryuichi Narita, eds. *Total War and "Modernization."* Ithaca, NY: Cornell University Press, 1998.

Yanagita, Kunio. *Yukiguni no fūzoku* [The Customs of Snow Country]. Tokyo: Daiichi hōki shuppan, 1977 [1943].

Yasumatsu, Miyuki. "1939 nen no berurin Nihon kobijutsu tenrankai to shinbun, zasshi hihyō: Kokka ishiki to bijutsu no kankei wo sihyōnishite" [The 1939 Japanese Ancient Art Exhibition in Berlin and Its Reviews in Newspapers and Magazines: On Relations between Nationalist Consciousness and Art]. In *"Teikoku" to bijutsu: 1930 nendai Nihon no taigai bijutsu senryaku* ["Empire" and Art: Diplomatic Strategies of Art in 1930s Japan], edited by Omuka Toshiharu. Tokyo: Kokusho kankōkai, 2010.

Yokoyama Taikan. "Fuji no tamashii" [The spirit of Mt. Fuji]. *Yomiuri shimbun,* February 15, 1942.

Young, Louise. *Japan's Total Empire: Manchuria and the Culture of Wartime Imperialism.* Berkeley: University of California Press, 1999.

INDEX

Akiyama, Kunio, 28, 108n66

Amaterasu, 10, 36–37, 45, 64, 109n29

American Occupation, 1, 4, 86, 101, 103n5

Araki, Sueo, 28–29

Arishima, Ikuma, 17, 59

Arishima, Takeo, 91

Art Deco, 61, 113n41

Bauhaus, 61, 63, 64, 94

Benjamin, Walter, 2

bijin-ga (pictures of beautiful people), 3, 4, 60, 67–68, 72–76, 81, 89

Braun, Emily, 12, 65, 114n57

Britain, 2, 3, 9, 11, 19, 29, 40, 45, 92, 103n9

Brown, Kendall, 6, 76

Buddhism, 32, 42, 46, 58–59, 69, 95, 112, 109n29, 112n10

Bushido, 14, 50, 52–53, 66, 112n11

Cabinet Information Bureau, 21, 40

capitalism, 10–12, 29

Celebration of the Japanese Imperial Reign's 2600th Anniversary, 6, 10, 23, 31, 37, 38, 45, 49, 55, 105n3, 110n47, 111n1

Charterjee, Partha, 39, 72, 115n31

China, 1, 4, 19, 22–23, 27, 40–42, 45, 54, 69, 86, 89, 97,

Chinese art, 26, 41, 42, 43, 44, 46, 47, 56, 104n9, 111n68, 112n10, 116n40, 116n45

colonialism, 3, 6, 20, 23, 83, 93, 96–97, 110n55, 119n45

communism, 18, 20, 43, 107n60

comfort women (*ianfu*), 4

Confucianism, 9, 36, 50, 53, 54, 82

Dadaism, 18

Davis, Darrell William, 72, 115n28

De Chirico, George, 65, 121

Dōmoto, Inshō, 24

Edo-period, 3, 4, 13, 16, 27, 32–34, 37, 44, 68, 72–77, 84, 89, 106n32, 109n32–33, 109n35, 115n33

Emperor Hirohito, 4, 37, 69

Emperor Jimmu, 10, 37

Ernest Fenollosa, 16, 41, 42, 73

Exhibitions and the Second World War: before, 16–17, 42, 59–60, 73, 75; during, 9–10, 20–23, 26, 29–31, 38, 45–47, 49–50, 55, 61, 66, 68, 72, 77, 82, 86, 92, 96, 98; after, 1, 3, 65, 87, 113n39, 117n4

Exhibition of the Imperial Academy of Arts (*Teikoku bijutsu-in tenrankai*, or *Teiten*), 31, 96

fascism, 8, 10–14, 24–26, 27–29, 32, 47, 49, 53–54, 65–66, 77, 101, 103n9, 104n25, 105n7–18, 108n1, 111n5, 117n64, 119n41, 120n2

fascist modernism, 6, 12, 49, 53, 65–66, 77, 101, 106n18, 111n5

feminism, 7, 67, 76, 80–83

France, 16, 27–29, 30, 59, 61, 64–65, 85–86, 88, 98

frugality, 78, 84

Fujita, Tōko, 38

Fukuda, Toyoshirō, 24, 62, 96, 113n44

Fukuzawa, Ichirō, 22

Gauguin, Paul, 75

Germany, 2, 7, 11, 15, 19, 29–30, 34, 37, 46, 49, 61, 65, 101, 104n9, 106n31, 111n77, 111n80, 114n59

good wife, wise mother (*ryōsai kenbo*), 17

Great Depression, 29

Great East Asia Co-Prosperity Sphere (*Daitōa kyōeiken*), 19, 31, 40, 54, 63

Griffin, Roger, 11–12, 100, 105n15–17

Gyokusai, 53

Hamaya, Hiroshi, 95, 119n38–39
Hariu, Ichirō, 5, 104n18, 107n63, 108n64, 108n69, 108n71
Harootunian, Harry, 6, 12–13, 24, 100, 104n26, 106n19, 106n31, 115n27, 119n25
Hasegawa, Nyozekan, 11, 71, 105n8, 115n23–24
Hasegawa, Saburō, 62, 113n45
Heian-period, 32, 50, 57, 62, 71
Heidegger, Martin, 71–73
Hirano, Masakichi, 87, 117n4
Hitler, Adolf, 23, 30, 46–47, 101
homefront (*jūgo*), 78

Ienaga, Saburō, 3, 107n46
Ihara, Usaburō, 22
Imperial Rule Assistance Association, 19, 28, 48
individualism, 2–3, 10–12, 42, 92, 100
Inokuma, Gen'ichirō, 22
Ishii, Hakutei, 17, 59
Italy, 2, 7, 11, 15, 19, 27, 29–30, 37, 46, 49, 65, 101, 104n9, 106n18, 106n31, 111n5, 114n58–59

Japan Art Academy (*Teikoku bijutsuin*), 31, 68
Japan Art Institute (*Nihon bijutsuin*), 21, 23, 49, 109n24

kabuki, 55, 73, 112n19
Kaburaki, Kiyokata, 31, 114n1
Kainoshō, Tadaoto, 75
Kajiwara, Hisako, 74–75, 114n1, 116n44
Kamakura period, 6, 48, 51, 54, 57–59, 61, 69
Kamei, Katsuichirō, 71–72, 115n26–27
Kanō school, 33, 44, 62
Katsuhira, Tokushi, 94, 119n31–32
Katsushika, Hokusai, 34, 37, 44–45, 109n33
Kawabata, Ryūshi, 22, 108n65, 112n10
Kawabata, Yasunari, 25, 95,
Kawata, Akihisa, 4–5, 22, 34, 45, 103n5, 104n17–18, 108n4, 109n34–35, 110n37, 111n71
kennōga-ten (Offering Painting exhibitions), 23, 49, 68
Kikuchi, Keigetsu, 31, 74
Kikuchi, Yuko, 92, 113n48, 116n56, 118n19, 118n21, 120n51–53,
Kim, Hyeshin, 97, 119n45
Kimura, Ihee, 40, 95
Kinbara, Seigo, 56–57, 112n26
Kitagawa, Utamaro, 73, 89
Kobayashi, Kokei, 56, 65
Kojiki, 36, 45

Kojima, Zenzaburō, 99, 120n54
Kokuga sōsaku kyōkai (Society of the Creation of Japanese Painting), 18, 59, 74–75
kokutai (national body), 9–10, 36–37, 41
Kokutai no hongi (*Cardinal Principles of the National Entity of Japan*), 8, 10, 14, 28, 35–36, 41, 110n38, 110n40, 112n14
Konoe, Fumimaro, 19, 28, 30, 37
Korea, 1, 4, 18–19, 54, 83, 96–97
Kuki, Shūzō, 73–74, 115n36–37, 106n19, 116n40
Kuroda, Seiki, 16, 27, 86
Kusunoki, Hisako, 77–80
Kusunoki, Masashige, 40, 78
Kyoto, 10, 33, 50, 57, 59, 62, 68, 73–74, 77–78, 87, 91, 114n1, 116n42

Le Corbusier, 61–62, 64, 98, 113n46

machine, 40, 59, 61–62, 64, 73, 113n38, 113n40–42
Maekawa, Kunio, 64, 113n52–53
Manchuria, 1, 8, 10, 15, 16, 19–21, 23, 45, 103n1, 104n24, 107n52, 116n53, 119n42
Maruyama, Masao, 11, 105n10
Marxism, 11, 103n1, 106n42
materialism, 3, 38, 56, 99–100
Matisse, Henri, 17, 59
Matsuda, Genji, 21, 31
Matsumoto, Shunsuke, 5, 22, 107n58, 109n23
MAVO, 18, 106n40, 120n1
Mexico, 86, 90, 118n12
militarism, 10–11, 15, 23, 41, 101–102, 105n7–8, 108n68, 113n38
Minamoto, Yoritomo, 9, 48, 50–51, 54–58
Minamoto, Yoshitsune, 9, 48–55, 58–59, 64
mingei, 7, 91–99, 106n19, 113n48, 116n56, 118n19–24, 119n23, 120n51–52
Ministry of Education, 10, 16, 21, 31, 35, 38, 49, 68–69
minzoku (ethnicity), 29, 30, 48, 120n48
minzokugaku, 91, 93–95, 99
Miyamoto, Saburō, 22, 29
Miyazawa, Kenji, 94, 119n28
modern aesthetics, 6–7, 48–49, 56, 60, 62–66, 77, 84, 101
moga (modern girl), 17, 60–61, 70, 76
monpe (peasant trousers), 78, 91
Morris, William, 92
Mukai, Junkichi, 22
Murayama, Tomoyoshi, 18, 20, 107n44, 107n51
Muromachi period, 32, 44, 69, 71

Nanjing, 4, 23, 69, 107n45

National Museum of Modern Art, Tokyo, 1, 5, 87, 114n1, 114n6

New Classicism, 65, 104n9, 106n18, 114n58–59

New Japanism (*Shin Nihonshugi*), 99, 120n54

New Ministry of Education Art Exhibition (*Monbushō bijutsu tenrankai,* or *Shin-bunten*), 30

New Order, 19, 28, 30, 105n11, 108n8, 120n55,

Nihon kaiki (return to Japan), 3, 9–10, 14, 24, 59, 105n1

Nihon shoki, 36, 45, 109n28

Nikakai, 17, 21, 31, 59, 86

Nitobe, Inazō, 14, 52

Nochlin, Linda, 81

noh, 3, 7, 67–73, 78, 84, 101, 114n9, 115n16, 115n23

Okada, Kōyō, 45

Okakura, Tenshin (Okakura, Kakuzō), 14, 16, 27, 30, 39–42, 49, 58, 60, 73, 104n23, 106n34, 110n54, 110n56,

Okazaki, Yoshie, 56–58, 74, 112n22, 112n24, 116n41

Ōnishi, Yoshinori, 71, 73, 115n20–22

Order of Culture (*Bunka kunshō*), 49, 69

Overcoming Modernity (*Kindai no chōkoku*), 8, 10, 14, 28, 71, 74, 104n26, 115n25–26

Pacific War, 10, 16, 103n1–2

Pan-Asianism, 14, 39, 56, 106n28

Perriand, Charlotte, 98, 113n46, 120n53

Picasso, Pablo, 29, 65, 86, 117n4

Pincus, Leslie, 74, 106n19, 112n23, 116n40

primitivism, 16, 60, 96–98

rekishi-ga (history painting), 58, 104n23, 106n35, 111n1, 112n32

Reorganized Japan Art Institute (*Saikō Nihon bijutsu-in*), 31

Reynolds, Jonathan, 95, 113n52–53, 119n38–39

Rimpa, 46, 62

Rivera, Diego, 86, 90

Ruskin, John, 92

Russia, 18, 22, 86

Russo-Japanese War, 14–15, 110n60

Saeki, Shunkō, 60–62

saikan hōkoku (serving the nation through art), 67, 79

Sawaragi, Noi, 1, 5, 103n4

seiki (righteous spirit), 36, 38, 41

Shinto, 32–33, 36, 38, 69, 45, 105n6, 109n29–30, 112n10

Shirakaba, 17–18, 59, 92, 106n38, 112n33

Sino-Japanese War: first 15, 45, 110n60; second, 10, 16

socialism, 12, 20, 91

Special Attack Forces, 41, 53

spirituality/spiritualism, 3, 6, 15, 21, 35, 38–39, 41, 43, 46–47, 78, 100, 107n53, 109n29, 114n9

Suzuki, Harunobu, 73–74, 76, 89

Szostak, John, 59, 74, 113n35–37

Taiwan, 18–19, 96–97, 104n25, 119n44–45

Takahashi, Yūichi, 34

Takamura, Kōtarō, 17

Takeuchi, Seihō, 68, 56

Takiguchi, Shūzō, 22

Tanaka, Stefan, 96, 119n43

Tange, Kenzō, 63–64

Tanizaki, Jun'ichirō, 70, 115n17

Tansman, Alan, 6, 12–13, 24–26, 47, 95, 100, 104n27, 106n20–21, 108n1, 119n41

Taut, Bruno, 62–63, 94–95, 98, 113n47–49, 119n35

tenkō, 20, 107n47–51

Tohoku, 24, 85, 87–88, 91–98, 117n1, 118n22, 119n23, 120n46

Tōjō, Hideki, 19, 53

Tokyo National Museum (Museum of the Ministry of Education; *Monbushō hakubutsukan*), 16, 42

Tokyo National School of Fine Arts (*Tōkyō bijutsu gakkō*), 16, 27, 42

tonarigumi, 21, 78

Tosaka, Jun, 11, 105n8

totalitarianism, 11, 29, 104n9

Tōyō, Sesshū, 42–44, 46

Tsuchida, Bakusen, 17–18, 59–61, 68, 75, 106n39, 113n35–57

Tsuda, Seifū, 20

Uemura, Takachiyo, 29, 108n14

ukiyo-e, 32, 34, 72–77, 89, 109n26

ultranationalism, 10, 105n6

Umehara, Ryūzaburō, 17, 59

United States, 1–4, 5, 9, 16, 19, 21, 27, 29, 41, 53, 61, 64, 76, 86, 101, 103n2, 103n5, 103n9, 105n7, 106n31, 117n81

Utagawa, Hiroshige, 34, 109n32

van Gogh, Vincent, 75

Wakakuwa, Midori, 81–82, 114n1, 115n32, 116n47, 116n59, 116n62, 117n66–70, 117n74
War Campaign Record Paintings (*Sensō sakusen kirokuga*), 1, 22, 104n21
war responsibility (*sensō sekinin*), 4, 83
Washburn, Dennis, 14, 106n25, 106n27, 106n29
Weisenfeld, Gennifer, 6, 64–65, 104n24, 106n40, 107n55, 113n54, 119n36, 120n1
Winther-Tamaki, Bert, 5, 37, 108n67, 110n42, 110n51–52

Women Artist Patriotic Group (*Joryū bijutsuka hōkōtai*), 82

Yamamoto, Isoroku, 49
yamato nadeshiko, 67, 77
yamato-e, 3–4, 6, 9, 33, 46, 49, 56–57, 59, 64, 74, 89, 113n43
Yamawaki, Iwao, 98
Yanagi, Sōetsu, 25, 91–93, 95, 97, 118n22
Yanagita, Kunio, 91, 93–95, 119n25, 119n28–29
Yanase, Masamu, 18, 20
Yasukuni Shrine, 80, 83

ABOUT THE AUTHOR

Asato Ikeda is an assistant professor in the Department of Art History and Music at Fordham University. She co-edited, with Ming Tiampo and Aya Louisa McDonald, the first English-language anthology on Japanese war art, *Art and War in Japan and Its Empire, 1931–1960*, and her research on Japanese war art has been published in *Modernism/modernity, disClosure, Review of Japanese Culture and Society,* and *Japan Focus*. Ikeda is also active as a curator. Most recently, she curated "A Third Gender: Beautiful Youths in Japanese Prints" at the Royal Ontario Museum in Toronto, Canada.